Ireland's
Traditional
Crafts

Edited by DAVID SHAW-SMITH

with 440 illustrations, 125 in color

Photographs by David Shaw-Smith
Drawings by Sally Shaw-Smith

THAMES AND HUDSON

Ireland's Traditional Crafts

© 1984 Thames and Hudson Ltd, London

Reprinted 1986

First published in the United States in 1984 by
Thames and Hudson Inc., 500 Fifth Avenue,
New York, New York 10110

Library of Congress Catalog Card Number 83-50752

Printed and bound in Japan by Dai Nippon

Contents

Foreword *by Justin Keating* 7

Introduction 9

Textiles

Wool and flax preparation 14

Spinning 18

Dyeing 19

Weaving 26

Fulling and napping 26

Crios weaving 27

Handknitting 27

Embroidery 28

Patchwork 30

Carpets 35

Tailoring 38

Lace and crochet 42

Stonework

Stonecutting and masonry 49

Clare slate 57

Millstone dressing 59

Drystone walling 60

Woodwork

Coopering 64

Furniture 71

Hurls 78

Pipes 80

Spinning wheels 82

Cabinets 85

Sticks 87

Lake boats 88

The Greencastle Yawl 90

Wooden boats of the west coast 91

Currachs 95

Uilleann pipes 103

Violins 107

Bodhráns 110

Lambegs 111

Harps 112

Willow, Rush and Straw

Baskets 118
Thatching 130
Bee-skeps 139
Súgán chairs 141
Rushwork 144

Leather

Harnesses and saddles 148
Pampooties 156
Shoes 158
Hurling balls 160
Bookbinding 161

Metalwork

Blacksmithing 168
Spades 173
Carriages 174
Gold- and silversmithing 177

Pottery

Coarse ware 186
Fine ware 191
Art pottery 195

Glassware

Waterford crystal 197

Candlemaking

201

Fly-tying

202

Rural life

Traditional crafts on a Co. Fermanagh farm 203

Map showing locations of craftsmen and women in the book 216

About the contributors 218

Suggested further reading 219

Places to visit 220

Acknowledgments 221

Index 222

It is an accident of history that the Industrial Revolution came later to Ireland than to many of its West European neighbours. In terms of wealth this was undoubtedly a disadvantage, but in terms of culture it had definite benefits.

Irish rural society has persisted, with much of its culture intact, to the present day. What is best known is the culture of words and music. For the dispossessed this was the most portable. In times of desperate stress it was easier to preserve an old tune or an old story than to preserve a cuisine or a way of making furniture. But of material culture a great deal still remains, right up to the present day. Half or quarter of a century ago it was not esteemed by the new middle class when they came to homemaking. The imported and mass produced was chic. The indigenous, the traditional, the work of the craftsman was neglected.

But fortunately the resurgence of interest has come in time, and David Shaw-Smith is an important part of that resurgence. Already he has put us all in his debt by his superb television series 'Hands', which has recorded in loving detail the work of craftsmen and women all over Ireland. (English lacks a proper word for the category of people we are discussing, which is in itself revealing.) Now he is the organizer and inspirer of a book that for scope and quality is a big step beyond anything currently existing.

It seems to me worth thinking about why the resurgence in interest in the work of the artist/craftsman is so widespread and full of strength. A large part of the answer must lie in human experience during the Industrial Revolution. This has seen us urbanized, separated from small communities where we have a sense of belonging, and separated from nature. The idea of alienation is widely and carelessly used, but it is impossible to contemplate contemporary society without recognizing how truly applicable it is.

Everywhere the thrust of industrialization is pushing into the last outposts of traditional society, and is being followed even before this revolution is complete by a perhaps even more profound change ushered in by current progress in communications, computers, information management and automation.

It is precisely in these disorienting and frightening circumstances that we need the reassurance of living with objects which are quite clearly the work of one particular identifiable individual person, working in a particular place, on a particular day, and within a particular tradition. We need human objects as part of our own search for identity and wholeness. We need the wood and clay and stone and natural fibres speaking directly to us as part of our search to re-establish contact with nature. This is not a cry against progress and change, but an affirmation that to face the ever-accelerating change as we must (and to welcome it if we can), we need to be secure and rooted and centred in our own identity, and connected to our human and natural surroundings. Again, this is not a cry for chauvinism in culture and a retreat into a

national mystique, but precisely the opposite. (The Ireland of the '80s knows these dangers).

If we must (as we must) learn truly to esteem and love the cultures of other peoples, and the quality and uniqueness of what they do, surely it can only be from a knowledge and love of what we do ourselves, of its quality and uniqueness.

The events of recent centuries, and most especially of this century, have left much of mankind traumatized, culture-shocked, alienated and suffering identity crises. In the end, the only real therapy is successful work in building peacefully a future which is more daunting but simultaneously more exciting than mankind has previously known. Many buffeted peoples, the Irish not least, use words in a magic way. I mean this not as praise, but literally; by incantation we can change reality without work. Of course we cannot, but the realization that we cannot is part of our growing up.

A culture which pays more attention to words and music than to material things is lopsided. When we can make things as well as we describe them, and revere the maker as much as the singer, we are on the road to health. That is why the refinding of our material culture, and the great surge of interest in the work of the craftsman and artist/artisan is so important in Ireland. That is why this book, as well as being beautiful and scholarly, is so important.

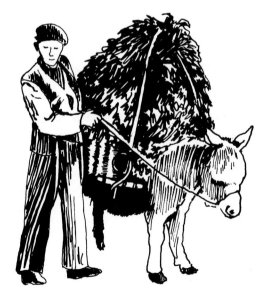

INTRODUCTION

In the social upheaval of the decades since the Second World War many features of Irish urban and rural life have disappeared or remain only as quaint curiosities. One day Mammy puts the spinning wheel into the loft – its rhythmic whirr becomes a fading memory. Jem the milkman calls for the last time with his pony and float. Paddy Faherty gets too old to follow his horses behind the plough. The familiar double knock of the cooper's hammer, driving home the tress hoops, falls silent.

There was nothing very remarkable about these activities or anything dramatic in their disappearance. It is as if by their very ordinariness they have failed to register on our mind's eye and they have ceased without our noticing. In their passing we have lost something of our traditional way of life forever.

It is perhaps too easy to wax eloquent about the romantic past: the woman of the house spinning by the flickering fire, the grand gatherings at harvest time, the scything of corn and the scutching of flax. All were associated with hard, practical and sometimes dangerous tasks carried out for sound economic reasons. When they became unnecessary or financially unrewarding they ceased, making way for faster, easier and more economic methods of doing the same job.

But if the technological advances of the twentieth century have brought increased material benefits and comfort, the price paid, in terms of the country's cultural heritage, has been high.

The motor car, for example, gradually brought to an end the era of the work-horse and all the related crafts. The blacksmith was one of the first casualties. Not so very long ago every village had its blacksmith/farrier, serving the needs of the community by making a whole range of useful agricultural and domestic articles. The disappearance of the work-horse seriously affected his business and instead of making simple horse-drawn agricultural machinery, he had to switch to the repair of power-driven ones, if his trade was not to be taken away by the new local garage.

That any traditional crafts at all have survived to the present day is a small miracle. Some were nearly lost thirty years ago. With the increasing popularity of the motor car after the Second World War, coach builders like the Breens of Enniscorthy were forced to branch into joinery and shopfitting to subsidize their craft, relying on restoration and repair work to maintain their skills and keep their craftsmen.

Some crafts stayed alive more for social than economic reasons. A household of bachelors and spinsters required to look after old parents would lack the drive of spouses and children to force them out of their narrow existence. They clung to the old ways and the old crafts and sadly, all too often, the craft was doomed. Other crafts such as handspinning were a necessity associated with the struggle to rear large families with

little money. They became symbols of poverty and hard times best forgotten. Often the thatched house was remembered in the same way.

Isolation has played its part in preserving crafts in some of the more remote parts of Ireland. Even in the quite recent past, communications were poor, and there was little to disturb the tranquil, secluded life. Another factor may have been that Irish was the language spoken (the English language being poorly understood). On the Aran Islands, in particular Inishmaan, pampooties (traditional moccasin-like shoes of rawhide) are still made and worn by a few of the older men, while most of the population over fifty years of age wear traditional dress, if not all the time, certainly on Sundays. It was also here that the famous Aran jerseys had their origin. They have now become a national export business and are made all over Ireland.

Throughout the fifties, sixties and seventies the economy steadily improved. As prosperity increased and living standards improved, much of the drudgery disappeared from rural life. This prosperity was to accelerate in the next decade after Ireland became a member of the European Economic Community in 1971.

With the expansion of the economy came a revival of interest in crafts. In the mid-sixties the Breens began to restore old traps and carriages for export to Europe. The Driving Club of Ireland was formed and suddenly the Breens were busy, making new gigs, dogcarts and carriages for the first time in years. The export trade had increased too and they were even sending carriages to America.

The craft of bookbinding also underwent an expansion – and one that was not confined to conservation and restoration, because there was also a renewed interest in appreciation of design bindings. The work of bookbinders sometimes mirrored the skills of the eighteenth-century craftsmen, and sometimes created exciting modern designs.

The increasing popularity of the horse for leisure purposes, hunting, show jumping, driving and trekking has meant a big upturn in the work of the saddle and bridle maker and the specialist harness and collar maker.

Trends also influence crafts. Irish music began to regain a following in the late 1950s and this popularity, which has today spread worldwide, encouraged the making of specifically Irish musical instruments such as the *bodhrán* (a traditional tambourine-type drum), the harp, violins, flutes and uilleann pipes.

The survival of traditional crafts in Ireland to this day owes much to the work of semi-state bodies, organizations, private companies and individuals. In 1891 the Congested Districts Board was set up by the Government of the day to relieve hardship and suffering and create employment in remote overcrowded parts of Ulster, Munster and Connaught. The Board encouraged the development of agriculture and forestry, the breeding of livestock and poultry, spinning, weaving, fishing and connected industries. Funds were made available and the assistance it offered enabled people to improve upon their traditional skills and establish for themselves a continuity of employment. The Board distributed an improved version of loom weaving tweed; in

conjunction with the Irish Industries Association and the Irish Lace Depôt it encouraged the setting up of no fewer than seventy-six lace schools; and among other crafts that were to prosper were those allied to the fishing industry, such as boat building and coopering, the latter being connected with fish curing.

An organization which has figured prominently in the preservation of traditional crafts is the Irish Countrywomen's Association (formerly the United Irishwomen). In 1930 a small group of their members and like-minded friends opened the 'Country Shop' in Dublin as a sales depot for traditional country and home crafts, and formed the private company of Country Workers Ltd to manage the shop and carry out a countrywide production programme in the small farm areas. Recognition and help for the isolated spinners and weavers of Mayo and Donegal were particularly in mind.

Five years later, at the invitation of the Royal Dublin Society, Country Workers Ltd founded the Irish Homespun Society for the specific purpose of organizing, at the RDS Spring Show, an exhibition of traditional crafts of every kind with emphasis on demonstrations by a wide range of country craftsmen and women. Expenses were met by the RDS. Successful and worthwhile exhibitions continued until 1946, in which year the Homespun Society decided that instead of exhibiting in Dublin, work should be concentrated on traditional craft production in the countryside and that this should be linked with a self-help programme at local level.

It was, therefore, at this time that the three organizations of Country Workers, the Irish Homespun Society and the Irish Countrywomen's Association joined together to form the Co-operative Society of Country Markets for the production and local co-operative marketing of the country's traditional and home crafts. The Royal Dublin Society generously donated an annual grant to assist Country Markets in its work, a grant which under the name of the 'RDS Craftsmanship Scheme' has continued from that time onwards with local craft development its priority.

The full extent of the Royal Dublin Society's financial and other support of Irish craft development over the years is known by too few. Beginning the very year the Society was founded, in 1731, this support has continued without cessation for two-and-a-half centuries and has been one of the most valuable contributions to the present healthy state of Ireland's crafts. The Society's main concern from 1968 onwards has been a national craft competition and exhibition held each year at the August Horse Show. Entries in this competition during the last few years have approximated 700 annually.

The Kilkenny Design Workshops, which were established by the Irish Government in 1965 to promote and improve good design in industry, have had a beneficial effect on crafts, as at that time most Irish industries were craft-based. The designers and craftsmen employed by the Kilkenny Design Workshops in its early years exerted a considerable influence on Irish crafts in general, bringing about a much-needed change in attitudes by encouraging quality and professionalism.

The Craft Council of Ireland was founded in 1971 and its members represent many organizations. It owes much to the Royal Dublin Society who, as a founder member, provided headquarters for the Council and met all secretarial and other expenses until a Government grant was forthcoming in 1976. It is State-aided through the Industrial Development Authority and it represents craftsmen and women at national level, organizes trade fairs, exhibitions, seminars and development projects.

Many companies have also helped to preserve traditional crafts for sound economic reasons. Magees of Donegal town, who are spinners and weavers and finishers of tweed, have long encouraged outworkers to weave for them. At the present time, they have a considerable workforce of handweavers throughout south-west Donegal.

The impetus craft has received during the past twenty years has led to a greater understanding and respect for the manual skills of these craftsmen and women. The pride these people take in their work is well summed up by Ned Gavin the cooper:

When you made a churn you really achieved something: that was the great satisfaction. You made a thing from start to finish and you were always trying to improve the next one. That's something that gets into you; you'd even sacrifice money to have the thing one hundred per cent right. I think it is beginning to dawn on people now that our future lies in the things that we create and that we will live or die by the things we make.

There is a sign of hope for the survival of traditional crafts. Living with the realities of redundancy and unemployment many young people reject the idea of a conventional business career. They are beginning to realize that an alternative exists which can offer a fulfilling and rewarding life. The future of traditional crafts rests with them.

DAVID SHAW-SMITH

Textiles

WOOL AND FLAX Brid Mahon

Within sight and sound of the wild Atlantic Ocean on the western seaboard of Ireland, Bessie Morrisson engages in the age-old craft of spinning, her wheel turning rhythmically in time to the high lonely cry of the sandpiper, 'knittyneedle, knittyneedle'. The thread she spins stretches back to a dim and misty past of which we know little. Spinning was probably a familiar activity in Ireland over three thousand years ago. A pottery vessel of that remote period found at Fourknocks, Co. Meath, shows a clear imprint of some woven material. Perhaps the bowl was moulded in a cloth sack, or else the material was used as a form of decoration.

Sheep were probably introduced into Ireland by the first Neolithic farmers around six thousand years ago. From early historic times black wool appears to have been used in the making of garments. Giraldus Cambrensis, or Gerald the Welshman, who visited Ireland in the twelfth century and wrote of his travels, remarked that nearly all the woollen clothes the Irish wore were black, 'that being the colour of the sheep of the country'.

Today the black sheep is extinct in Ireland. Breeds are generally divided into Lowland sheep, of which the Galways are the most numerous, numbering around one-third of a million, and the Mountain Blackface sheep which account for three-quarters of a million. The natural Aran sweaters are generally made from the wool of the Galways. The wool of the Blackface is of a coarser variety and cannot be dyed a uniform colour because the long strands of kemp present in the fleece do not accept dye readily; it is used mainly for carpet making, blending and often for Donegal homespuns. Wicklow Cheviot, a long-to-medium-wool sheep of which there are some 300,000, is somewhat akin to the Blackface sheep, while the short-wool Suffolk Down yields a finer wool. Here and there is found the occasional cross-breed, like the brown-wool sheep living on the Aran Islands. In all there are three-and-a-half million sheep yielding some nine million kilos of short wool, in addition to two-and-three-quarters of a million kilos of skin wool from the abbatoir.

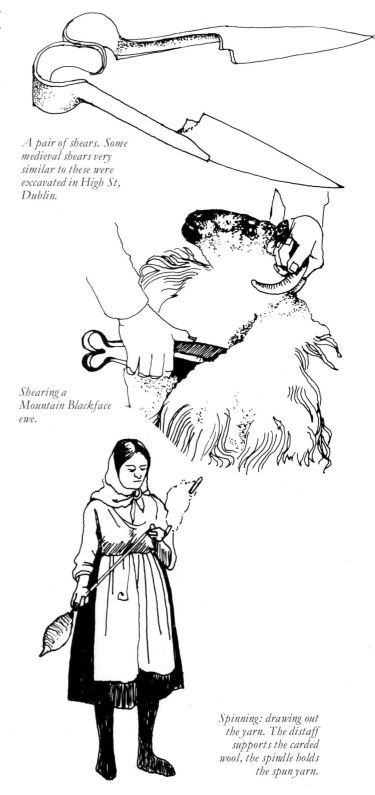

A pair of shears. Some medieval shears very similar to these were excavated in High St, Dublin.

Shearing a Mountain Blackface ewe.

Spinning: drawing out the yarn. The distaff supports the carded wool, the spindle holds the spun yarn.

The correct preparation of wool for spinning is vital. The fleece has to be sorted, for it is not uniform but made up of different textures and qualities of wool, not all of which are considered suitable for spinning. It is then carefully washed and, in the traditional way, put out on a stone wall to dry. Briars and pieces of stick have to be removed and a greasing agent is added to lubricate the fibres. A thorough combing or carding of the wool removes tangles and causes the fibres to lie side by side; each fibre is covered by a layer of microscopic scales which cling together in a ratchet effect when the wool is spun. The big spinning wheel once common on the western seaboard is now very rare. It was superseded in Donegal, particularly, by the smaller flax wheel. The two types of wheel were frequently found together in the same house where the big wheel was used for plying the wool for knitting or modified to wind yarn onto bobbins for the weaver.

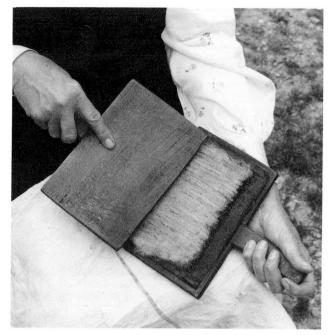

Carding untangles the wool fibres and leaves them lying parallel ready for spinning.

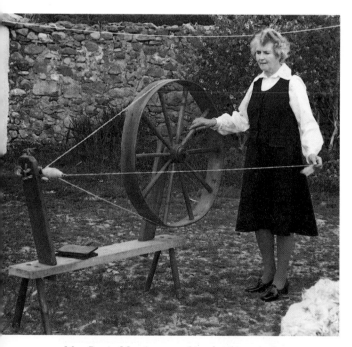

Mrs Bessie Morrisson working her big spinning wheel Tuirna Mór at Thallbawn, near Louisberg, Co. Mayo.

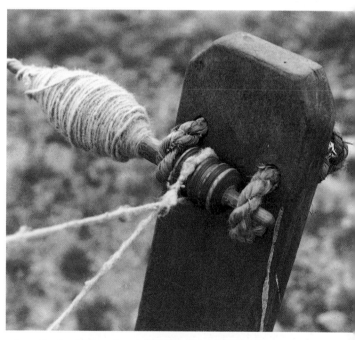

A woollen band drives the spindle of the big wheel, which is attached to the tail stock by 'ears' of woven rush. Willow or 'sally' is often used.

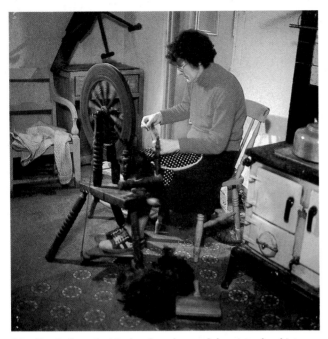

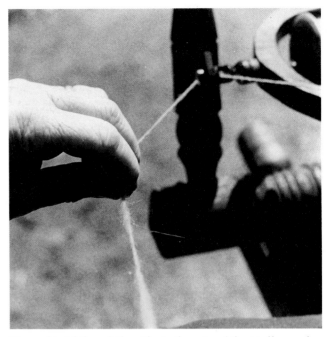

Mrs Toye's flax wheel is thought to be one of those introduced into Ulster by the Royal Linen Manufacturers at the end of the eighteenth century.

The wool is fed through the orifice in the centre of the spindle, round hooks on the flier and thence to the bobbin (see also p. 82).

Sheep fairs, once a common feature of the Irish countryside, are fast becoming a thing of the past, replaced in many places by marts and factories. But the September fair is still held in Carrick, a Donegal village on the Killybegs–Glencolumbkille road, where sheep are tied in the old-fashioned manner with *súgán*, or straw ropes.

So important was spinning in early Ireland that the Brehon Laws (written down 600–800 AD) lay down a wife's entitlement in the case of divorce or separation. In addition to her lap dogs and cats, looking-glasses, sieves and kneading-troughs, she was entitled to keep her spindles, wool bags, needles, weaver's reeds and a share of the thread she had spun and the cloth she had woven. Even today the word 'spinster' is sometimes used to designate an unmarried woman. She was given the name because long ago she was considered unfit for marriage until she had spun the yarn for a set of household and personal linen. Cloth was always spun and woven by the mistress of the household and her female helpers. It was not until quite late that men became weavers.

Flax was probably grown in Ireland from the Bronze Age onwards. The early literature has splendid descriptions of kings and queens, brave warriors and fair maidens, wearing tunics, shirts and gowns of fine linen.

Linen continued to be popularly used down to the sixteenth century, when Henry VIII passed a law that no Irishman should be allowed to use more than seven yards of linen in the making of a shirt. However, like many such laws it was found to be unenforceable, and in the reign of Elizabeth I we read of the rebellious Irish using up to thirty yards of linen in their dress.

The preparation of flax for spinning has varied little over the centuries. The flax is not cut but pulled from the ground (nowadays harvested by

OPPOSITE, TOP *Hand-woven Irish tweeds from 'The Weavers Shed' woollen mills.*
BOTTOM *Cones, shuttle and bobbins in front of the warping mill on which the warp threads lie in the correct order ready to be wound onto the warp beam and carried to the loom. 'The Weavers Shed', Dublin.*

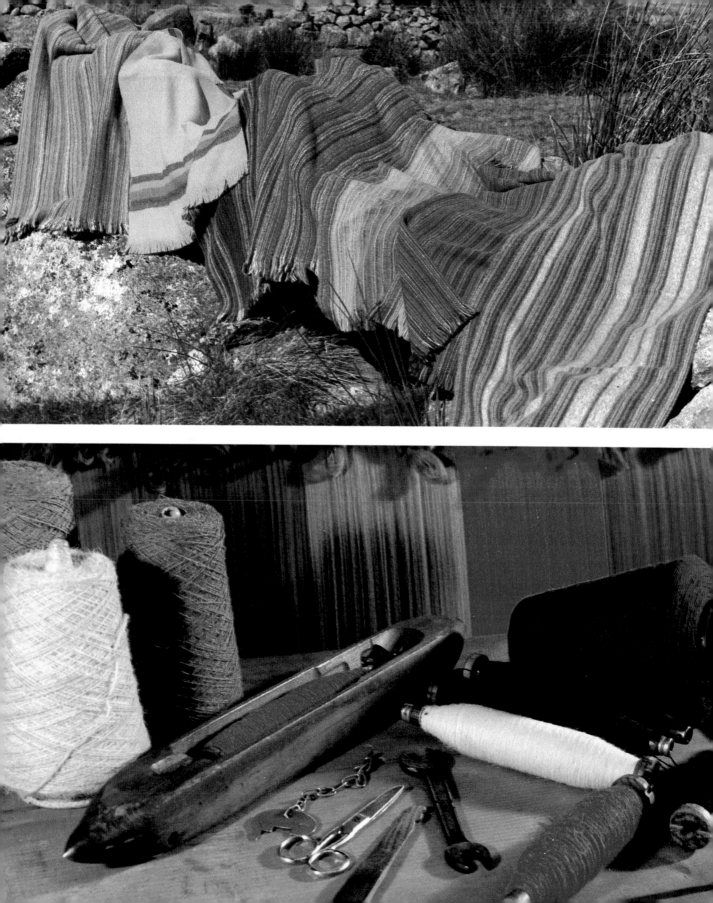

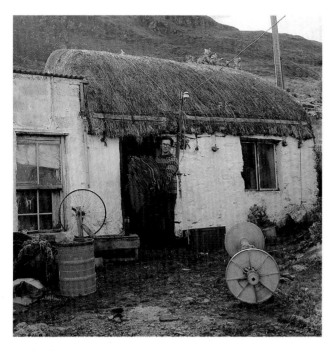

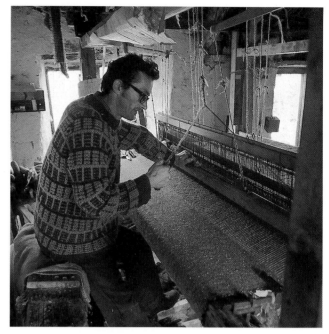

Packey McHugh of Laconnell, Ardara, Co. Donegal, with a bolt of tweed to be dispatched for finishing (washing, fulling and tentering). On the right, is a modern warp beam. The bicycle wheel mounted on a wooden base is for winding bobbins.

The Congested Districts Board, set up in 1891, distributed thousands of flying shuttle looms. Like many other weavers today Packey McHugh works from his own home, under contract to Magees of Donegal town, who will finish and export the tweed.

machine), then tied into sheaves and dried. It is then steeped to rot the woody fibres (a process known as 'retting'), spread out to dry and broken, i.e. beaten with a mallet to break the brittle woody covering of the flax fibres. Next comes the scutching or cloving to remove the tow. Sometimes the quality is improved further by combing, or 'hackling': this divides the fibres into finer filaments, and it can now be spun. After spinning, the thread is made up into hanks or skeins, boiled in home-made potash and spread in a tub to bleach. It is then rolled into balls ('clews') and is ready to be woven into linen.

Spinning

Present-day methods of spinning wool and flax are still broadly similar to those used in earliest times. In the spinning of wool the fleece is broken up and torn into pieces; it gets a rough hand-mixing and is then washed gently so that it will not tangle or felt (become matted). When the wool is dry, it is 'teased' or pricked clean of any briars or sticks. Next it is greased. Different spinners use different

greasing agents: oil, paraffin, rancid butter and traditionally goose grease. When the wool has been sorted, washed, teased and oiled it is carded. Carders have fine wire teeth mounted in leather. A handful of fleece is placed between two carders and combed backwards and forwards between the teeth until the tangled fibres lie side by side. Lastly the fibres are rolled on the back of the carder and the wool is ready for spinning.

Before the invention of the wheel, spinning was done by means of the distaff and spindle. Wool or flax in preparation for spinning was wound and fastened loosely on a distaff, called in Irish *cuigéal*. The distaff was held in the left hand, the spindle or spinning stick in the right. The material was manipulated dexterously so as to twist it into thread and wind it onto the spindle, as it was spun.

This method of spinning was superseded by use of the spinning wheel, of which three main types developed in Ireland: the big wheel, a smaller version of the big wheel, and the flax or treadle wheel. The big wheel, found in the counties of

Mayo and Galway, requires the spinner to stand, turning the wheel with the right hand, while drawing out the roll of wool with the left. On the spinning wheel that Mrs Morrisson uses, the spindle is held in place by two pieces of sally willow or woven rushes, called 'ears'. It is driven by a band of wool which passes around the outside of the wheel. To start spinning, a short length of wool is drawn out of the carded wool and wrapped around the end of the spindle. A turn of the wheel starts the spindle revolving, which twists the wool fibres into a strand of yarn. As the spinner turns the wheel she draws out the roll of wool which increases the length as it is spun and ends up by being approximately the length of the distance between the spindle and the centre of the wheel. The spinner walks towards the spindle, winding the spun yarn onto it, and then starts again. This time, however, she deftly joins the end of a new roll of carded wool onto the end of the previous roll.

In Kerry a low type of big wheel is used; it has short legs enabling the operator to sit while at work. The third type, favoured in Donegal, is known as the flax or treadle wheel and is propelled by the foot. The three-legged treadle spinning wheel is said to have been introduced into Ireland by Sir Thomas Wentworth, Charles I's viceroy, who also brought over craftsmen from Holland to teach the Irish woodworkers how to make the wheel – for which reason it came in time to be known as the Dutch wheel.

This wheel gave a boost to the making of linen in Ireland and flax growing was further encouraged by the Royal Linen Manufacturers in Ulster, which in 1796 alone distributed six thousand flax wheels and sixty looms in Co. Donegal. Before long almost every Donegal homestead owned its own flax wheel, which was promptly used for spinning wool. Indeed, this formed the basis of the nineteenth-century homespun tweed industry.

The introduction of the flax wheel into Donegal homes changed the social pattern of the countryside. It was light in weight, easily transported and it became customary for the young women of a parish to gather in a different house each night for communal spinning. Each girl carried her own wheel to the gathering, or 'factory', as it was known in some parts of the north and the night was whiled away carding and spinning, storytelling and singing. When the work was finished the girls were usually joined by the young men of the parish, and the night ended with a dance. As the saying goes, 'Many's the match was made at the factory'.

Fairies were reputed to be skilful spinners and many stories were told of their spinning activities. A prudent housewife would, before retiring to bed, remove and hide the wheel band to make the wheel unworkable for any supernatural visitors. It was also said that a spinning wheel should never be taken out of the house after midnight lest the owner be led astray by the people of the 'other world'.

Dyeing

The process by which for many people a piece of fabric acquires its individuality is the dyeing. For centuries dyes have been extracted from the roots and stems, leaves, berries and flowers of various plants, as well as from insects and shellfish. Of all the traditional dyestuffs used lichen is the oldest and has remained the most popular down to our own times. Lichen is a plant organism composed of fungus and alga; usually green, grey or yellow in colour, it grows on rocks, tree trunks, roofs and walls. The most common lichens, sometimes referred to as crottle, are the *parmelia saxatilis* and the *parmelia omphalodes*, much used by traditional weavers. Often it was the children's job to go out after it had rained to collect lichen for use in dyeing.

A shuttle seen from the side and from above.

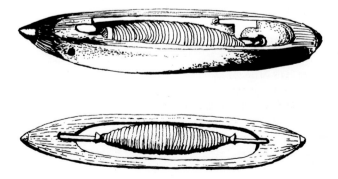

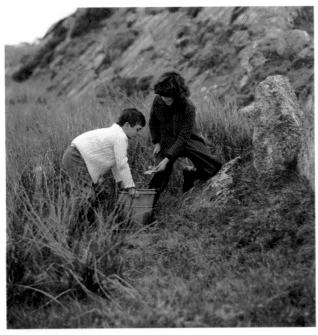

Kevin and Patricia Aspel gathering crottle, parmelia saxatilis, *a lichen which has long been used as a wool dye imparting a fast reddish-brown colour.*

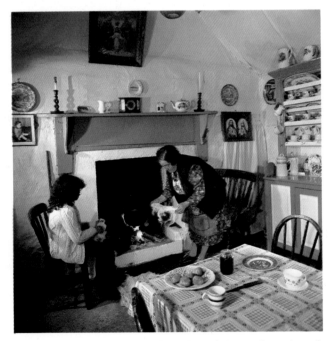

Mrs Mary Coyne of Cleggan, Co. Galway, dyeing wool over the turf fire. Mary was born on the nearby island of Inis Boffin and spent her childhood there.

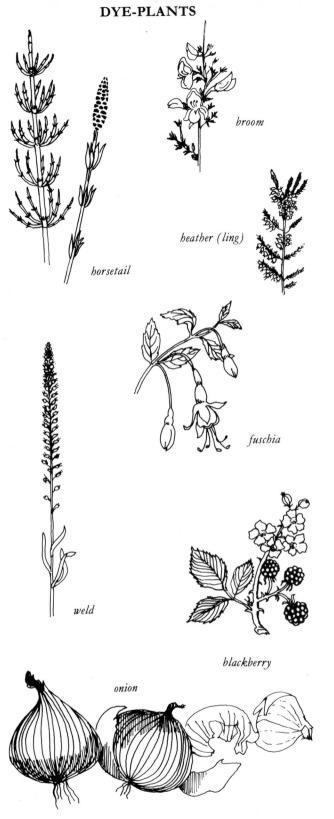

horsetail

broom

heather (ling)

fuschia

weld

blackberry

onion

OPPOSITE *Women leaving church after Mass on Inishmaan, one of the Aran Islands. The crochet shawls and indigo-dyed petticoats are the traditional dress of the older women.*

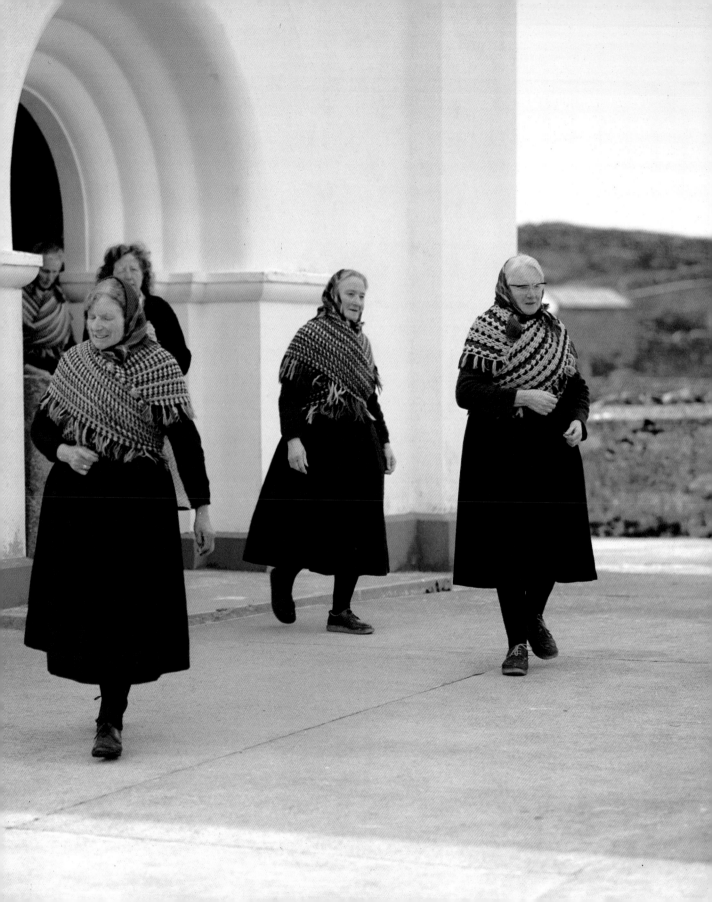

The first break in the long continuity of the craft came with the introduction of foreign dyewoods in the seventeenth and eighteenth centuries, and in many places the native plants were rapidly displaced. They fell into almost complete disuse during the eighteenth century when aniline dyestuffs made their appearance, so that in time many of the old dyestuffs and the shades they once represented were all but forgotten.

The process of dyeing has three stages: washing, mordanting and the dyeing itself. In order to allow the colouring matter to penetrate freely, the material must be thoroughly scoured, otherwise its natural grease comes between the dyes and the fabric.

Mordants, or 'drugs' – usually metallic salts – are used to render the dyestuff permanent. The fabric is treated with the mordant and then plunged into the dyeing solution. The most common mordants used with wool are alum, copperas and bichromate of potash, but formerly crude native alum could be obtained from wood ash, sheep manure, oak galls, human urine and the sediments of certain pools containing alumina or iron.

The vegetable substances most commonly used in homespun dyeing down to our own times are as follows:

Black sediments of bogpools, containing alumina or iron; iris or yellow flag, and the bark of certain trees.
Brown crottle, dulse (a type of seaweed), peat soot, water lily, onion skins.
Blue and blue-black indigo, frauchens (bilberries) or blackberries, sloe or blackthorn.
Red madder
Yellow heather, bracken, common dock, weld, autumn crocus, fustic.

KNITTING STITCHES

Some of the distinctive stitches used in knitting Aran Jerseys.

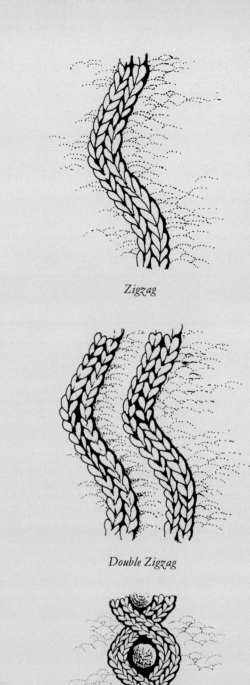

Zigzag

Double Zigzag

variant of Cable

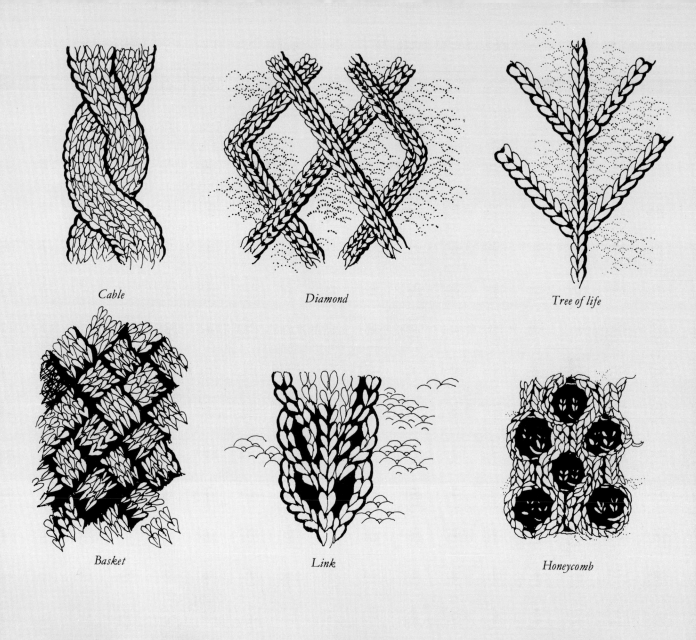

Cable Diamond Tree of life

Basket Link Honeycomb

Irish Moss detail of Irish Moss Link Trinity or Blackberry

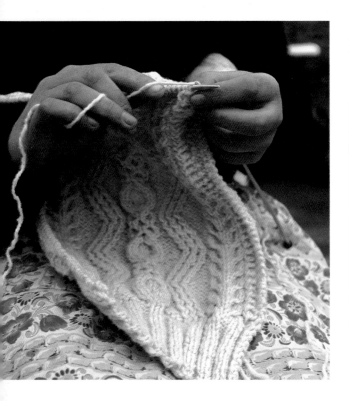

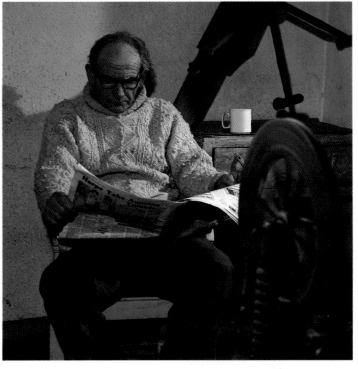

Knitting an Aran Jersey.

Hugh Toye wearing an Aran jersey originally knitted on the Aran Islands forty years ago.

The three most useful dyewoods are logwood, fustic and madder. Used singly and in combination with various mordants a great variety of shades may be obtained.

Dyeing was traditionally a woman's task and it was considered unlucky for a male to be present when the dyepot was down. A popular legend tells of how the young St Ciaran of Clonmacnoise (died AD 548) put a curse on the dyepot because his mother ordered him to leave the room while she was about her task. However, in the end all was well; the young saint removed the curse and the story goes, 'when the dyeing was finished the cloth was a beautiful deep blue. And it was said that if all the people of south-east Galway put their clothes into the dye vat they would come out the same beautiful colour. And when the dyewater was thrown out some fell on the cats and the dogs and made them blue and the trees on which the water splashed were also turned blue.'

Nora Maher and Bridgid Mahon of West Village, Inishmaan. Mrs Maher is knitting the neck of a natural coloured Aran jersey. Bridgid Mahon wears the traditional shawl and red báinín petticoat.

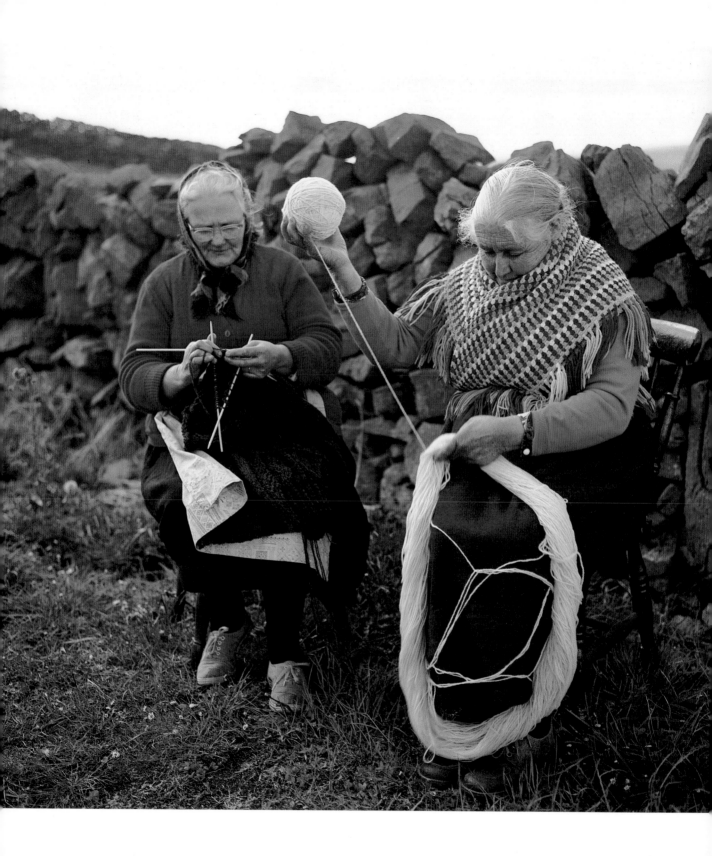

Weaving

The techniques of weaving have remained essentially the same from earliest times. There are references in the Brehon Laws to combed wool, spinning sticks, reeds and weaving swords. The story of weaving in early Ireland is shrouded in mystery, but it is likely that the early loom consisted of one main beam propped up above ground level with warp threads strung independently, each weighed down with a stone. Later developed a loom with a horizontal frame and a reed to separate the threads, and later still 'heddles' were invented to separate the group of threads. This in turn led to the hand-thrown shuttle, whereby the shuttle was propelled manually across the web between two sets of warp threads which were alternately raised and lowered – a quicker method of threading the weft but still difficult and laborious.

The fly shuttle, invented in 1733, became increasingly popular in the nineteenth century for linen weaving; the older type of throw shuttle was used more in woollen weaving. In 1895 a loom incorporating a fly shuttle was introduced into Co. Donegal for woollen weaving and within a few years this type of loom became popular along the western seaboard where it gradually replaced the throw loom.

In the process of weaving, the yarn must first be warped and beamed, after which it is drawn through the heddles and the reed. The object of the reed is to keep the warp threads in the same position, equal distances apart, all through the weaving. It also serves to beat up the weft into its place.

Today hand weaving has survived in Co. Donegal, for example, largely due to companies such as McNutt's of Downings, McGee's of Donegal town and others. McGee's have operated for many years a very successful system where the prepared warp beams are delivered to the weavers working throughout the countryside, and at the same time the previous week's woven tweed is collected for washing and finishing in the woollen mill.

Fulling and napping

After the woollen cloth has been woven the final stages in the preparation of homespuns are known as fulling and napping. The process of fulling is carried out to give the material greater density and a softer finish. This is effected partly by shrinking but particularly by the loosening of the fibres from the threads to close up the spaces between weft and warp and to leave the surface covered by a short pile.

By the Middle Ages fulling mills were commonly found in various parts of Britain. When they were first introduced into Ireland we do not know, but there is evidence that they were there in the thirteenth century, and possibly earlier. By the seventeenth century they were very numerous indeed.

Various traditional methods of fulling cloth were used from early times right down to the end of the nineteenth century: beating with a hazel rod, working with the hands, trampling in a tub, or simply kicking the cloth. Two barefooted men might sit facing each other, kicking for as long as the type of cloth required; the operation could last for several hours. The cloth was continually moistened with warm soapy water which acted as a lubricant, as well as facilitating the movement and working of the cloth. Another popular method was to lay the cloth over a turf creel or basket and beat it with hazel sticks. When the fulling was completed the cloth was washed clean, partially dried and rolled up tightly so that it would not crease.

Napping is simply the raising by hand of the nap on the homespun frieze or flannel. This process too was known from early times: in Irish literature and folklore there are many references to the 'shaggy cloak' in which the owner wrapped himself. Perhaps one of the most famous examples of this cloth is the so-called relic of the mantle of St Brigid of Ireland, preserved in the Cathedral of Bruges in Belgium. It may possibly not date as far back as the days of the good Brigid, but it is mentioned in an inventory of the possessions of the Cathedral in the year 1347, and was possibly brought from Ireland by some early monk or traveller as a 'holy relic'. It consists of a rectangular piece of crimson woollen cloth covered with tufts of curly wool.

Napping was still carried on in parts of the west of Ireland down into the present century. An account from a traditional weaver near Oranmore, Co. Galway, possibly the last person to practise the

craft, is as follows. The cloth was spread over a pad which sat on a small table, the pad being held firmly in place. Two carders were used to comb the flannel lying on the pad to draw out enough fibres to produce a fairly long nap. When one section of the cloth had been napped, it was unhooked from the pad and a fresh piece combed, and so on until the whole length of cloth had been treated. Then the first section napped was replaced on the pad and sprinkled with droplets of honey which were spread over the nap fibres in sweeping movements with a brush. Finally the nap was curled with a sheet of cork which gave a knobbly finish to the surface. Honey was the traditional substance, but if none were available golden syrup or treacle might be used.

Today no finishing of cloth by hand is carried out on a commercial level. Most hand weavers arrange to have their cloth finished by one of the larger woollen mills.

Crios weaving

On the Aran Islands, weavers still engage in the age-old craft of weaving the multi-coloured woollen belt or sash known as the *crios*. It is done by stretching the warp threads between two chairs or stools – or, more traditionally, between one hand and one foot, tying the ends to the shoe – making the length $3\frac{1}{2}$ yards if the *crios* is to be worn by a man and 2 yards if by a woman. It is customary to have two white threads on each outside selvedge, using perhaps five or six different colours in between. The actual weaving needs dexterous fingers, as no loom or mechanical device is used. When the *crios* is woven each end is furnished with three plaits.

Handknitting

Handknitting, like weaving, is a craft with roots deep in the life of the Irish countryside. Handknit 'ganseys' or sweaters, caps, stockings, trousers and shawls were once commonly worn, but the 'cottage industry' of Irish handknits has lasted longest along the western seaboard. The handknit sweaters of Donegal and Aran are world-famous. Made of heavy oiled wool, guaranteed to keep out wind and weather, they are the traditional costume of the fisherman. Equipped with sweater, homespun bawneen trousers and jackets, he braved the stormiest of seas in his currach. It was said that if a fisherman were drowned at sea and washed ashore far from home he might be identified by the stitches or pattern of his gansey or other garment. John Millington Synge, who based some of his most famous plays on the stories he had heard, and the life he had experienced, on the Aran Islands, describes in *Riders to the Sea*, how a girl identifies the body of her drowned fisherman brother by the stockings he wore. 'It's the second one of the third pair I knitted, and I put up three score stitches and I dropped four of them.'

In places like Aran and Donegal they will tell you that the stitches in a gansey have a meaning or tell a story, relating to the life of the fisherman – sea, earth, sky, marriage, sons to take his place. Many, too, are supposed to have a religious significance. *The Trinity* (also known as the Blackberry stitch) is supposed to represent the Holy Trinity. It is done by making three stitches from one and one from three. *The Marriage Lines or Crooked Road* is a zigzag stitch, depicting the ups and downs of married life (usually shown running from shoulder to hem of the garment). *The Ladder of Life.* Purl or twist stitches, worked to form the poles and rungs of the ladder of life, against a plain stitch background. It symbolizes the pilgrim's road to eternal happiness. *The Tree of Life*, sometimes known as the Fern stitch. It symbolizes a long life and sturdy sons. *The Irish Moss* or carrageen moss (seaweed with medicinal properties – also used for making blancmange). It represents wealth to fisherfolk. *The Trellis.* An intricate pattern of plain stitches worked to form a trellis effect over purl stitches, representing the stony fields of the west, and the nets of the fishermen. *The Honeycomb.* This looks like its name and is made by twisting stitches forwards and backwards across the panel. It is a tribute to the bee. It was considered a lucky omen if a fisherman saw a swarm of bees before setting out to sea: a good catch was assured. *Cable and rope* are of all types and represent the fisherman's ropes, while the *Diamond*, usually formed in moss stitch is said to represent wealth.

EMBROIDERY

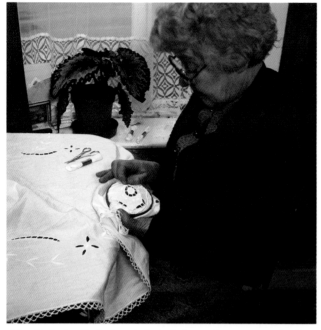

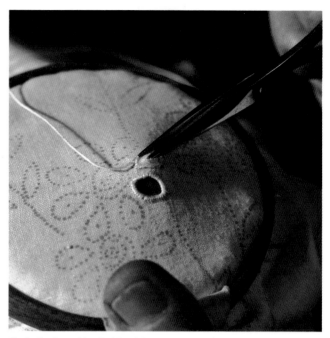

Mrs Catherine Gallagher of Ardaghy is one of many women in this part of Donegal who do linen embroidery or sprigging. She uses two hoops, the inner of which is padded to hold the work taut.

Only the finest bleached Irish linen is used. It is sent to her, with the design printed on it in washable ink, by the agent for the area, Mrs Teresa Gillespie of Bruckless.

CRIOS WEAVING

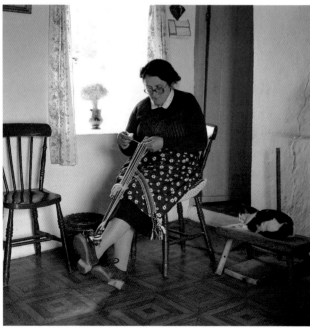

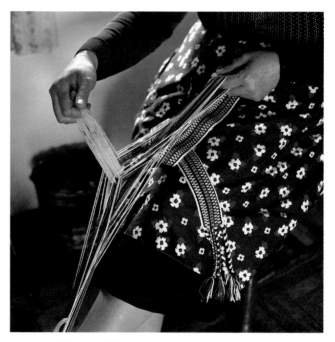

Mrs Maureen O'Donnell of Moore Village, Inishmaan, weaving a crios in the traditional manner, with the warp threads attached to

the laces of her shoe. When the lengths of wool are pulled up they separate one set of warps to form a new shed.

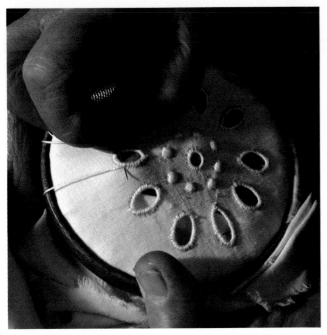

Mrs Gallagher has just laid a padding thread around the design which is lightly whipped into place.

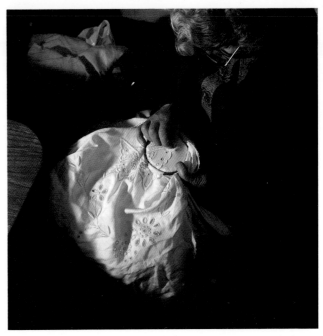

All sprigging is known as raised work. White work on bleached linen is paid better than the less popular coloured work, though the skills are exactly the same.

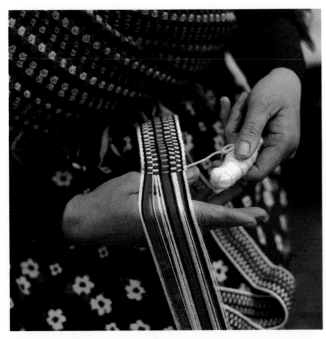

Once a shed has been formed in the warp it is held open by the right hand and the weft can be passed through.

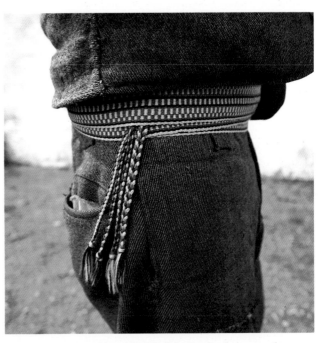

The crios is a type of woven sash or belt worn by the men on the Aran Islands.

Patchwork occupies a special place in Irish craft tradition. It is one of a small number of crafts identified almost exclusively with women and was regarded as a housewifely skill rather than a specialist means of livelihood. Patchwork was used for bedcovers in the makers' own homes and it thus provided a creative outlet for people who had few means of expression as well as combining symbolic significance, practical function and visual beauty.

Conscious aesthetic awareness is important in an Irish context as Ireland, unlike many European countries, has no rich heritage of folk art and the pleasing appearance of some vernacular artefacts is accidental as function usually determined form. Patchwork is special too in that in a country noted for strife and division it was common to all women and was made equally enthusiastically by Anglo-Irish ladies in their drawing-rooms, in the farm parlours of Ulster Presbyterians and in the cabins of labourers in Connemara.

Indeed, philanthropic landlords and the Commissioners for National Education encouraged the making of patchwork by the people because it fostered industry and thrift, improved the comfort of the home and freed the money saved when bedding was homemade for other purposes. Paradoxically, it was the worst off who usually bought fabric for patchwork, obtaining scraps by weight from dressmakers or textile factories because their clothes were either too worn to use or had to be remodelled for other family members, whereas the middle and upper classes who abandoned their clothes when fashion changed always had a ready and varied supply. Indeed, patchwork can be used to chart the development of the textile industry.

The technique of patchwork is ancient and universal and it is not known when it first appeared in Ireland. There are early literary references to what is thought to be a type of appliqué, but the craft as it is known today is accepted as having been introduced by the aristocracy from England during the eighteenth century, spreading from the top to the bottom of the social scale and from east to west across the country. It reached its peak of popularity during the second half of the nineteenth century, declined almost to extinction after the Second World War, aroused interest again in the 1960s and is today enjoying a healthy revival with the additional creative stimulus of the efforts of the professional designer–craft workers.

Broadly speaking there is a correlation between the date of manufacture, method of construction, type of design, fabric used and social level. Bedcovers from better-off homes also tend to be bigger, though most old patchwork from whatever stratum was intended for use on double beds. Patchwork can be made in different ways and examples are to be found of almost every method, but the bulk of Irish patchwork was, and still is, made using the appliqué, mosaic or log cabin methods of construction.

The earliest-known surviving specimens date from the late eighteenth or early nineteenth century. Most are appliqué, by which method the fabrics forming the pattern are cut out and sewn on to a background with buttonhole or herringbone stitch over raw edges if good quality furnishing cotton is used. If it is a fine or inferior quality fabric, the pattern pieces are cut out with a hem which is turned under when the pieces are sewn in place. Early designs are elegant and sophisticated and usually depict flowers and birds, often cut directly from imported game bird prints, arranged in elaborate frame patterns evocative of plasterwork of the same period. This method allowed almost total freedom in design, but block or frame arrangements are most common and although flowers and birds remained popular motifs, later examples are more primitive and use plain instead of printed fabrics.

Mosaic is perhaps the truest form of patchwork, as the entire fabric is composed of small pieces of cloth sewn together either over a paper template with overcasting or by running stitch without the use of templates. The first method, known as the English method, occurs more often on specimens of fairly high social origin, as it involved an extra process and therefore more time as well as the use of large quantities of good-quality paper. The second method, also popular in America, is generally found on pieces of humbler origin, though this does not imply crudeness in either craftsmanship or design and some highly complex patterns composed of

minute units exquisitely assembled were made in this way. Mosaic designs must be geometric so that they fit together like pieces of a jigsaw, but elaborate patterns can be created by combining several simple components like squares and triangles. Despite the limitations of technique on design there is ample evidence of individual interpretation, whether in cotton or silk. Care must be taken to have fabrics of equal type and weight to prevent uneven wear.

Over the origin of the log cabin method there is some dispute. It was formerly thought to have been introduced through emigrants who sent patterns home or through women's magazines in the late nineteenth century, the period to which most survivals belong, but it may be that it was made here earlier and that examples have simply failed to survive. It is made by sewing strips of equal width of light and dark coloured fabric on opposite or adjacent sides round a central square until the required size is reached. The squares can be assembled in many ways to give different patterns. Despite its complicated finished appearance, log cabin is a simple method and can be made with or without a background. It is usually found with a background as this made it possible to combine fabrics of different type and weight. It is one of the few methods in which it is possible to use men's heavy woollen suitings which, despite their dismal appearance, were warm; bedcovers of this type were popular for winter use.

Patchwork patterns can also be classified in groups. Frame patterns consist of concentric borders of various widths round a central motif. Block patterns are composed of a number of identical units fitted together to form a repeating pattern. Strip patterns are made of fabric strips which may or may not be composed of smaller units. All-over patterns are those in which a single unit such as a hexagon forms the pattern.

All patchwork bedcovers consist of a top and back and sometimes an interlining. The most common way of securing these layers together was by quilting, i.e. sewing penetrating all layers. It is a separate process and a skill in its own right but is so closely associated with patchwork that some mention is appropriate. Quilting was a special social activity and quilting parties, where neighbours

gathered in each other's houses on winter evenings to quilt in return for food and entertainment, are remembered with affection.

Quilting is executed in a frame which is composed of four separate pieces, two sides and two laths, and which measures about 2 m, or 6 ft, square when fully extended. The top of the bedcover is sewn to one side of the frame and the bottom to the other. The laths are then inserted into mortices in the frame's sides giving a taut flat surface. Any interlining is positioned and the top is smoothed over it and tacked down. Six or eight quilters work at once, sewing from the outside inwards to a depth of about 45 cm (18 in.) before the quilted surface has to be rolled round the frame to bring unquilted cloth within sewing reach. This process is repeated until the quilting is completed.

Quilting parties were often used for match-making and mothers made special patchwork bedcovers as wedding gifts for daughters here as in other countries. The number of bedcovers brides received varied according to the number of girls in the family and the mother's industry. No stringent rules governed their colour or design but birds and hearts appliquéd in Turkey red or white were popular. In some countries red and white symbolize male and female but in Ireland the combination it seems had a practical origin. Red had been used for plain woollen bedcovers from early times and when a cheap chemical means of obtaining the formerly expensive Turkey red on cotton appeared it was naturally popular; white cotton fabric was always freely available in the form of flour bags, which were unpicked, washed, bleached and used for backing patchwork as well as making it.

Irish patchwork mirrors the lives of those who made it. To look at it without understanding this is to underestimate its value.

Irish patchwork falls into three distinct types: appliqué, mosaic and log cabin. The earliest surviving patchworks are most commonly appliqué: designs printed on furnishing fabrics of the day were cut out and sewn onto a backing of calico or cotton. A patchwork can often prove to be an archive of textiles; the fabric will frequently supply a clue as to the social background of the maker.

It is often said that mosaic is the truest form of patchwork. Scraps of material of geometric shape are sewn together to create many unusual effects such as tumbling block, in which three diamond-shaped pieces of fabric – light, medium and dark – are sewn into a hexagon. They are assembled so that they all face in the same direction and a three-dimensional result is obtained. Log cabin patchwork is made by sewing light and dark strips of fabric on opposite or adjacent sides of a central square expanding outwards until a square of the required size is formed. The squares can be assembled in different ways to create various interesting patterns.

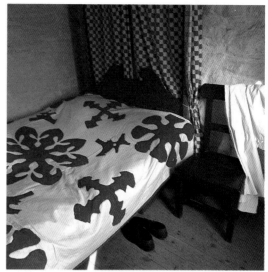

TOP *Turkey red and white cotton appliqué patchwork: nineteenth century. Ulster Folk and Transport Museum Collection.* LEFT *quilting a white on white cotton bedspread; cotton/polyester wadding is used as interlining.* RIGHT *Combination mosaic/appliqué patchwork, embroidered and quilted.* UFTM *Collection.*

LEFT *Detail, appliqué patchwork and quilted bedcover. Printed furnishing chintz applied to a calico background. Dated 1827.* UFTM *Collection.* RIGHT *Log cabin patchwork bedcover made from multicoloured woollens and cottons. Ulster, early twentieth century.* UFTM *Collection.*

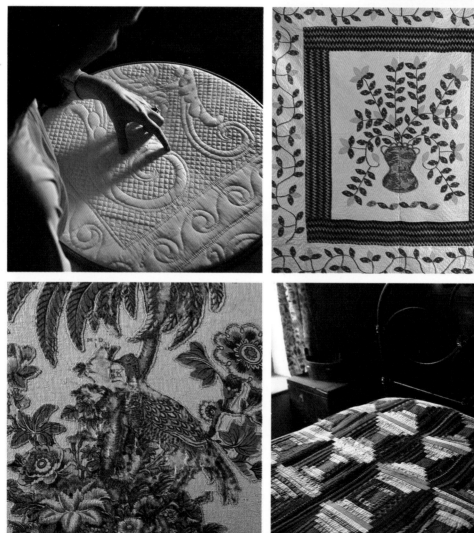

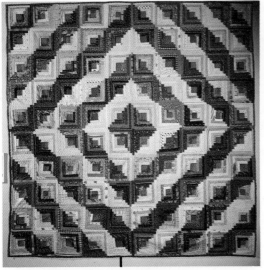

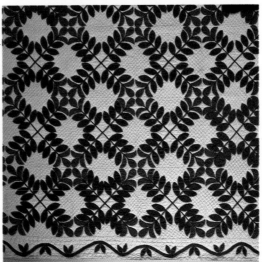
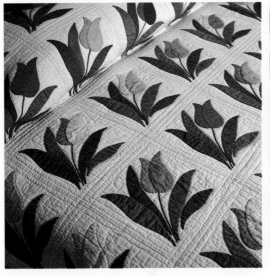
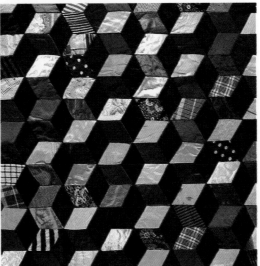

LEFT *Log cabin patchwork cover made in Farranfore, Co. Kerry, in 1850, from printed cotton fabrics.* RIGHT *Mosaic patchwork bedcover in printed cottons made in Co. Galway. Date unknown. National Museum of Ireland Collection.*

LEFT *Mosaic patchwork bedcover. All-over hexagon pattern in late nineteenth-century dress fabrics. Ulster, 1900.* UFTM *Collection.* RIGHT *Appliqué patchwork and quilted bedcover in cotton fabrics. Cotton wadding interlining, plain white cotton backing. Date unknown.* UFTM *Collection.*

LEFT *Appliqué cotton patchwork and quilted bedcover made on the Dingle Peninsula, Co. Kerry, in 1833. Owned by Mrs Mairead O'Gorman, Taghmon, Co. Wexford.* RIGHT *Mosaic patchwork bedcover. Tumbling block pattern in gentlemen's silk waistcoat linings, satins and taffetas. Ulster, late nineteenth century,* UFTM *Collection.*

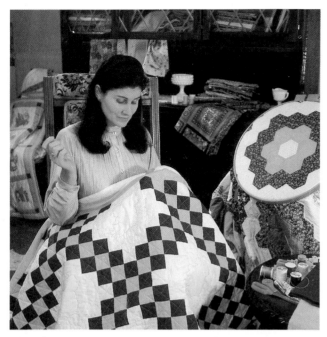

Mrs Mairead O'Gorman completing her border on a mosaic patchwork block pattern known as Irish chain.

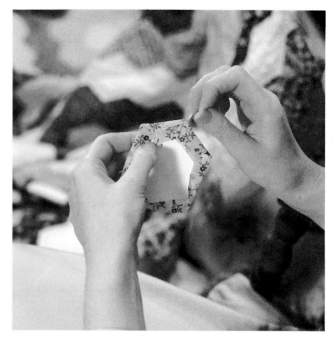

For the English method of mosaic construction a metal template is used to gauge precisely the size of the paper templates over which the fabric patches are tacked before being sewn together.

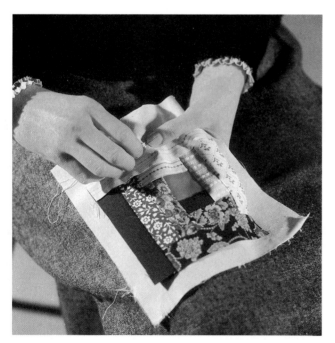

The log cabin technique is believed to have been introduced from North America in the late nineteenth century.

This humble bedcover, made for a child's bed from an old tan woollen coat, is a touching example of thrift. Ulster, 1900. UFTM Collection.

DONEGAL CARPETS

Donegal carpets were first made in Killybegs in 1898 when Alexander Morton introduced the craft of making hand-knotted carpets from his native Scotland. The factory, which was built with a loan from the Congested Districts Board, was an immediate success. Because of the high quality of the design, workmanship and materials used, Donegal carpets soon became famous and were exported all over the world. They could be found on the Cunard liners Queen Elizabeth and Queen Mary, in Buckingham Palace and the South African Houses of Parliament. Today they are just as sought after for the palaces of sheiks, for embassies, even for government offices in Washington.

All Donegal carpets are individually designed and hand-knotted in 100 per cent wool. Once the design and colours have been decided upon, the sketch is transferred onto graph paper and squared up to one-half the size of the finished carpet. The weavers will work from sections of this.

The yarn is dyed in the selected colours; eight miles of warp goes into the average Donegal carpet. It is prepared in the same way as the warp for a hand loom for weaving fabric. The threads are fed through a reed to keep them in the correct order and assembled on a huge peg-warping board.

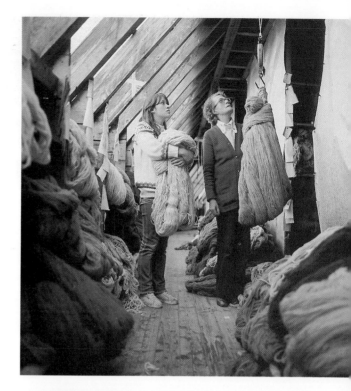

ABOVE *Mary Ellison, forewoman, and Fidelma Laffan selecting and weighing carpet yarn.*

RIGHT *Fidelma Laffan winding and plying yarn onto bobbins, which are placed on spikes at the back of the loom. The yarn ends are passed through to the workers.*

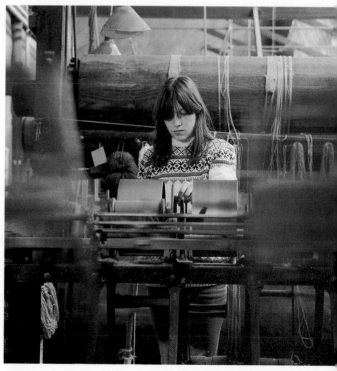

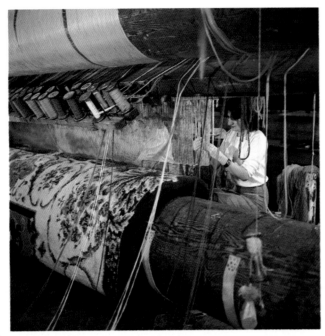

Anne Hegarty hand-knotting a Donegal carpet. The pitch-pine beams of the loom were shipped in as tree trunks from Canada nearly one hundred years ago.

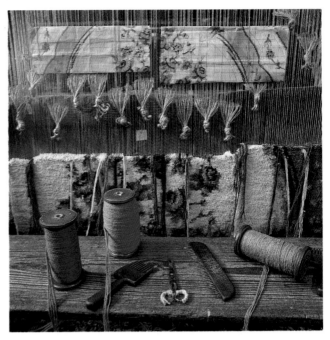

The design has been transferred onto graph paper. The twine loops with a knot at the end keep the warps in the correct order when forming a shed for the weft.

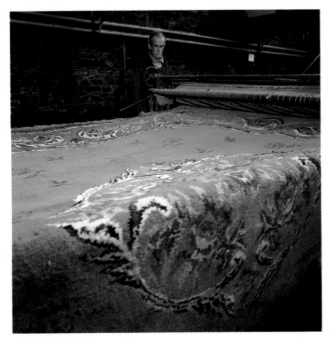

Edward Sweeney operates the cropping machine; like a gigantic lawnmower (with blades mounted on a cylindrical shaft), it crops the carpet pile to the correct height.

The warp is wound onto the upper of two massive wooden rollers or beams of the carpet loom and secured to the lower, forming a vertical curtain of paired warp threads which are then tensioned. As the hand-knotting progresses the warp is wound down. The completed carpet passes around the bottom beam and out to the back of the loom.

Knotting is done by a special technique known as the Turkish or Ghiordes knot. When a line of knots or tufts is completed they are combed to ensure that no ends have been buried. Next comes the 'shedding': the hand tugs made up of string loops threaded around alternate warps are pulled out, and they create a shed or opening between the warps into which the weft thread (a mixture of hair and wool) is inserted by hand. Two lines of weft are firmly placed between each line of knots and are tamped down with a carpet beater which tightens the weave. Then the yarn ends are trimmed level with a pair of scissors.

The carpet is finally released from the loom and cropped. When the edges have been trimmed and hand-cropped the carpet is complete.

OPPOSITE *A view from behind the flax warp: Alice Lana has just looped the yarn around a pair of vertical warps.*

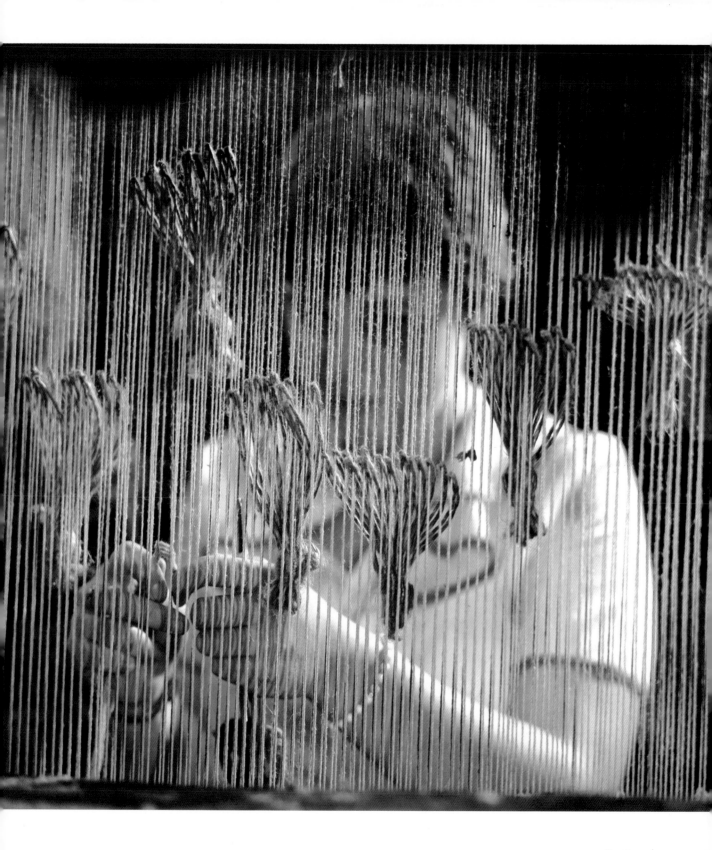

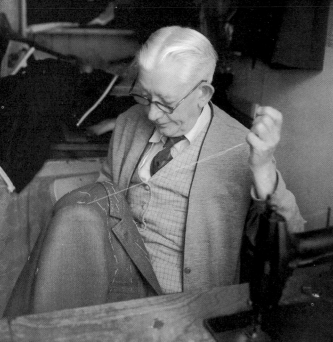

TAILORING

*In the town of Cappaquin, Co. Waterford, two tailoring
establishments face each other across the street: Thomas and Noel
Lonergan on the one side, Peter Cahill on the other.*

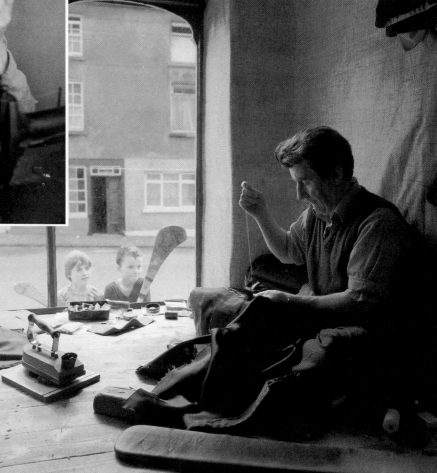

*RIGHT Thomas Lonergan sews a suit jacket
sitting cross-legged in the traditional way,
while Peter Cahill (ABOVE) is basting a
suit jacket, a tacking stitch which holds the
materials together while the jacket is made.*

Today the handmade suit is a luxury and merchant tailors are a dying breed.
When the measurements have been taken, a pattern is prepared and the cloth
marked up for cutting. The material and interlining are basted or tacked
together to form the 'skeleton base' for the first fitting, when details of style
are decided upon.

The skeleton base is ripped apart and adjusted, seams are machine sewn,
interlinings fitted into the jacket to give it body, shoulders shaped and
perhaps padded, the collar and lapels carefully turned and sewn. The iron,
lapboard and plonker are constantly in use, shaping and setting the cloth in
the required manner. The speed and rhythm of a good hand-sewer are
remarkable: buttonholes appear and are whipped like magic, buttons sewn
on with doubled and plied thread.

A second fitting follows and after a final pressing the suit is ready.

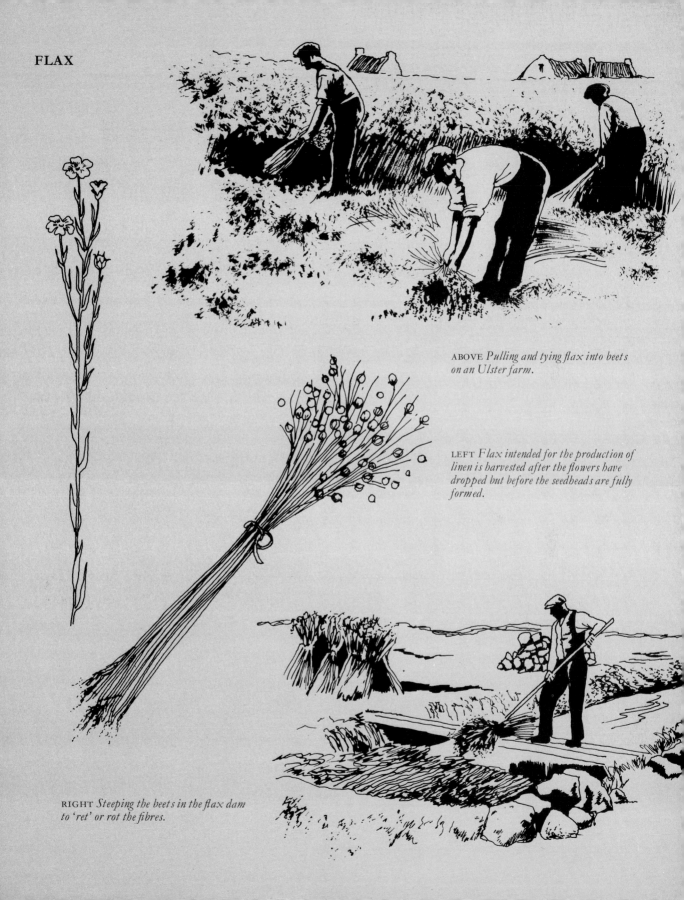

FLAX

ABOVE *Pulling and tying flax into beets on an Ulster farm.*

LEFT *Flax intended for the production of linen is harvested after the flowers have dropped but before the seedheads are fully formed.*

RIGHT *Steeping the beets in the flax dam to 'ret' or rot the fibres.*

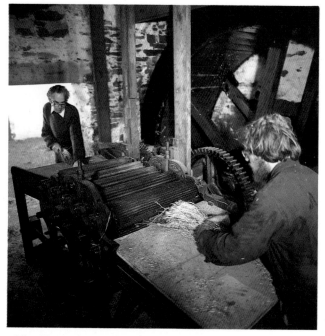

Silcock's scutching mills. John Lewis-Crosby feeding the breaker which crushes the brittle outer sheath of the flax stalk.

Flax has been grown in Ireland since the Bronze Age for its long, tough, yet silky fibres. Home-grown flax was the raw material for the thriving linen industry in the eighteenth and nineteenth centuries, particularly in Ulster, where production supported communities of farmer-weavers. At harvest time flax was pulled by hand and the beets or bundles steeped in a flax dam to 'ret' or rot the fibres; this helped to separate the woody tissues from the bast.

After removal and drying, the flax was delivered to the mill for breaking and scutching, followed by cloving and hackling to further prepare the fibres for spinning and weaving. The woven cloth was then bleached and finished to give the linen its characteristic whiteness and body.

Water-powered scutching mills were first introduced in the eighteenth century. Silcock's Mills, near Crossgar, Co. Down, dates from before 1832; it derives its power from the Ballynahinch River. Water, controlled by sluices, is fed from the mill pond through a leat or race to drive the high breast shot water-wheel.

Today pulling and scutching flax is done by machine. Little flax is home-grown but experimentation is taking place in the retting of flax with the controlled use of selective weedkillers while the crop is still standing. This eliminates the laborious dam retting process and the risk of water pollution.

Scutching flax at the stocks. Five rotating wooden handles on a scutching ring flay the bundles of flax, separating the broken pieces of woody tissue from the long silky fibres.

Tow, the brittle outer tissue, falls to the ground as waste. The bundles will be further cleaned or cloved by the next worker in the line.

OPPOSITE *Flax* (linum usitatissimum) *of the Hera variety growing in Ulster. The crop is ready for pulling. Other varieties have a blue flower.*

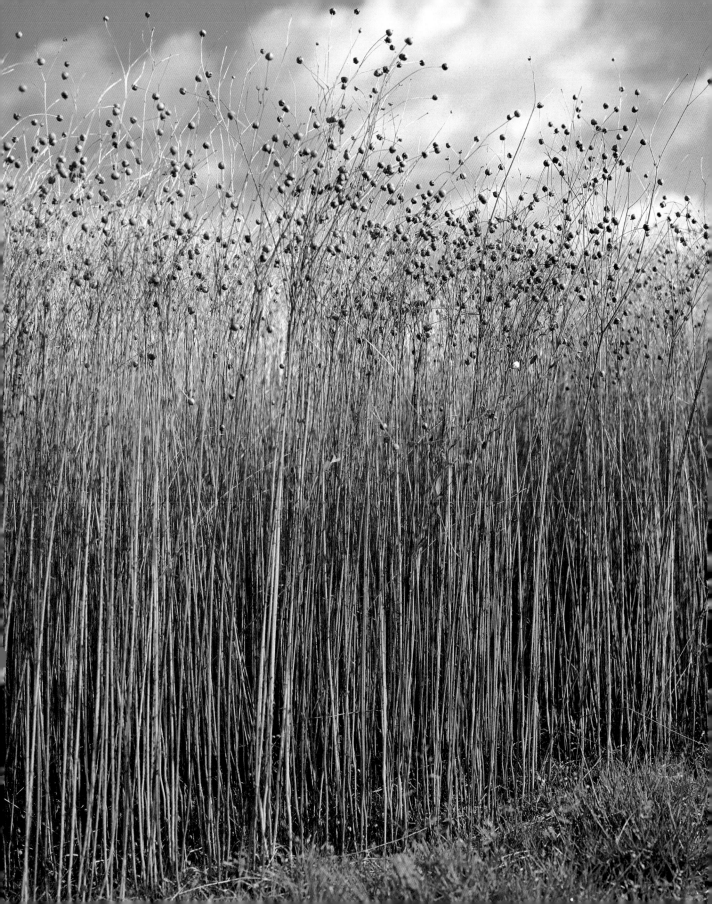

The importance to the country of a flourishing lace industry in both economic and social terms was recognized by Dean Swift at the beginning of the eighteenth century. As a result he encouraged Lady Arbella Denny to introduce lacemaking to the inmates of a Dublin orphanage, thus enabling the fashionable to buy home-produced goods instead of expensive imported European lace, and the needy to earn a useful living. The Dublin Society encouraged high standards by the introduction of premiums for proficiency. This combination of philanthropy and patriotism and the use of foreign laces as models for Irish ones coupled with the active involvement of individuals, often with church affiliations, was a pattern that remained unchanged even in the heyday of the Irish lace industry.

During the eighteenth century, lacemaking centred around Dublin society and when the Act of Union abolished the Irish parliament, thus removing the patrons of luxury trades from the city, the need to find other markets became acute. In addition, the need to stimulate employment compatible with the country's social structure and settlement pattern increased with rapid population expansion and the decline of old industries. Perhaps the only positive thing to happen during this time was the relaxation of the Penal Laws, which allowed Catholic philanthropists and convents to be active in economic and educational development – a part for which in relation to the lace industry they were appropriately equipped.

The reference by Alan Cole, one of its leading figures, to Ireland's lace industry as the handmaid of agriculture puts it into context. Lacemaking within the home was not an integral part of native vernacular culture. Lace was not designed by the makers or primarily intended for their use but was introduced so that large families living on small uneconomic land holdings could remain there. The making of lace was executed by women and girls who, once trained, practised at home, doing as much as house or farm work allowed. Available statistics show that families whose female members were thus employed were better off, as their earnings were not their personal pin money, but part of the total family income. However, this was never more than an income supplement and it would have been impossible to have been self-supporting on money earned by lacemaking alone.

Training in lacemaking was given free of charge at lace schools, of which a countrywide network sprang up in the middle and late years of the nineteenth century, different areas being identified with different techniques, though in many cases more than one type of lace was produced in one place. The association of place name with technique causes a certain amount of confusion in identifying lace. For instance, excellent lace using the Limerick technique was made at Newry, County Down, and the type of crochet referred to as Clones lace was produced elsewhere.

The amount of training needed varied according to technique, from a few weeks for basic crochet to many years in the case of needlepoint. As a result the quantities produced and relative costs of different laces varied, as did their end uses. The most expensive ones were generally used by the Church and on state occasions. Even when the proprietors of lace schools had financial assistance from the state or commerce they were bedevilled by marketing and design difficulties.

Attempts to improve design by arranging art training for apt pupils, who had the advantage over artists of appreciating the constraints of technique, were sometimes successful, but as a rule the best designs are those which most closely resemble their European models. Where artistry and technical understanding were combined superlative results were achieved and a book of exquisite designs for Kenmare point lace executed by two of the sisters, often for British and European royalty, can still be seen in the Poor Clare Convent at Kenmare. Marketing success, despite the efforts of organizations such as the Irish Lace Depot which arranged for the collection and sale of work, to a large extent depended on the personality and influence of the patron.

Every known method of making lace by hand has at some time been used in Ireland. The earliest of these was bone lace, later known as bobbin or pillow lace. The design is first drawn on parchment which is pricked over with a pin before being

secured to a hard pad or pillow, which can vary in shape and size. Special pins are inserted into the holes and threads wound on bobbins, sometimes made of bone, are twisted and plaited in different ways around the pins to form the pattern. Most French, Belgian and English laces belong to this category.

An equally exacting type of lace to make is needlepoint. It is based on Italian models and is sometimes referred to as rose point. There are two types, flat and raised needlepoint. The design is drawn on a piece of glazed calico and a thick thread sewn down with a finer one is used to outline the pattern forming the skeleton for the filling stitches. These are worked with fine thread using an ordinary needle and although they vary considerably in appearance all are variations on buttonhole stitch. When the work is finished, the calico is removed by cutting between the two layers. Raised needlepoint is produced by the addition of buttonholing over cords of different thicknesses. This technique is very slow, so large pieces are made by several workers and care has to be taken so that this is not obvious when the piece is assembled. Needlepoint lace is usually identified with Youghal, Co. Cork, Kenmare, Co. Kerry, and Inishmacsaint, Co. Fermanagh, but it was made in other places.

Limerick lace can also be made in two ways but both are methods of embroidering on net. Tambour, as its name suggests, is worked on a small drum-shaped frame over which the net is stretched. The stitches are worked with a special hooked needle which produces a chainstitch. This method is suited to small, separate, well-defined motifs. Run lace is more delicate in appearance and is made simply by darning through the mesh of the net with an ordinary point needle to outline the pattern which is then embellished with filling stitches. James Brennan, an art school lecturer working at the turn of this century, drew attention to the fact that in designing for run lace, account should be taken of its angular quality resulting from the shape of the mesh. Designs which relied on curves for their effect suffered in translation into run lace.

Carrickmacross is another form of embroidery and can also be made in two ways, appliqué and guipure. Appliqué is made by tacking fine net over a design drawn on paper. On top of this is placed a layer of muslin. The design is then outlined by sewing through both layers of fabric with a thick thread sewn down at close intervals with a fine one. The surplus muslin is then cut away and filling stitches of the type used in Limerick run lace are added. The character of modern Carrickmacross appliqué differs from older examples because of a change in materials. Net with a hexagonal mesh has replaced the soft cotton bobbin net and organza is used instead of muslin. Guipure is made by tracing the outline of the design with thread on cambric and cutting away the surplus.

Crochet lace is probably the commonest of all Irish laces and its character and quality vary enormously according to place and time of production. It was one of the first laces to be introduced by nuns at the Ursuline convent at Blackrock, Co. Cork, through the influence of a local gentlewoman, Honoria Nagle. It is broadly similar to ordinary crochet except for its fineness. The best work of the past was produced using a hook and thread of the same thickness and hooks were sometimes made by removing one side of the eye of an ordinary sewing needle and sticking the point in a cork. The design is drawn on glazed calico, and the motifs, usually flowers, are worked individually and then tacked in place on the calico. They are joined together with crochet chainstitch and the backings removed when all the motifs have been joined.

The importance of the Irish lace industry should not be underestimated because of its loose structure, but it suffered during the First World War and never regained a firm foothold, though small quantities of Carrickmacross and crochet lace are produced for *haute couture* and the tourist trade today and individuals sometimes make it for their own use. The story of the Irish lace industry is the story of the women of Ireland, not just of the rich and successful who wore its products, but of the poor and underprivileged they tried to help – flawed though these efforts sometimes were. Despite its identification with hard times past, there are few of those who ever made lace who do not have a deep and abiding affection for their craft.

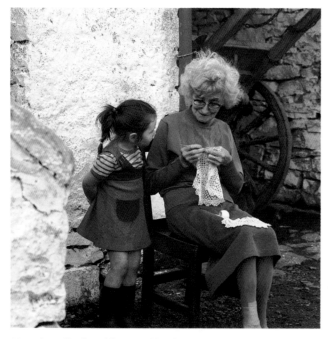

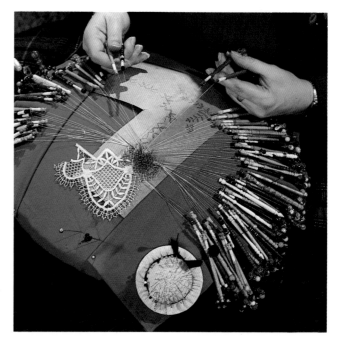

Mrs Agnes Boyle and her granddaughter Annette of Bruckless, Co. Donegal, crocheting the border of a place mat.

A handkerchief edging in pillow lace made by Susan Latham (in a traditional English design). A mixture of Bedfordshire and Buckinghamshire lace.

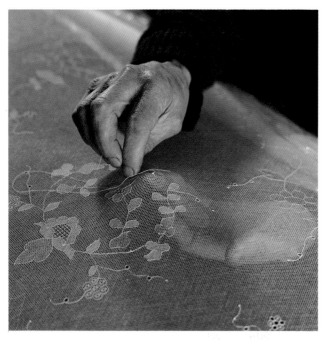

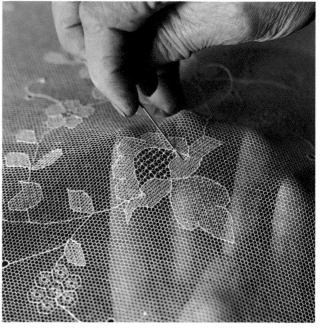

Whipping the stem of a flower in Limerick run lace. The name 'run' omes from the running stitch which traces the outline of the pattern. Whipping and filling stitches follow.

The seed filling stitch, enclosed by heavy and light darning, are peculiar to Limerick run lace.

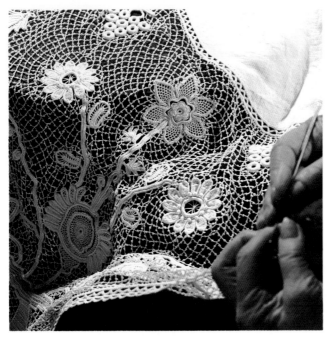

Tablecloth border in Clones-type crochet lace by Mrs Mollie Moore. The sprigs are crocheted in the hand, pinned to a square of material and the ground between them crocheted in.

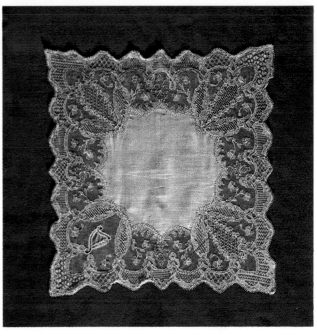

Handkerchief in Limerick run lace (with a cambric centre), illustrating a variety of filling stitches. Ulster Folk and Transport Museum Collection.

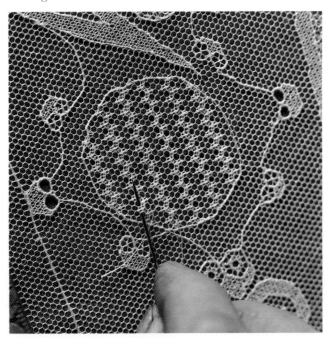

The Caraway stitch is a hallmark of Limerick run lace.

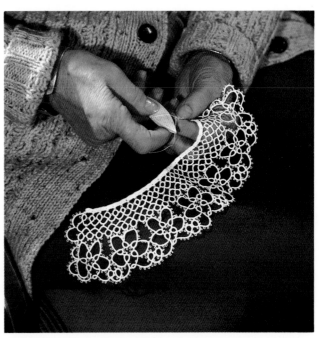

Tatting a collar using an ivory shuttle. The loops and knots are made by the fingers without the use of a crochet hook.

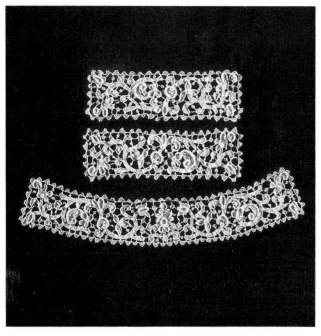

Inishmacsaint lace collar and cuffs: one of the small group of Irish laces based on Italian raised needlepoint. UFTM *Collection.*

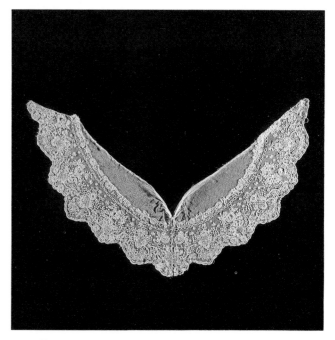

A collar in Limerick tambour lace using the chain stitch. In the past this was considered the simplest form of Limerick lace and was the first to be taught in schools. UFTM *Collection.*

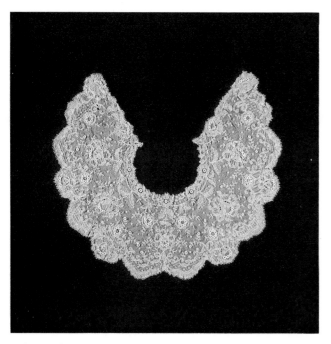

A magnificent Carrickmacross appliqué lace collar. Characterized by the combination of superb craftsmanship with good design. UFTM *Collection.*

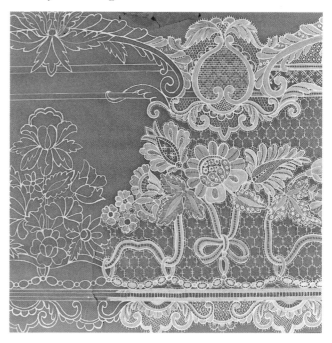

Design for Kenmare point lace, Poor Clare Convent, Kenmare, dated 1885.

Stonework

STONECUTTING AND MASONRY

Timothy P. O'Neill

In Ireland there is a long tradition of working with stone. It has been used to form field boundaries since Neolithic times. The first farmers of the prehistoric period used stone for the foundations of their houses and it has been an essential part of house construction since then. As a medium for the artist it has given us some of our finest and most enduring art work. To-day, however, with the advent of other, easier building materials the stonemason is a rarity except for specialized tasks.

In its best years the stonemason's craft included workers of differing kinds: stonecutters, stonecarvers, stone-polishers and labourers. Only stonecutters' sons were admitted to the craft, whereas that of stonecarving was open and anyone could become an apprentice to it; however, while stonecutters could do a little stonecarving the carvers were never allowed to do any stonecutting. The stonecutters' guild in Ireland traced its origins to the granting of a charter in England in 1410 and in 1861 it had 242 members. In modern times stonecarving was reintroduced into Ireland by English stonecarvers who went to work on the hundreds of new churches which were built after Catholic Emancipation in 1829.

The first factory of any kind in Ireland was at Tievebulliagh, 300 m (1000 ft) up on the mountain overlooking Cushendall in north Antrim, where the hard igneous rock was suitable for the making of stone axes. In the Neolithic and Early Bronze Ages axes from there found their way to many parts of Britain and Ireland. The burial cairns of the same period, called court cairns, made extensive use of stone in the northern part of the country, but the arrival of the passage grave builders from Brittany brought a new and remarkable group of stonemasons to Ireland. These people grouped their graves in cemetaries, first in the Boyne valley, later in Loughcrew and Carrowkeel, and finally on the Atlantic coast at Knocknarea in Co. Sligo. Their tombs are of interest because of the sophistication of the building techniques. In each the passage is roofed with lintels which rise as it approaches the chamber, and generally has a rising corbelled roof.

The tombs are covered with large earthen mounds, some of which extend up to an acre and a half, and contain up to 200,000 tons of material. Another feature of passage graves is the large number of highly decorative motifs incised into the stones of the tombs. Almost all the motifs are geometrical in character: circles, spirals, herring bones, triangles and diamond shapes. These stones are the earliest examples of decorative stonecarving in Ireland and it is interesting that it is still in carving headstones for graves that many of our stonemasons find employment.

Of all the megalithic tombs the portal dolmens of the late Neolithic period show the ability to use stone at its finest. Three massive stones supporting an enormous slanting capstone are all that remains of many of these, though they were originally covered with mounds. The structural strength of the arrangement has meant that in the majority of the 150 dolmens in Ireland the capstone still sits in position. It is little wonder that even today people marvel how the capstone was raised: that at Browne's Hill in Carlow weighs about 100 tons. In the succeeding prehistoric generations each new set of invaders added their distinctive talent for stoneworking. The great hill forts of the Late Bronze Age made extensive use of stone, as did many of the ring forts. Ring forts built of stone were usually referred to as cathairs or caiseals and some forts continued in use as house sites till the seventeenth century.

Stonecarving continued and the Turoe stone which stands near the rath of Feerwore in Co. Galway is one of the most impressive carved stones in Ireland. The stone is a little over 1 m high and is completely covered with curvilinear patterns which are typical of the work of Celtic craftsmen, owing its origins to the La Tène style. It is evidence of either the arrival of a new generation of stonecarvers or, more unlikely, the copying in stone by indigenous people of new decorative patterns which were to be seen in metal objects like the gold torque from the Broighter hoard in Co. Derry. From the same period there are iconic stone heads – the head being especially venerated by the Celts as the seat of the soul. A curious feature of these interesting stone carvings is that the heads may be single-, double- or triple-faced.

With the arrival of Christianity the stonecutters and carvers moved into new styles. Very soon after St Patrick, the Irish church, which at first was organized on the basis of dioceses or episcopal sees, evolved an administration which placed great emphasis on the monasteries. The great abbots of these monasteries had ecclesiastical jurisdiction over the surrounding districts, and considerable scope was given to the stonemasons. They built churches and round towers, carved cross pillars and high crosses. On the rocky Dingle Peninsula are preserved the remains of early monastic beehive huts and the superb Gallarus Oratory. They are a striking reminder of the continuity of a stone building technique as they are corbelled; these roofed, dry masonry structures are similar to the chambers of the passage graves built 3000 years earlier.

The great ruined monastic remains date from a later period, however, and the high crosses belong to the eighth to the tenth centuries and are associated with only certain areas in Ireland. These crosses contain both iconography and ornament. The iconography presents a remarkable set of well-known biblical scenes as well as some secular motifs like hunting. The ornamentation tends to be curvilinear; there is some animal interlacing, though foliage – so beloved of later stonecarvers – is not very common. The pre-Romanesque crosses are works of high art which have been properly recognized as an important part of our artistic heritage.

The stonemason was the architect in earlier times and the round towers rising tall and slender from Irish fields are perhaps their finest achievement. Built between AD 900 and 1100 they served as refuges in time of attacks by Viking raiders and also as bell towers of campaniles to summon the monks to pray.

Stone-built churches generally replaced earlier wooden structures from about AD 900 and many of these are very small with stone roofs. After AD 1000, churches consisting of nave and chancel were built and a feature of many of these churches is the stone projections at the apex of the roof ridge where the stonemasons copied the architectural style of earlier timber roofs still to be seen in traditional Swedish timber houses.

A small carved figure in the cloister arcade of the twelfth-century Cistercian Abbey of Jerpoint, Co. Kilkenny.

Early Christian cross-inscribed pillar. Reask, Dingle Peninsula, Co. Kerry.

OPPOSITE *Stone walls on Inishmaan. Beyond is Doonconor, an oval stone fort, believed to date from the early Iron Age.*

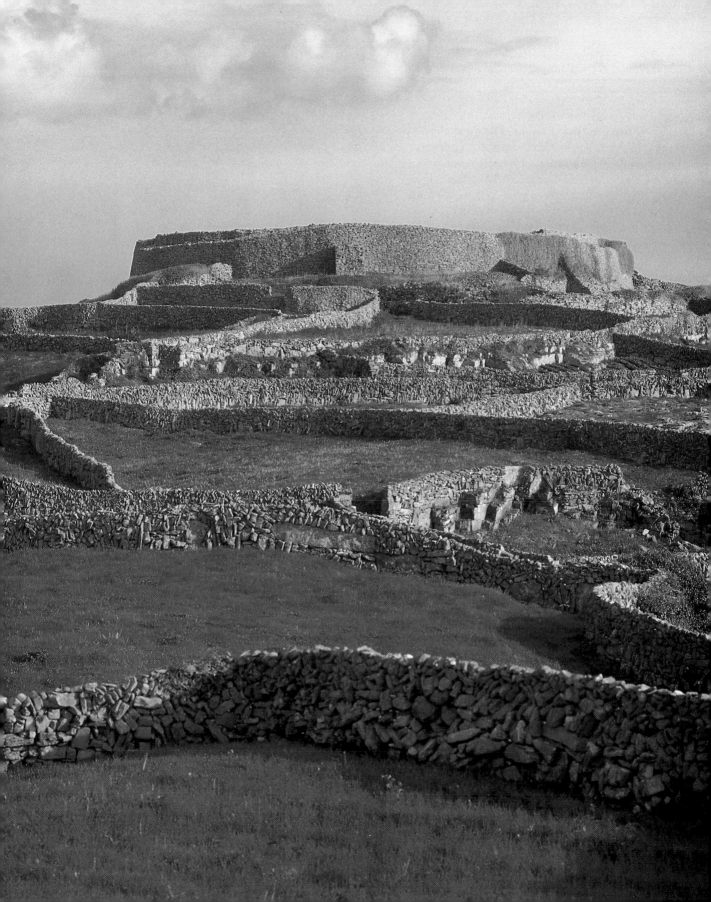

The Vikings, though great craftsmen in wood, bone, metal and leather, appear to have had few stonemasons. Their metal workers used stone as moulds, but their houses were of timber, as were the pathways in the towns they built and even their waterfront revetments. Of all the invading groups who make up the Irish, their contribution to stonework was the least. The availability of timber in the Nordic lands probably prevented the development of the craft there.

That cannot be said of the Normans, however. Their contribution was to be enormous. As early as AD 1200 they began to build stone castles, of which the largest still standing is Hugh de Lacy's at Trim in Co. Meath. Their castles resemble those built by Normans in France, England and Wales and the huge scale of these structures introduces a new era of stonework in Ireland. The Norman influence extended to every area in Ireland and even though many intermarried and adopted Irish manners and customs, in building techniques the Norman style never declined. Over three thousand stone castles or tower houses were built before 1600 and although many were built for Irish chiefs the Norman influence is apparent.

Side by side with these castles came a spate of church building. Twelfth-century ecclesiastical reform encouraged this and new Romanesque churches were built with typical features like round-headed doorways, chancel arches and windows, many of which had elaborate decorative motifs.

The study of medieval stone art and iconography has been greatly neglected, but the work of the late Dr Leask on churches and of Miss Helen Roe on items like medieval stone fonts in Co. Meath indicate how extensive stonework was in that period. Many churches, abbeys and friaries were built by the great new religious orders which arrived in Ireland after the middle of the twelfth century. The Cistercian monastery at Mellifont, Co. Louth (whose church was consecrated in 1157), was the first in Ireland to be built on the standard plan used throughout Europe, with chapter house, refectory, lavabo and dormitories all centred round a rectangular cloister. It was modelled in particular on the monastery at Clairvaux, from where St Bernard sent his own master-mason, a monk called Robert, to work on the buildings. The Cistercian

A weeper from an altar tomb, Jerpoint Abbey.

The east side of the tenth-century Cross of the Scriptures, Clonmacnoise, Co. Offaly.

Connemara marble has been quarried from the Streamstown quarry for over one hundred years. Formerly it was transported by steam engine to the rail head in Clifden.

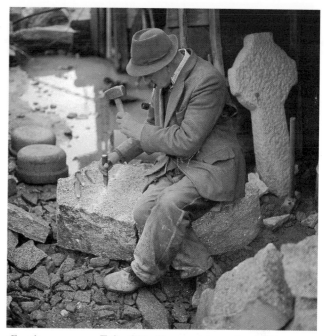

Granite quarryman Felix O'Reilly uses a 'sharper' (punch) to 'sweeten' the holes for the three 'devils' (small wedges) at Rowe and O'Neill's quarry Ballyedmonduff, Co. Dublin.

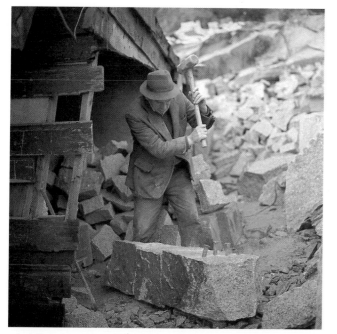

A sledgehammer is used to drive the punches home and split the granite.

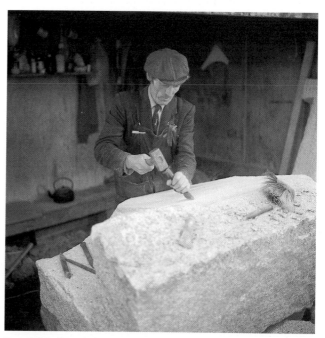

Jem O'Neill broaching the face of a granite block in preparation for inscribing.

influence spread to Bective, Co. Meath, Boyle, Co. Roscommon, and many other areas. The great monasteries like Mellifont and Jerpoint, Co. Kilkenny, are impressive examples of the stonemasons' craft, interesting both for their architectural style and for their abundant stone carvings.

In the early modern period the new settlers brought with them masons and stonecarvers to enrich this long tradition and references to them can be found in Elizabethan state papers. By the eighteenth century, brick had arrived, but stonemasons still found employment on the new Georgian houses. In the same century also modern graveyard headstones appeared, with their distinctive Roman lettering and decoration. The tomb of the poet Art O'Leary in Kilcreagh, Co. Cork, is one example of this and while much of the decoration was new there are still signs of continuity with medieval motifs, such as the cock and the pot. The eighteenth century also saw the arrival of the canal builders. The hump-backed stone bridges may be unsuited to modern high-speed, four-wheeled vehicles but they are still masterpieces of engineering and design. It is well recorded that the masons who built them were men who had learned their craft on similar work in England. Nineteenth-century church and railway building saw the last flowering of the stonemason's art before its decline in the present century.

Very little recording of the craft has been done. Its records are its monuments which defy destruction in the field. Yet in every area the tradition of the stonemen is very strong. Seamus Murphy's *Stone Mad* is a unique record of the craft in Cork. The method of apprenticeship culminating in a period as a journeyman ensured that trainee stonecutters learned the particular talents and skills of masters in different areas.

The stonecutters and masons were a tightly-knit group and the closed nature of the craft meant that families remained in it. Even today stonecutters' families are found congregating in the townlands which contain the quarries. In the granite area of County Dublin which comprises Barnacoille, Glencullen, Ballybrack and Ballyedmonduff the vast majority of the households are Murphys, Walshes, Ryans, Roes, O'Neills, Cannons and Doyles.

A further complication arises from the repetition of Christian names in each generation with the result that it became necessary to have an individual nickname to avoid confusion. This would often be passed on to the children; thus, the Daddy Doyle's sons were known as Joe the Daddy, Pat the Daddy and so on. Names could be either derogatory or complimentary. There was Kipper and Flier, Gipser and Dancer, Thugs, Good Chap, Cricket, Tosser and Feck, the last two referring to their owner's skill at the game of pitch and toss where a flat stick called a 'feck' was used to toss two coins.

Hickey's in Cork can be traced back five generations in the business. Wrafters, Molloys and Brackens working in Tullamore, Cahills in Tagoat, Galvins and Gearns in Foynes and O'Connors in Ballinasloe were all families of stoneworkers often calling themselves monumental masons. Not all were involved in the same type of work. The Mulhollands of Eshbrally in Co. Fermanagh are still stonecutters and part-time farmers who use the soft sandstone on their farm to produce whetstones for sharpening implements such as scythes and to make large circular grindstones which are mounted in a stand and turned by a handle.

Craftsmen working in stone still fall into distinct categories, a direct link with the old guild system. Quarrymen, assisted by labourers, remove the blocks of stone from the quarry. The quarrymen are regarded as semi-skilled but draw the same wages as the labourers. Stonecutters dress and shape the stone and the stonemason is the builder, often reshaping and adjusting the pieces. The last two are skilled craftsmen. A stonecarver is a craftsman who executes free-style carving other than geometric shapes, for example foliage on the capitals of columns.

Types of stone vary from district to district, as do methods of dressing and shaping, and even of severing. At Eshbrally the soft sandstone can be easily removed by using small iron wedges (known universally as 'gads') inserted into holes made with a pick. Some types of limestone are split in the same manner. At Liscannor in Co. Clare small flat triangular wedges are used to separate the large flags of the harder reef sandstone from the main bed of rock. For really hard stone such as Wicklow granite, plugs and feathers are always necessary.

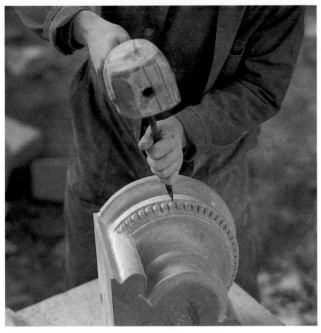

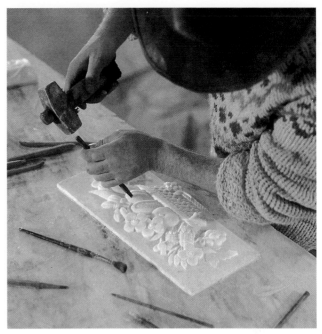

A new limestone capital for a nave clerestory window in Christ Church Cathedral, Dublin, under restoration.

Philip O'Neill carving a reproduction centre panel for a Georgian marble fireplace in white Cevic marble from Carrara, Italy.

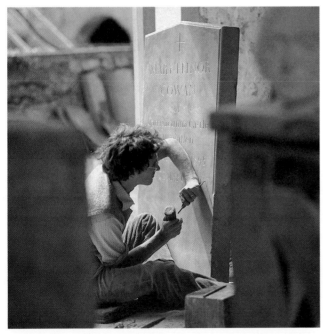

its welfare, and of its exalta
The Irish Republic is en
ms, the allegiance of every
.The Republic guarantees
equal rights & equal oppo
ns, and declares its resolv
ss and prosperity of the w
s parts, cherishing all the
equally, and oblivious of the
stered by an alien govern

Kenneth Thompson of Carrigtohill, Co. Cork, who has revived and adapted a very beautiful form of lettering common on Irish tombstones of the eighteenth century.

Detail of the 1916 Proclamation of the Irish Republic, in Arbour Hill Cemetery, Dublin. Cut in Ardbraccan limestone by Michael Biggs, who has led and inspired the revival in hand-cut inscriptions.

The feathers are half-moon shaped pieces of iron about 15–35 cm (6–14 in.) long with a slight flange at the top. They are dropped in pairs into the drilled-out hole to form a sleeve and a wedge or plug is driven between the two feathers, effectively increasing the pressure brought to bear on the stone. Plugs and feathers are used in groups driven in every 18 cm (7 in.) or so in a straight line across the section of the stone to be removed.

In the 1920s stone was removed from a granite quarry as follows. The quarryman would select first the general area and then the exact spot for a charge, and a hole would be drilled for it 2–3 in. in diameter, up to 2.4 m (8 ft) deep. This was done with a jumper, a heavy iron rod not unlike a crowbar with a straight cutting edge. One man held the jumper and two others wielding 6.5 kg. (14 lb) sledgehammers struck it alternately; between strokes the jumper was turned. This drilling operation could take up to a day or more. Half of the black gunpowder was now poured into the hole and the fuse set in place. The rest of the powder was poured in, followed by a filling of fine granite dust which was tamped well home with a long wooden pole. The success of the blast depended on the firmness of the tamping. Finally the fuse was lit. The blast was carried out not to blow the stone out of the face but rather to loosen it on the bed so that it could be removed in straight lengths.

To break out a block of stone from the bed a short, sharp quarry pick was used to start the holes for the large 15 cm (6 in.) long wedges. The holes were then 'sweetened' with a punch to take the wedges and the wedges struck with a sledgehammer until the stone split. Today a block of granite once hoisted out of the quarry is split into sections of the required size in exactly the same manner. A bull set is used to roughly dress the stone; this is a tool not unlike a very robust hatchet complete with handle, which is struck with a 14 lb sledgehammer in a two-man operation. A block is placed on the banker, the stonecutter's work bench, and hand tools come into play.

The first, a pitcher, has a straight edge and is used in conjunction with a lump hammer to cut away waste. Next are used punches – pointed tools that come in a variety of sizes. They can be the last tools to be used if a punched surface giving a pock-marked effect is required. For a smoother, 'broached' finish, finer straight-edges chisels are preferable, followed by 'rolling' – smoothing with a carborundum wheel – and polishing.

Often softer stones require different techniques and tools. For working the more yielding marbles, limestones and sandstones the tools are divided into two categories: those used with hammers, which have small heads to lessen the amount of burr; and mallet-headed tools with broad striking ends to avoid damaging the wooden mallet or bolster. Rifflers – stonecarvers' files – are used to finish off finer work and for small delicate pieces and a final rub is given with wet and dry sandpaper. The stonemason uses squares, set squares, plumb-rules, compasses and bevels, pitchers and hammers. The bevel consists of two metal blades slotted and fastened by a thumb screw and is essential for measuring and marking out angles. Like so many of these tools, they are often made by the mason himself.

Apprenticeship schemes introduced recently have guaranteed the craft a new lease of life. The demand is mainly for headstones, fireplaces, cornices and ornaments of various kinds, window sills and arches over doors. Banks and other commercial institutions commission marble countertops, wall-linings and other pieces and many architects demand stone and marble for special jobs.

The craft still survives in the traditional areas, where there are plentiful supplies of granite, limestone and marble. In the Dublin–Wicklow area granite quarries continue to be worked extensively by the same families. Larger concerns work the quarries at Ballybrugh, Ballyknockan and Valleymount. In the midlands MacKeons of Stradbally, Co. Laois, and smaller quarries are to be found. In Ballinasloe, Co. Galway, the major builders Sisk have a large quarry and works. MacCarthys of Cork City carry on the great tradition of stonework in the south. Marble is worked in two areas in Connemara, at Recess and Clifden, where the distinctive green marble is quarried. At Threecastles in Kilkenny a black marble or limestone is worked by MacKeons.

The masons and the cutters still get opportunities to show their skill. Galway Roman Catholic Cathedral has excellent examples of their talents.

CLARE SLATE

A great bed of reef sandstone runs from Doolin at the northernmost point of the cliffs of Moher, Co. Clare, to disappear under the Shannon estuary. Before the First World War this provided the basis of a large-scale industry exporting flagstones, but only recently has intensive quarrying started again to supply the demand for this attractive stone.

There are two types of stone, differing only in surface appearance. One, known as Liscannor slate, is smooth-faced; the other, Moher slate, a much bluer stone found near the sea, has a distinctive ripple effect caused by the fossilized casts of marine animals that squirmed their way across the sea-bed millions of years ago.

Moher slate is used for flooring, as a cladding on walls, even for paving loggias. Large flags make substantial field boundaries and very large ones are used to cover the roofs of outhouses, while the smaller ones become slates on the main dwelling. One of the excellent properties of this stone is that when wet it still affords a good grip, very important in street paving. The Liscannor slate, with its slightly smoother surface, is used for decorative fireplaces, mantelpieces, even shelving, as well as roofs.

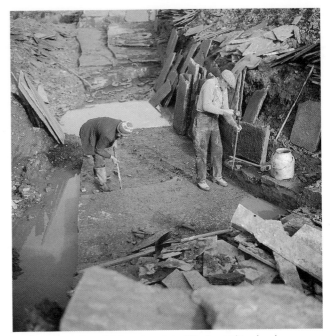

Wedging out a flag of Liscannor slate. The flag splits cleanly away from the bed.

A series of flat metal wedges are driven in to split the flag, then crowbars inserted underneath will raise it.

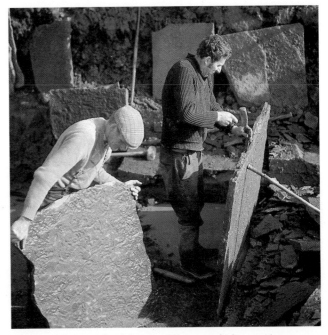

The larger flags are divided into smaller ones which are easier to handle; only the edges require dressing.

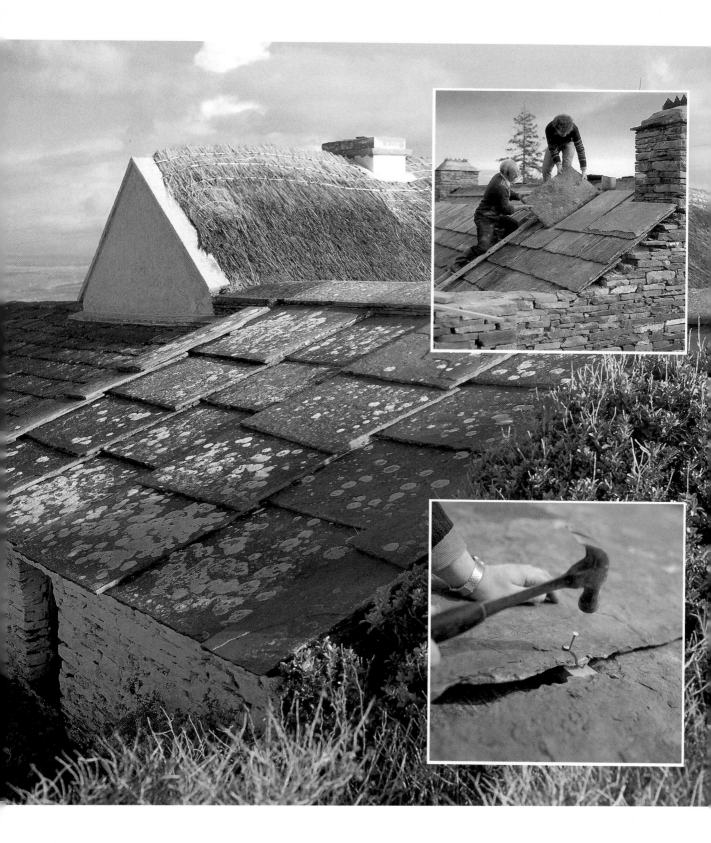

OPPOSITE *Flags are also used to roof dwellings and outhouses. Unlike the thatch, they will last unattended for centuries.* INSET, TOP *Patrick Gleeson and Patrick Sullivan roofing a house in*

Liscannor slate at Bunratty, Co. Clare. The dwelling has now been built entirely of Liscannor stone. INSET, BOTTOM *nailing to roof timbers.*

MILLSTONE DRESSING

Martry Mill on the Kells, Blackwater, is one of the few remaining mills that still produce stone-ground flour. There was a mill at Martry as long ago as 1641, owned by Nicholas D'Arcy. The Tallon family have owned and run the mill since the middle of the last century. It boasts three sets of millstones which fulfil different grinding functions, imported French burr for milling wheat, granite for crushing oats, and Derbyshire sandstone for de-hulling them. If in constant use millstones wear and require redressing. This was formerly the task of visiting journeymen.

Now Michael Tallon does the job himself (below). First he rubs lampblack on a spar of wood and passes it over the surface of the bedstone. The lampblack indicates the high spots on the stone which are picked level with a special millwright's pick, hafted in a very ancient manner. The runner stone (also Derbyshire sandstone) stands behind.

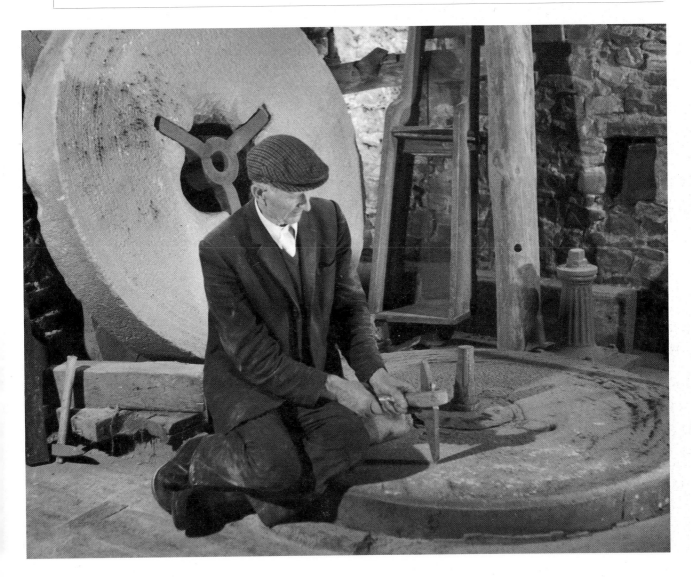

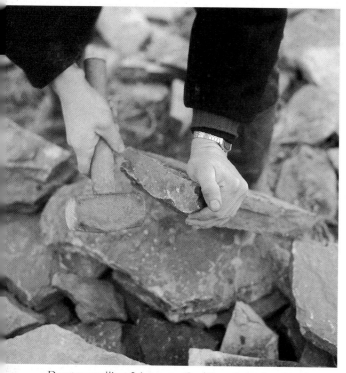

Drystone walling, Liscannor, Co. Clare, in local reef sandstone.

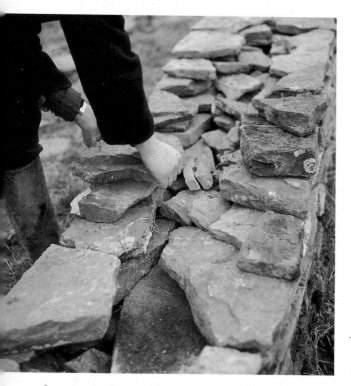

Large stones with a good face are selected for the outside of the wall. The middle is filled in with smaller stones.

The Investment Bank of Ireland building facing Leeson Street Bridge in Dublin has a beautiful façade with one-piece 3 m (10 ft) granite columns. Restoration work on St John's Castle in Limerick and St Audeon's in Dublin demanded the best of the craftsmen involved.

One group who have all but died out are the quarrymen. Conditions in the quarry and the stonecutters' yards have improved greatly, with the use of power tools, diamond saws and new methods of removing stone from the ground. But despite modern machinery the work is too hard, and young people are not keen to follow in their footsteps. The ones that remain are much in demand.

In the past, houses for rich and poor alike called for the stonecutter's skill. The trade has declined and while many fine new buildings make extensive use of stone, and there is still much skill among traditional stonecutters, they are no longer essential craftsmen in society. Younger stonecarvers are experimenting with new techniques and styles. Michael Biggs and Ken Thompson are leading a revival in decorative lettering and a number of stonecarvers are setting up studios for the production of stone carving as art objects.

But as Seamus Murphy recorded, many of the old quarries closed as demand declined. Today quarry faces have been badly damaged as a result of indiscriminate blasting to extract stone for road works. Some of the stoneworks now import Indian and South African granite for headstones, though the native granite is in no way inferior – a claim for which there is solid evidence in the form of the weatherbeaten headstones that have already lasted for centuries.

OPPOSITE *Drystone walls are often built with little or no dressing of the stone, but the construction is nevertheless executed with great care and skill. Hundreds of miles of walls were put up in the nineteenth century to protect livestock and crops. The tracery of limestone walls here overlooks Lough Corrib, Co. Galway.*

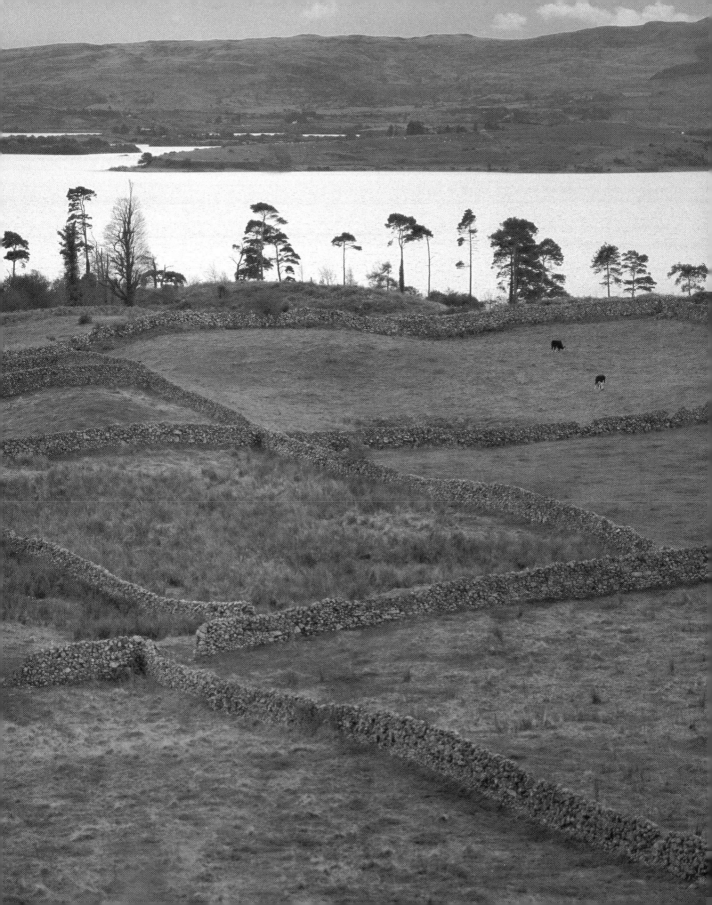

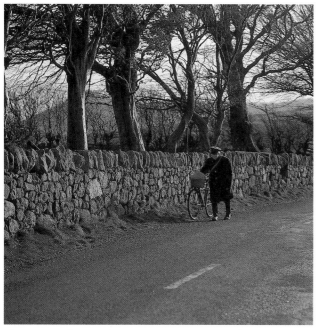

A granite wall near Glencullen, Co. Dublin.

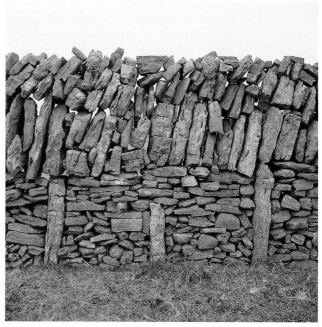

Limestone wall, Inishmaan, Aran Islands. Cattle turds drying on the wall will be used as fuel.

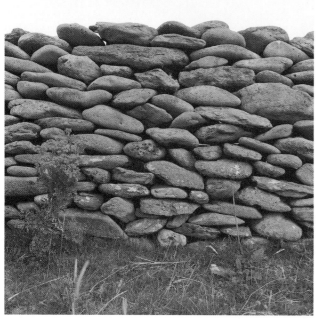

Water-rolled stones of old red sandstone make a wall near Ballydavid, Co. Kerry.

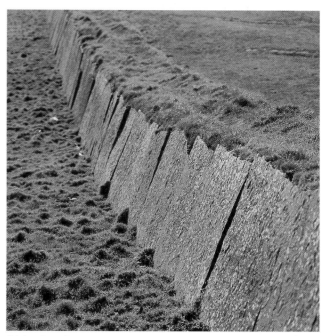

Moher flags form a protective outer facing on each side of an earthen bank, Co. Clare.

Woodwork

When the foundation stone of the O'Connell Monument was laid on 8 August 1864, over two hundred coopers marched behind a band led by seven men on horseback and a carriage pulled by four horses on which the coopers' banner was mounted. The cooper's craft was at its height at that period and was divided fairly sharply between the country and city branches.

The craft is of great antiquity and was known in Ancient Egypt. The Romans brought this skill to England and wooden vessels made from staves and single pieces are known in Ireland from the early Christian period. Single-piece vessels were found in Garryhinch in Co. Laois and an eleventh-century stave-built vessel datable from stratification and ornamentation has been found in excavations in Dublin. The Coopers' Company received its charter of incorporation in 1501 and it is a revered and venerable craft.

Of all woodcrafts it is one of the most intricate, calling for a skill for instinctive measurement rarely required in othe crafts. Without any written measurements the cooper must produce, after bending timber, vessels of symmetrical proportions which will hold precise weights and measures. Each vessel must be strong enough to take the pounding of the dash in a churn or the pressure of fermenting liquids, it must last a lifetime in spite of rough handling and retain its shape and functional value.

The craft flourished in Ireland in the eighteenth and nineteenth centuries when huge numbers of coopers were at work. In the cities and towns the brewers, distillers, provision merchants, butter merchants and butchers all employed coopers. Each product demanded a container of different type to hold a different weight and the names of each are strange sounding in these post-metrication days. For the provision trade a 'navy tierce' held 300 lb, a 'pipe of port' held 115 gallons, a 'hogshead of brandy' held 60 gallons while a 'hogshead of whiskey' held 55 gallons. For the brewers a 'pin' held 9 gallons and a 'hogshead' 52 gallons. For the cooper the names of these barrels or casks were part of his everyday vocabulary.

Casks had to be robust and as whiskey would run through the slightest flaw in a joint the cooper had to be extra careful. Every cask made carried the maker's initials and if a cask leaked in bond the employer knew whom to blame. Split rushes with the core removed were used in distilleries to give a tighter seal to the square joint between staves.

The country cooper had a different type of customer: mainly farmers who required churns, butter tubs, piggins, noggins, buckets, cools for gathering milk, washing tubs and a variety of other vessels. This trade declined in the present century with the spread of creameries, and the advent of cheap plastic materials has sounded its deathknell. Just as the tinsmith has become obsolete so the cooper's craft is no longer needed and though some are still employed in the distilleries in Bushmills in Co. Antrim and Midleton in Co. Cork, there is probably only one remaining country cooper who still follows his trade, Edward Gavin of Ballinagh, Co. Cavan, a fine craftsman who is still fully active.

Ned was born on a farm in the stony grey hills of Co. Monaghan. As the eldest of eleven children he left the 16 acres to serve his time with a cooper called McPhillips in the neighbouring townland. He learned his trade over a period of eight-and-a-half years in the early 1930s.

Ned's great hero was a man called Jim Keenan. 'He was the greatest artist in wood I ever saw and I learned all I know from him – and I could have learned a great deal more.' Keenan, like so many of the coopers, was a journeyman following a centuries-old pattern, staying in one place for as long as the work or his fancy took him and then moving on doing a circle from Dungannon to Portadown, Armagh, Castleblayney, Cavan and Clones.

Ned began his 'tub thumping' – that is learning the trade – making pickle barrels used by a local bacon factory for the export of pigs' cheeks to places as far away as the French Cameroons. In 1938, at seventeen years of age, he made his first churn. This was regarded as the highpoint of the craft. Once a journeyman could fit the crib (neck) on a churn, or compass an oval bottom, he had achieved a high degree of skill at the trade. Ned was primarily engaged in white coopering in his early years, and Scotch firs from local forests were mainly

used. It was still possible in those days to get large Scotch firs; the trees available today would be saplings to the old coopers. Oak was used for churns for the west of Ireland and teak was preferred in the northern counties. Much of the timber used was recycled. Old whiskey barrels were knocked down and the staves reused; these were much favoured as giving a flavour to the butter. Ships' deck planking from the shipyards of Belfast and Guinness barrels were also eagerly sought by the country coopers, who liked to work with well-seasoned timber, though some Burma teak was purchased. A good cooper had to know his timber and was always on the look-out for suitable supplies.

Churns were of great importance to country coopers. Every farm in the country had one and different types were preferred in different regions. Tall slim churns were popular in Donegal and in the north; smaller, broader and lower churns were in demand in the west and in Kerry and Clare barrel-type churns with a bulge at the bottom were favoured. Instinctively or on demand the cooper made the churn appropriate for the area, though in the old days the cooper would have made the one type for sale in his own area. In the nineteenth century the farmer would buy the timber and the cooper would call to the farm bringing with him the tools of his craft. One of the first tasks the cooper would perform was to split the timber using a clefting axe. While there he would be fed and looked after and besides making new pieces would repair old stave-built vessels.

Ned Gavin describes the steps he takes in making a butter churn in the following way. He first sharpens his tools and selects the timber to be used. The width of the staves can vary from 5 to 15 cm (2–6 in.) but a rule is used to measure the length. The churn is made in two basic parts: the 'body' or base part and the 'crib' or neck of the churn. The two combined make a churn 57–59 cm high (22–23 in.) and this he describes as a one-cow churn. The base when completed measures 40–45 cm ($15\frac{3}{4}$–$17\frac{3}{4}$ in.) in diameter.

When the timber is split for the staves it is then brought to the mare to be dressed. The mare is a stool with an arrangement which allows the cooper to put his feet on two pedals and hold the timber.

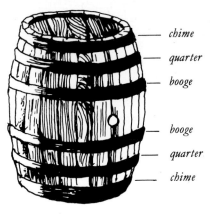

Barrel showing names of the hoops

— chime
— quarter
— booge
— booge
— quarter
— chime

The mare was popular with a variety of country craftsmen being used extensively by chairmakers and basketmakers. Since medieval times this device has been a more efficient one for specific tasks than even a modern bench vice. Using a hollowing knife the inside of the wood is dressed and the direction of the grain is noted. The sides are shaved and the staves are brought to the jointer. The jointer is a long wooden plane one end of which rests on the ground while the other rests on two splayed legs. The face of the jointer is uppermost and on this the joint is shaped. It is a square joint, not bevelled, and the staves are narrower at the top to make the curve on the churn.

The churn is next 'raised', a process that Ned Gavin describes as follows. The staves are arranged in tress hoops which are heavier and stronger than the hoops used on the finished article. These are used again and again. More tress hoops are added and the body has to be symmetrical at this stage otherwise it will always be lopsided. The half-shaped body is then moved to the firing ring. A bucket of shavings is set on fire inside the piece and the intense heat softens the staves so that as the tress hoops are hammered down the staves close up. To tighten the hoops a hammer and a wooden driver are used.

'A cooper without a compass is like a banker without a pen', says Ned Gavin, one of the last of the country coopers of Ballinagh, Co. Cavan. 'When you could compass an oval bottom you were considered to have finished your apprenticeship. Coopers were never any good at carpentry work; everything in our trade is judged by eye.'

'We make the teak churn for this part of the country but they loved the oak in the west and in Kerry – it gave a nice tang to the butter. The teak churn is equally good when it is well tempered, that is, scalded, thrown up on the hedge to air and used a few times. The life of a teak churn is a long one, fifty to sixty years. As a matter of fact, the trade used to say they lasted too long! – whereas the oak churn had a short life of only fifteen to twenty years.'

Ned is making a 'one-cow dash churn', the type that he can still sell in Counties Mayo and Galway. It is made from staves of teak and is constructed in two separate parts: the body and the crib. The upper section, the crib, is fitted down over the body incorporating a 'knife-edge' joint. A waisted collar hoop reinforces the join.

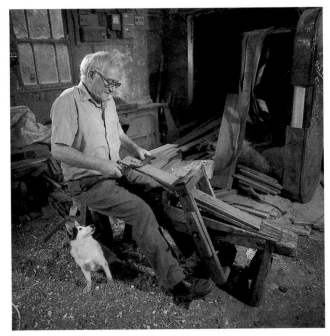

Edward Gavin sits astride the cooper's mare using a hollow knife to dress the teak staves which will form the body of a dash churn.

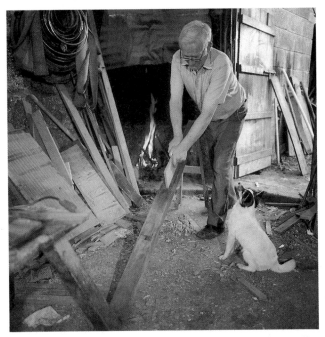

The jointer is like a very large box plane, one end resting on a small A-shaped frame, the other on the ground against a stop. Instead of the plane being brought to the wood, the wood is brought to the plane.

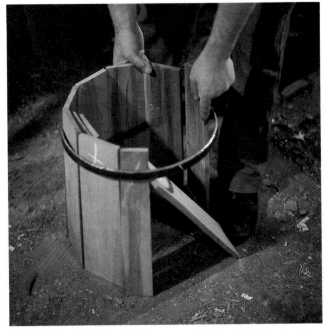

One tress hoop is held and the first stave placed inside the hoop and propped by another stave held with the cooper's boot. He fills in the staves until they wedge themselves inside the hoop.

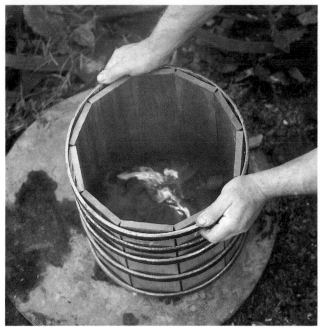

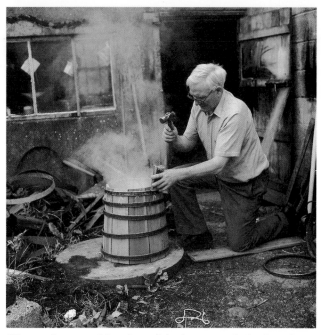

The body of the churn, staves still rectangular and supported by five tress hoops, is ready for firing. It is placed over a small fire of shavings and scraps of wood. The heat will make the wood supple.

The tress hoops are driven down with a hammer and a hard wood block. The staves are forced to bend and take on the curve of the hoops. The joints close.

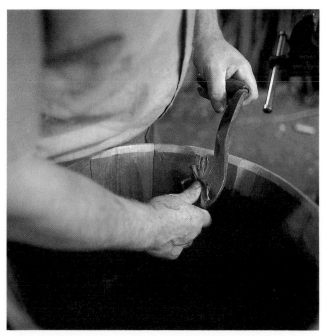

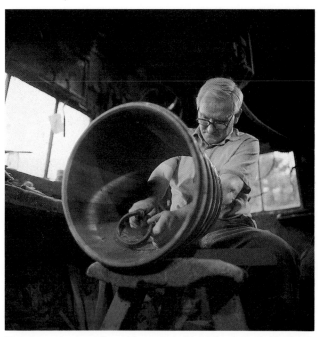

Before the wood has fully cooled, a crumbing knife removes the charred wood from the inside edge of the churn and leaves it the correct shape.

To remove the charred wood from the inside of the churn the 'in shave' is used.

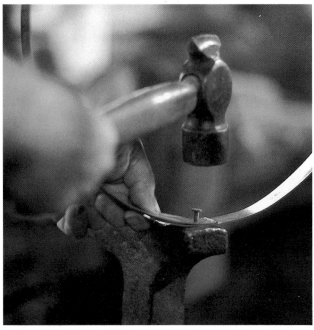

The galvanized iron hoops are bevelled with a flogging hammer to allow them to sit at the correct angle against the sloping side of the churn.

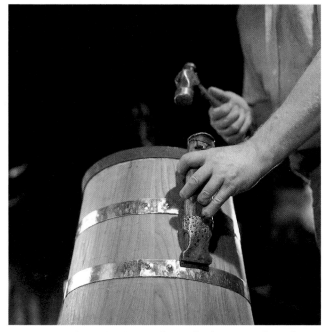

The hoops are driven firmly into place with a hammer and metal-tipped driver.

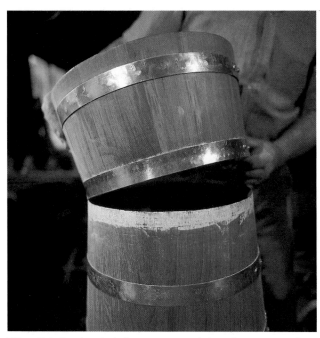

The crib is fitted to the body, extreme care being taken to ensure that there are no ill-fitting joints.

REGIONAL VARIETIES OF
CHURNS AND DASHES

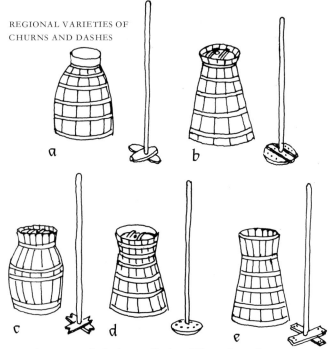

a *south-west, particularly west Cork and Kerry.* b *south-east, Wexford and Waterford.* c *west/south-west, Clare and parts of Limerick.* d *west, Galway and Mayo.* e *north-east, Cavan, Monaghan and parts of Down.*

The body is next brought to the bench where a crumbing knife is used to bevel out the ends before they are levelled off using a topping plane. In the old days an adze would have been used instead of the crumbing knife. The base is now a stave-built barrel-like vessel open at both ends. While the wood is still warm a down-shave is used to remove the charred wood and to smooth the inside. It is next turned on its side and an in-shave adds the finishing touches. Another plane-like tool called a 'croze' is used to put in a groove for the bottom or base.

The base is usually made from three pieces joined together with coopers' dowels, as the headless nails are called. A pair of compasses and chalk are used to mark the diameter, and then the base is cut out using a bow saw. Accuracy is essential.

The next step is to replace the tress hoops with the ordinary galvanized iron hoops. The tress hoops at the top are removed and their positions chalk-marked. The iron hoops for the finished churn are 3.2 cm 16-gauge iron except for the base hoop which is slightly heavier and wider. Each hoop is measured, cut and then brought to the cooper's 'back iron' or anvil where two holes are punched in it. The ends of the hoop overlap by 5 cm and two rivets hold it in shape. One side of the hoop is 'flogged' to make it taper to fit the side of the churn. The hoop is then ready for driving down over the churn. This is done with a steel driver, consisting of a wooden wedge with a steel tip to prevent it slipping off the hoop. When the bottom tress hoop is taken off, the base is put in position. As each tress hoop is removed the wood underneath is planed with a spoke-shave. The top tress hoop stays in position until the crib is ready.

The crib is made of staves 7.7 cm long by 1.9 cm thick ($3 \times \frac{3}{4}$ in.) by various widths. A 'champer' (chamfer) is taken off one side so that the crib will slip down over the body; it is held in position by what is called the collar hoop.

The lid then has to be made to fit 3.8 cm ($1\frac{1}{2}$ in.) from the top of the crib on the inside. Three pieces of timber are joined and two bars are placed across the lid with a row of fine nails. Between these is placed a cross bar, called a 'pulley up' in Cavan, where each cooper made this to his own pattern as a type of trade mark. A centre hole is cut out using a

bit and brace and through this is fitted the dash, a kind of plunger used in the making of butter.

The dash was not usually made by the cooper. In Cavan off-cuts from cart felloes were usually used to make a rodded dash consisting of three pieces, a centre and two wings joined by four rails running through the three pieces. In the old days joiners or wheelwrights would have made these and the pattern varied from district to district. Around the handle or staff of the dash and over the lid was fitted a 'jogler' to prevent splashing through the hole at the top. It was a small cup-shaped object made from sycamore by a wood turner.

The churn was then ready for varnishing and in some cases the hoops were painted black. The oak churns for the west were often painted blue or green and in older times yellow ochre, black or venetian red was used to paint everything, dresser, bin and churn.

Ned Gavin grew up in an age when the countryside was full of craftsmen. He has seen the traditional blacksmiths of Co. Cavan disappear; the mysterious world of the journeymen stonemasons has gone and he is the last of the country coopers still active. His friends and colleague coopers, Conlons of Dromnalara, Reillys of Killinaleck, Sextons of Milltown, Galligans and Keenans of Cavan town and Smiths of Granard, have all abandoned the trade. He has survived because of his skill, his business acumen and flair.

Over the years he has taken his wares in his Morris Minor to any area where markets were to be found in Galway, Mayo, Dublin, Clandeboy, Portadown and Belfast; he has worked on contracts for Irish Lights and the Botanic Gardens and has made many reproduction pieces. Though he has enjoyed his life he has few regrets that the craft is dying – the hard times were too hard. Ned Gavin could not see any other person doing what he has done during his lifetime. He recalls:

In olden times, the working on the mare – that was one of the brutal jobs of the game. You could be sitting for two days pulling a big hollowing knife and you could have blisters on your hands and you could have shavings built up around you and you might have a smell of whiskey or a smell of porter off them (i.e. old staves), as the case

might be, and that was a sobering job. You would never get used to that: it was purely blood money, if you like. But then again it had its compensations – you got up again and you had a change of job. The job changed that often and it is not like an assembly line. It made you so fit you could jump a hedge after a hard day's work.

Recognition of his artistry is only now coming with exhibitions in the National Museum and elsewhere.

It is a matter of regret that so many excellent coopers have gone. The study of regional variations of their products will depend in the future on museum collections. Little was done to develop new products which would have kept this craft alive. In the modern world of mass-produced goods, any skill of this kind has a commercial value; it is our loss that new products have not been designed to open up new markets. We lose a part of our history and our heritage with the death of a craft just as surely as with the loss of architectural remains. The curiosity of Ireland is that the disappearance of a craft generates little sense of loss and this lack of awareness is typical of our neglect of our material folk heritage.

A selection of Ned Gavin's wares. From left to right: a churn in the process of being made; a completed one-cow churn and dash of the north Galway/Mayo type; noggin; piggin; plant tub and umbrella stand. Back row: brass bound plant tubs and a tub made with alternative staves of greenheart and oak. Extreme right: plant tubs.

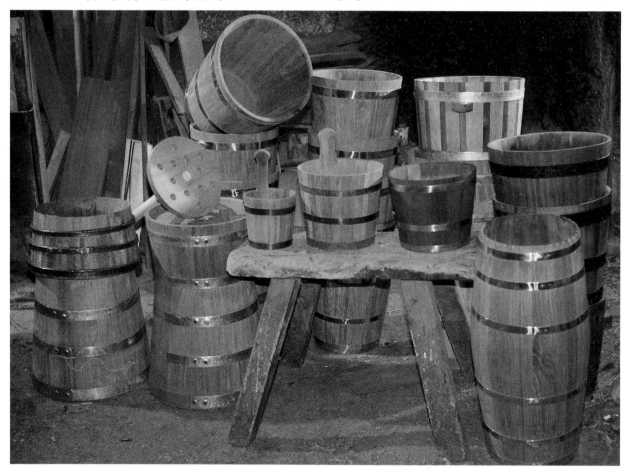

Furniture, in the sense of the clutter of miscellaneous objects with which we crowd our houses today, is, at least in its variety, a comparatively modern phenomenon. We would not, naturally, expect to find much in the way of furniture in the camps of food gatherers like the Bushmen or the Tasaday, or among nomadic people like the Bedouin or the Buryat, but we may well be surprised by the fact that most of the great civilizations were content with a minimum. The Egyptians, the Greeks and the Romans, even in wealthy homes, had some bedsteads, chests, seats and tables, and usually no more, and there was little change in shape and form over the centuries. Not until Rome's decadence in Imperial times was there any elaboration, and this, to the old fashioned and strict-minded of the time, was a symptom of that decadence. Even today the house of a wealthy old-fashioned family in Japan appears very scantily furnished to the eye of a Western visitor.

The same was true, in former times, in Ireland. There were raised bedsteads, though often these were built into alcoves and were fittings rather than furniture. But there are many references to movable beds. When the rapacious throng of poets descended upon King Guaire the Generous with their outrageous demands, such as fresh strawberries at Christmas, they insisted on a bed for each poet, with a second bed beside it at a lower level, for fear they might fall out in their sleep. Lucky for the king that his brother, St Mo Chua, was a learned man who made the poets retreat in shame by showing up their lack of letters.

Many a folktale relates how the hero conceals himself in a chest, for these boxes took the place of wardrobes, sideboards and cupboards; when well made, with tightly fitting lids, they were proof against moths and other vermin which harmed clothes, and so were commonly used to preserve and store garments and household linen.

Tables in Ireland were purely functional. One worked at a table and left it when the work was finished, whether it was work with a chisel, a needle, a pen or a knife and fork. Eating a meal was the only social occasion when one sat around the

Early Irish dresser.

Gibson chairs from Oldcastle, Co. Meath. Also known as 'fool's chair', a variation on the Windsor theme.

A development of the four-legged stool.

table, and it seems that eating, too, was mainly functional, and that the social gathering began when the party left the table and sat around the hearth to talk and drink. It is interesting to note that the word *bord*, a 'board', meaning a body of people which discusses and decides matters of moment, has recently been adopted into the Irish language. This comes from the English or Continental fashion of holding such meetings seated around a table. The older Irish words for such a group, *dáil* – a distribution or sharing (of ideas or decisions), or *cruinniú* – a gathering in a circle, have no such implication.

It is not surprising, therefore, that in the average Irish farm kitchen of half a century ago, the table had no prominence, but was pushed aside when not needed. Some smaller houses had folding tables attached to the wall, and some had no tables at all. Some even continued what must have been a very ancient custom. A large pot or cauldron full of hot water was placed in the centre of the floor. On it was set a large flat wicker tray or basket on which the food was laid out, while the family sat around and helped themselves. The hot water and rising steam kept the food warm and moist.

Probably the oldest of all pieces of furniture is the seat. At first, no doubt, it was no more than a large stone or lump of wood, or a bundle of vegetation, but before long, we may be sure, it was a more deliberate fabrication. In the course of time, the seat became a symbol or expression of power, authority or wisdom. Monarchs have their throne, magistrates their bench, professors their chair, and Members of Parliament their seat. In country tradition until recently only the man and woman of the house, and perhaps one or two honoured guests, had chairs, while the commonalty sat upon stools. A strict order of precedence was observed, often needing tact if guests of varying importance arrived. Witness Eric Cross's *The Tailor and Ansty*: 'There are times, however, when the Tailor's diplomacy is swept aside by Ansty's more abrupt methods. If a guest should already be installed in the chair of honour and a guest of higher rank arrives, Ansty will simply and directly command "Get up, 'oo, and give the chair to So-and-so".'

For thousands of years, therefore, at least some chairs were elaborate and ornamental, and the chair maker was a craftsman of skill and repute. Methods, materials and fashions all played their part in producing a particular type of chair in any given locality and period. In forest areas where wood was plentiful and large tree trunks easily obtained, the 'tub chair' evolved. This was simply a stout cylinder of wood, usually a section of a tree trunk with its upper part cut away and hollowed to make a round back while the solid lower part formed the seat. When wooden barrels were common as containers, a large cask could be easily cut down to the same form to make the 'barrel chair' popular in some regions, while copies of this shape produced the straw armchair and the wicker 'basket chair'.

Another product of the woodland areas, and mainly associated with the great forests of central Europe, is the backed stool, which most of us know best in the form which we call the 'windsor chair'. The seat is a solid slab of wood cut to a suitable shape. Holes are bored in it and the legs and back uprights secured in the holes. Careful tapping with a mallet allows the back to be removed to leave a still serviceable stool.

Another, quite different type we know as the *súgán* chair or rope-seated chair. This form had its origin in ancient Egypt and is characteristic of areas where heavy timber is not so common. It is made from relatively slender pieces of wood fitted together to make the chair framework. It is also

Wooden cradle, Ulster.

called the 'ladder-back' chair because the back, which comprises the back legs as well, is detached and takes the form of a short ladder, two uprights with rungs between. This type is to be found (possibly spread from Egypt) along both sides of the Mediterranean and up the west coasts of Europe. In its simple form it has been found in the homes of ordinary people from Cyprus to Norway for at least a thousand years, and it is the basis of the fashionable eighteenth-century chairs of France, Spain, the Low Countries and England, the Louis XV, Sheraton, Adam and Chippendale examples of which are usually regarded as the acme of the chair maker's art.

And it may justifiably be called an art. Examine a well-made country chair and it will be seen that it is no simple job. Notice that every member is subtly shaped for strength and comfort and that every joint is slightly 'off the angle'. Then watch the craftsman at work and observe that he uses no elaborate measurements or calculations but judges his angles, his curves, his mortices and auger holes by eye, just as a painter or sculptor does – truly an art.

Both of these main types, the 'windsor' or backed stool type and the *súgán* or ladder-backed type are still made by craftsmen in Ireland. Their distribution is interesting. The 'windsor' is north-eastern – east Ulster, north Leinster, the north-eastern corner of Connaught – while the ladder-backed type is normal in west Ulster, most of Connaught, most of Leinster and all of Munster. This bears out the theory of the introduction of the ladder-back in ancient times from the Mediterranean along the seaways of western Europe and the later arrival of the backed stool type from central Europe via Britain.

Another chair type seems to be of Irish origin, although its beginnings are not certain. This is known as the 'Tuam chair' because in recent times it has been confined to the Tuam area of Galway. It is a three-legged chair of which the back and back leg are made from one wooden board and the seat is triangular and made from jointed pieces of wood. They are known to have been in widespread use in Connaught 150 years ago but are undoubtedly much older. They are still made with skill and care by craftsmen in Co. Galway today.

Hen dresser.

Irish blanket or clothes chest, Co. Kilkenny.

CHAIRS

LEFT *Making the Leitrim chair. Boring the holes with an auger calls for skill and judgment.*

BELOW LEFT *John Surlis and his grandson Ciarán on their cooper's mares, a vice used by coopers, chair- and basketmakers.*

BELOW *Completing a Leitrim chair; John Surlis' grandfather moved from Leitrim to Sligo, bringing the design of the chair with him.*

OPPOSITE *Clefting ash for their chair legs and rungs.*

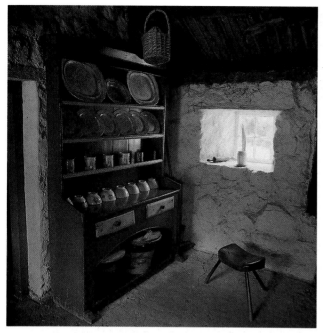

The dresser has evolved from built-in shelves of wood or stone on the side wall of the dwelling. Cruckaclady Farmhouse, Plumbridge, Co. Tyrone. Permanent exhibit Ulster Folk and Transport Museum.

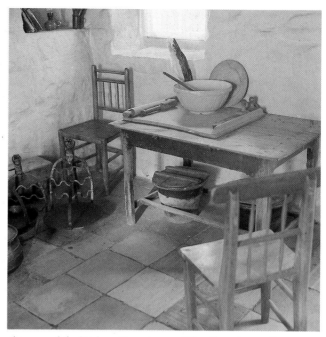

A corner of the kitchen, Corradreenan West Farmhouse, Co. Fermanagh. Note the bread-irons on the floor, wooden-seated ladder-backed chairs and crock under the table. Permanent exhibit, UFTM.

Vincent Killen sanding a 'Tuam' or 'Old Irish Chair', a development perhaps of the three-legged stool. Older versions of this chair were made in north Clare, Galway, Mayo and Sligo.

Near the back door of the Cruckaclady Farmhouse, ladder-backed chair, wooden rotary churn, turned wooden bowl, piggin of stave construction.

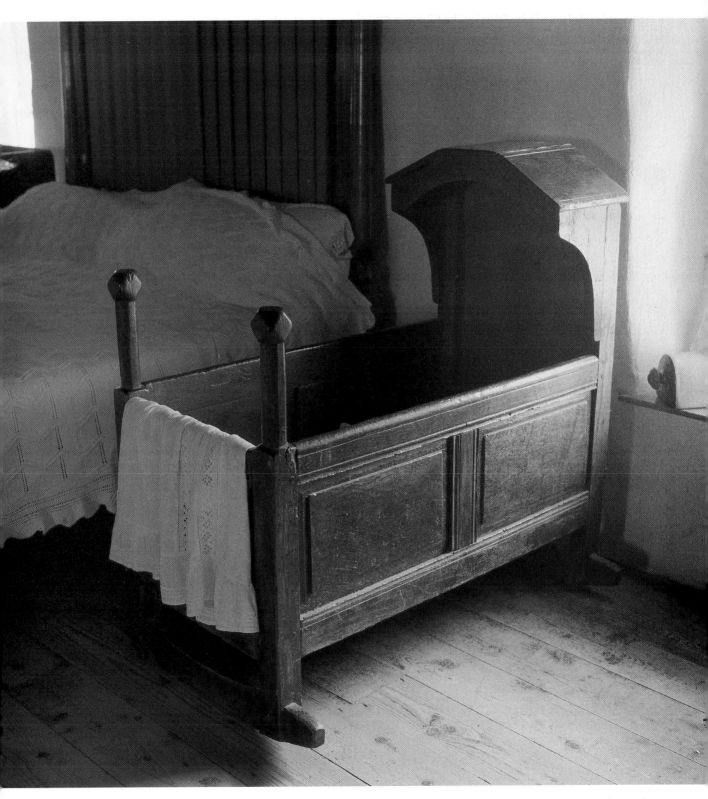

Cradle made in oak c. *1700, in the main upstairs bedroom of Lismacloskey House, Toomebridge, Co. Antrim. Permanent exhibit,* UFTM.

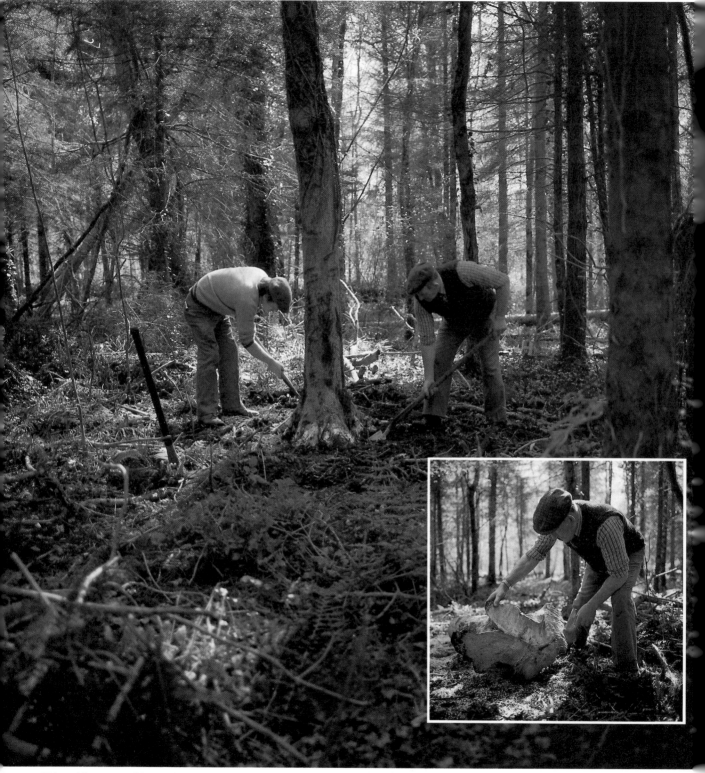

Edward Brennan and his son Michael digging around the roots of an ash tree prior to felling.

INSET *The boss of the hurl is formed from the curved part of the bottom of the ash root.*

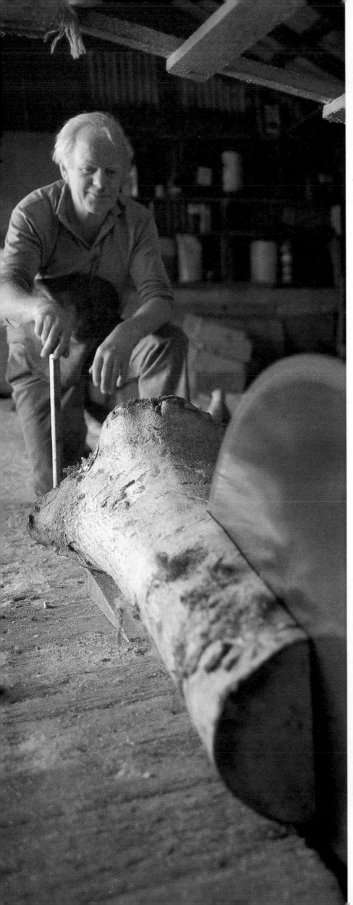

ABOVE *Ramie Dowling, the well known hurl maker of Kilkenny town, repairs a broken hurl.*
BELOW *John Surlis of Monasteraden, Co. Sligo, shows his grandsons Ciarán and Declan the old way of dressing a hurl (with a hatchet).*

LEFT *Sawing planks for hurls at the water-powered Inch Saw Mills, Co. Kilkenny, which has been in Liam Brett's family for many generations.*

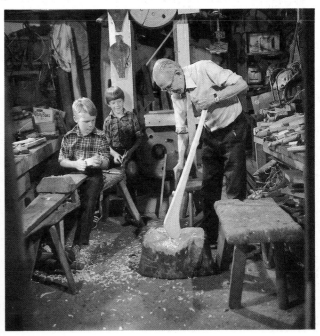

PIPES

Marking out the bowl for a briar pipe of erica arborea.

Kapp and Peterson have been making pipes for over a century in Dublin. Their briar pipes are made from the root of the Mediterranean tree heath or bruyère, erica arborea. *Hallmarked sterling silver bands are hand-turned for the junction between bowl and stem, made from vulcanite, a rubber by-product. Occasionally if a rare briar graining is found a special pipe is made with gold bands and an amber stem.*

Pipes are also made out of meerschaum (the German word means 'sea foam'), a mineral not unlike soapstone that consists of hydrated magnesium silicate. Kapp and Peterson import meerschaum from Turkey and Somalia.

Turning the inside of the bowl on a lathe.

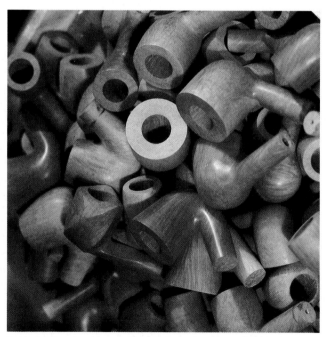

Individually turned briars that can be made to special order.

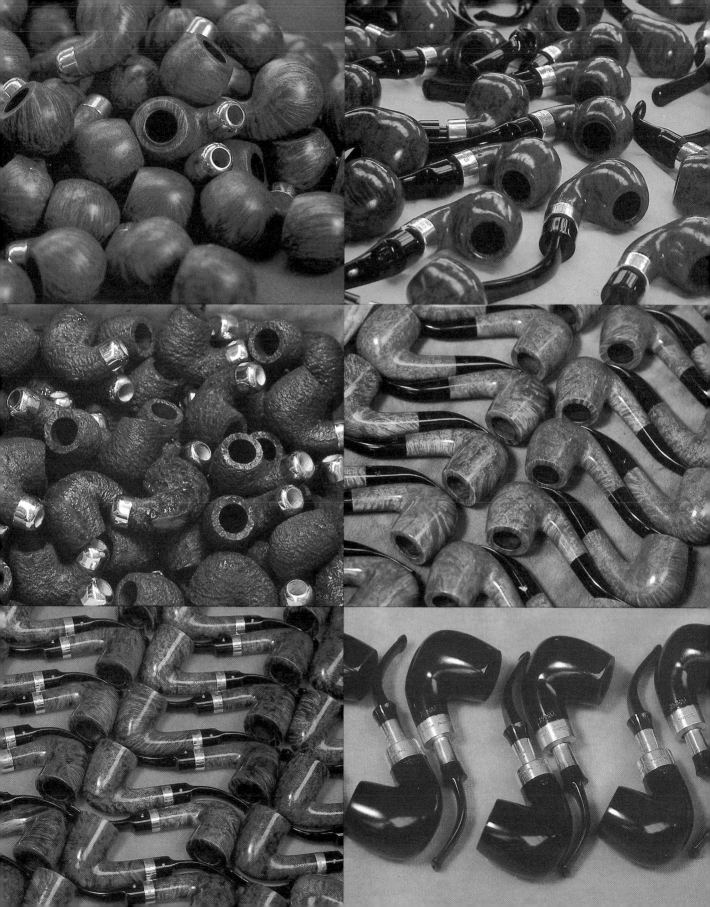

SPINNING WHEELS

The spinning wheel that James Shiels and his son John of Carndonagh, Co. Donegal, make is known locally as the small or Dutch wheel: small because the three-legged treadle-driven wheel is considerably smaller and more portable than the older hand-operated big wheel; Dutch after the Dutch craftsmen brought over by Sir Thomas Wentworth, Charles I's viceroy (who is also credited with introducing the wheel), to teach the Irish woodworkers how to make the wheel in the eighteenth century.

Turning one of the three legs for the treadle spinning wheel.

Hammering a spindle (not to be confused with the main spindle) into the nave or stock of the wheel.

The treadle, linked by cord to the wheel spindle, will transmit the power to turn the wheel.

Fitting the spindle shaft and tension screw into the stock or stool.

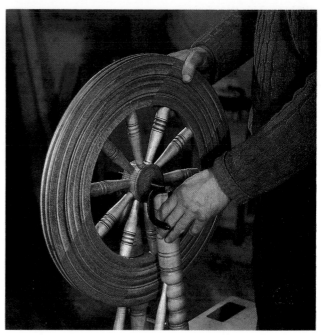

Dropping the wheel into the uprights. Note the wheel spindle in position.

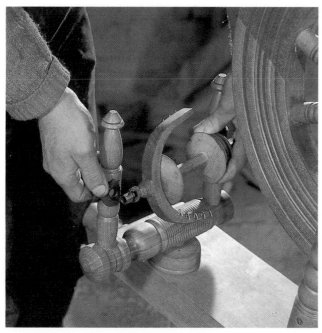

Assembling the spindle. The teeth on the 'heck' or 'flier' help to guide the yarn evenly onto the bobbin.

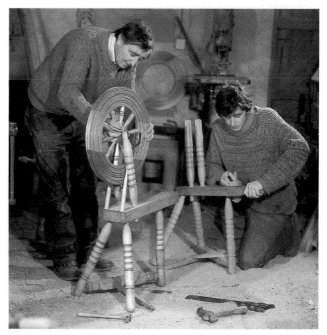

James Shiels and his son John; second and third generation spinning wheel makers.

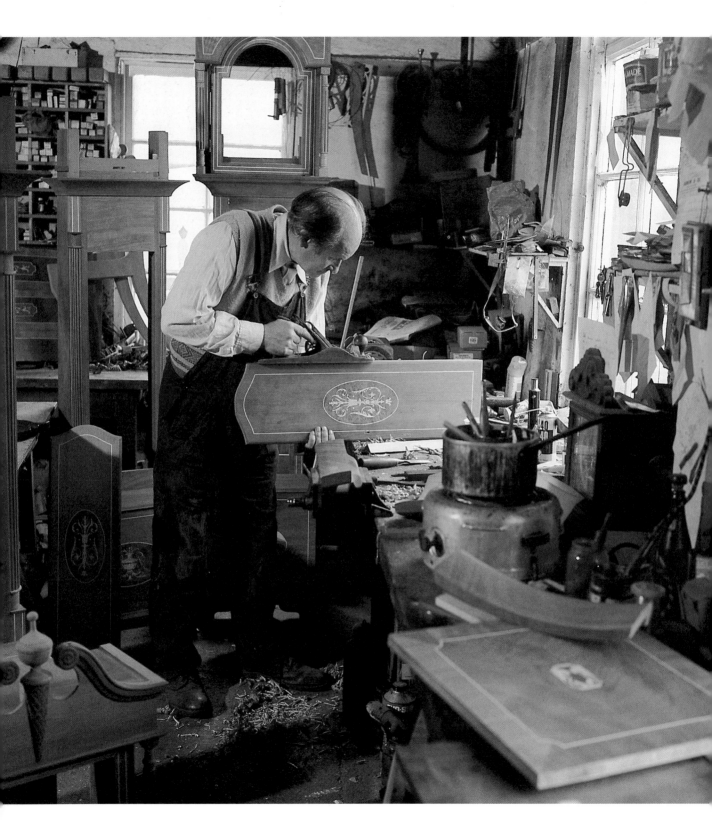

CABINETS

Formerly coopers, the Robinson family now make fine reproduction furniture in the Regency style, which calls for considerable marquetry skills. The art of marquetry is very ancient, having been practised by the Egyptians, examples of whose casks have survived. Veneers of wood, brass, ivory and even mother-of-pearl are inlaid or applied to the piece of furniture to form a picture or design.

The first step in creating a marquetry panel or motif is to make a well-balanced design; it must enhance the finished piece of furniture by being neither too fussy nor too dominant. Natural wood veneers produce an enormous tonal range of colours and patterns even within the same tree. For example, at the intersection of the trunk and forking branches are cut crotch or curl veneers. The wart-like growths produced by some trees, called burls, yield end-grain veneers or burrs. Two of the most widely used veneers are sycamore and mahogany.

A motif has to be cut to the required size, made into a veneer sandwich of twelve alternate layers of pale and dark wood, and stuck together with animal or Scotch glue. A backing piece of walnut veneer is also included to take the swarf cut of the saw. The design plan is stuck to the face of the sandwich and beeswax is applied with a hot iron to the backing piece to ease the passage of the saw. Next the islands within the plan are pierced with a small drill bit to allow the fretsaw blade to be pushed through.

The Robinsons use a marquetry swing saw to cut out the design. The blade is operated by a foot treadle leaving both hands free to manipulate the work. A small bellows automatically blows away the sawdust from the point of contact, giving a clear view of the cutting line.

The cut marquetry is placed in a shallow tray of water for twenty-four hours to soften the glue and to allow the leaves to be carefully separated and the contrasts swapped. Gummed paper is placed over the individual leaves to hold the motif together until required. When applying a motif to a piece of furniture, impact adhesive is applied to the back of the marquetry and to the furniture and allowed to become tacky. The motif is now carefully laid on and rolled with a veneer hammer to get the best possible contact.

ABOVE AND BELOW RIGHT *The swing saw used to cut out the motifs leaves both hands free to guide the work.*

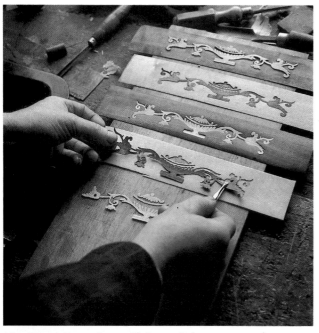

Matching and swapping motifs for applied marquetry; pale sycamore dark mahogany.

Contrary to what one might expect, the motif is not recessed. It is an optical illusion created by a groove cut around the 'lay on', which can be left open or made into a right-angled channel into which hot glue is introduced; a length of spindle wood stringing is inserted (inlaid) and rolled with a hot, wet roller.

The Robinsons use traditional motifs, graceful Grecian urns, the flowers of wild woodbines and convolvulus. Some are sand shaded – dipped in hot carborundum powder to scorch the piece – to add an additional contrast to the design.

Great secrecy has for generations surrounded the craft of marquetry. The Robinsons firmly believe in dispelling this mystery and in sharing their knowledge. Charles teaches at his local technical college so that this venerable and beautiful craft will continue in Co. Cavan at least.

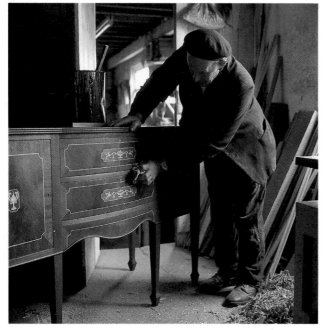

At least seven stages of polishing are needed to achieve a perfect finish.

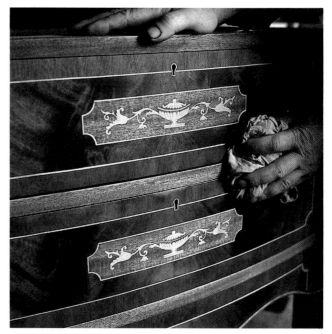

The marquetry or 'lay-on' has been framed by inlaid spindle wood stringing in this reproduction Regency sideboard.

STICKS

Cutting a blackthorn. The best sticks sprout from a pollarded crown.

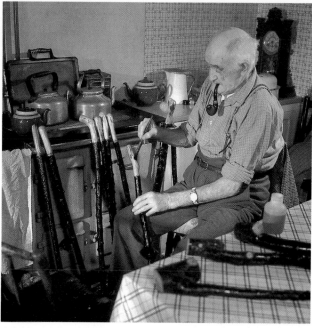

John James McCaffrey, Killyfana, Co. Cavan, adds the final coat of varnish to a blackthorn stick.

Blackthorn sticks and shilelaghs are as Irish as poteen and uilleann pipes. The blackthorn or sloe used as a hedging plant is one of the earliest of the flowering shrubs, its small misty blossoms first appearing in March. Sticks are normally cut in winter, leaving a knuckle at the top (near the crown) to fit snugly into the hand or a bit of a handle that can later be coaxed into the right shape.

When the spikes and small shoots have been removed a crooked stick needs to be corrected. After a few minutes in a steam pipe (longer would cause the bark to separate) to make it supple, it is placed in a former to straighten it. A simpler method is to lash the stick to a straight, stout, piece of timber and leave it in a warm place for a few days. It should then be left in a cooler place for a month or so to season properly. Some more work with a penknife, the luxury of a ferrule, a couple of coats of varnish and it is complete.

Shilelagh, a peaceful village in the heart of Wicklow countryside, gave its name to a stout club or cudgel formerly made from blackthorn and oak that surrounded the village.

The flail, or 'stick and a half', is now only rarely encountered. In living memory its use was widespread in country places where small fields of corn were grown to be cut and thrashed or flailed by hand for home use. The staff was commonly made of ash, a fine, flexible wood, and the souple or swingle of hazel or holly, a hard, heavy wood. At rest the swingle was nearly as long as the staff.

Flailing.

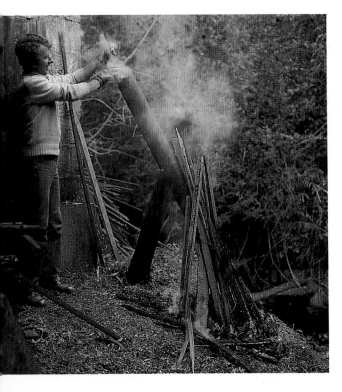

LAKE BOATS

Wooden boats have been used for thousands of years on Ireland's inland waterways. The dug-out canoe made from a single tree-trunk was constructed up to the mid-1600s and possibly later. Examples have also been found which can be dated back to the Bronze Age.

There are many different types of wooden boat still in use. The River Nore cot is a long narrow craft pointed at each end (which rides low in the water). It has a flat bottom with clinker-built sides (overlapping planks). Used for fishing, it can be paddled or poled and is perfectly adapted to negotiate the runs of fast-flowing water.

On the River Bann another type of cot is used to fish for eels. It is on average 5m (16 ft) long, with a beam about 1m (3 ft 6 in.), and is of carvel construction (planks laid side by side) with a square, chopped-off sloping bow, called a 'swim bow'. On the big eel fisheries it has been replaced by boats similar in design but made of steel.

On the great limestone lakes a fine clinker-built boat has been developed for angling which meets the often stormy conditions and short, steep waves of these vast bodies of water. The overall length varies but the average is 5.5m (18ft) with a larch keel and hull of overlapping larch planks. The ribs are of steamed oak and the stern and stem post are of teak. It is traditionally painted a pale grey colour. The oars pivot on thole pins and it is normally powered by an outboard motor.

On Lough Corrib a narrow 4.3m (14ft) boat is also found, called a Corrib punt. Like a slimmer version of its larger relative, it is designed for one person and is used by local professional fishermen especially in the early spring trolling for brown trout. Up to three lines are fished attached to simple hazel wands.

Thomas Philbin of Carrick, Clonbur, Co. Galway, is the third generation to make both these lake boats. They are ideally suited to drifting down over the long shallows dapping or fishing with a wet fly for trout and salmon.

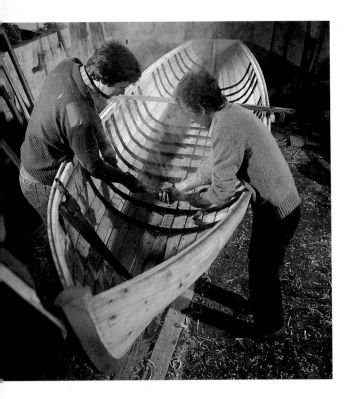

LEFT ABOVE *John Welsh putting laths of oak into a sealed metal pipe for steaming to make them flexible.* BELOW *Tom Philbin and John Welsh fitting the oak ribs into a 5.5 m larch clinker-built lake boat.*

OPPOSITE *The clinker construction of overlapping planks enables the boat to grip the water when drifting.*

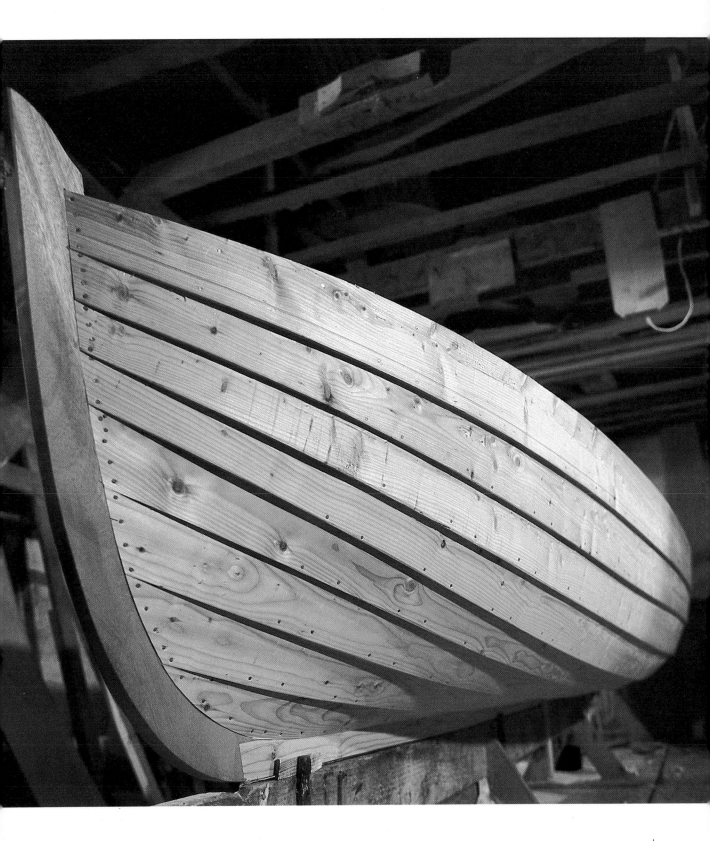

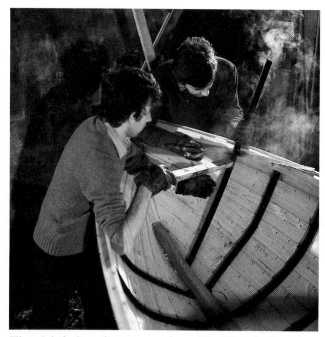

The oak laths from the steamer are hot and flexible and take on the contours of the hull.

The teak stern and stem post contrast with the copper-riveted larch planks.

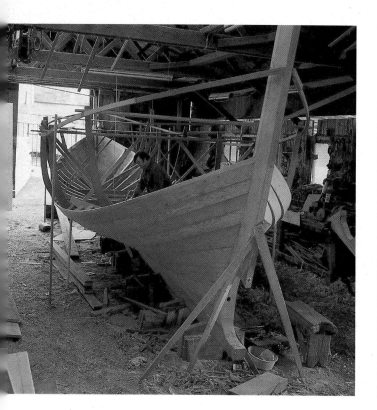

A descendent of the Greencastle Yawl under construction, reminiscent of the Viking longboat.

THE GREENCASTLE YAWL

The McDonald family have been established boatbuilders in Moville, Co. Donegal, since James McDonald founded the firm in 1750. Brian and his brothers Philip and Eamonn are the sixth generation to practise the craft. They make a variety of wooden boats. One in particular, a 10.4 m (34 ft) clinker-built inshore fishing boat, is of special interest. It has evolved from the old Greencastle Yawl, a close relative of a Norwegian fishing yawl, and in the early stages of its construction looks remarkably similar to a Viking longboat of the ninth century.

The Greencastle Yawl was a sailing, fishing boat of 8 m (26 ft) overall length. The mainmast was stepped amidships supporting a sprit-rigged mainsail and a long boom which extended out over the stern. A foremast stepped in the bows and a long bowsprit enabled a smaller gaff-rigged sail and jib to be used. This made it a very seaworthy and stable craft.

Today sail has given way to an inboard diesel engine and the size of the hull has increased. The basic construction remains the same: copper-riveted, clinker-built larch planking and ribs of oak. The boat is used for fishing lobster, crab and salmon around the hazardous Donegal coastline.

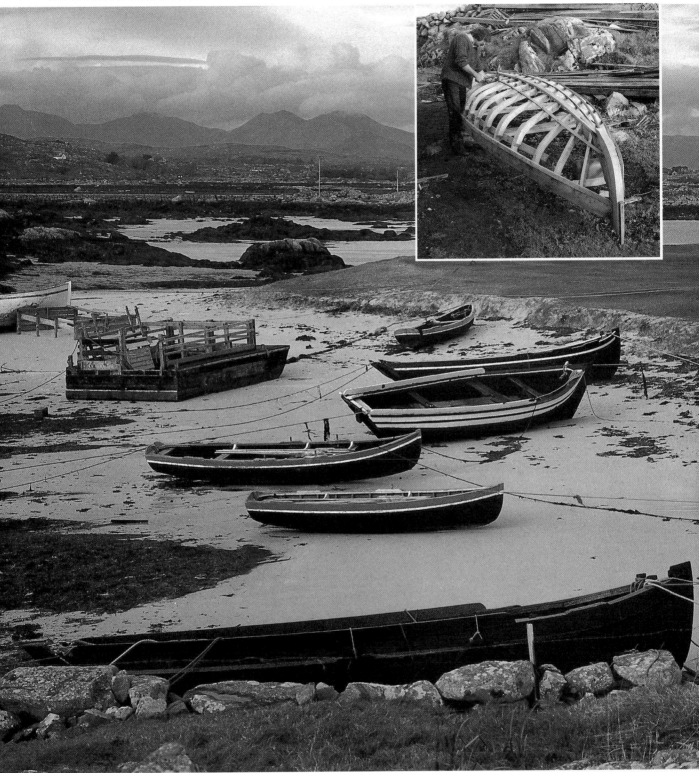

Local carvel-built fishing boats on the strand, Mweenish Island near Carna, Co. Galway.

(INSET) *the* Currach ámaid, *smallest of the carvel-built Connemara boats. Not to be confused with the skin- or canvas-covered craft.*

The adze, a very ancient tool, has long been used by shipwrights.

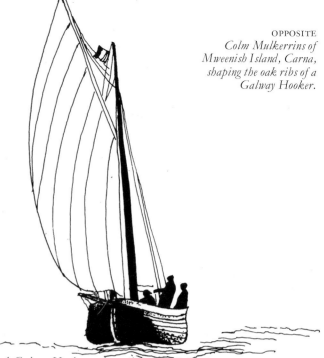

OPPOSITE
*Colm Mulkerrins of
Mweenish Island, Carna,
shaping the oak ribs of a
Galway Hooker.*

A Galway Hooker under sail.

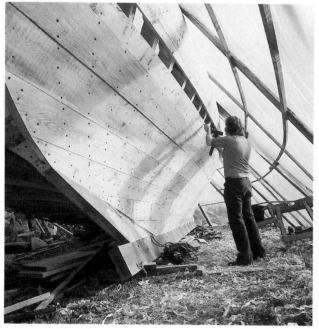

Countersinking galvanized nails. Timber laths and polythene form a modern protection from the weather.

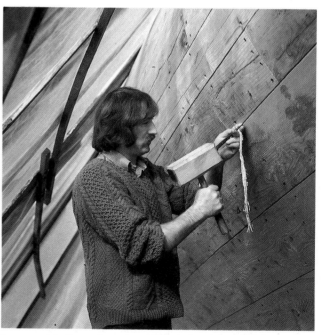

In a carvel-built vessel cotton caulking is forced into the joint and filled with red lead putty.

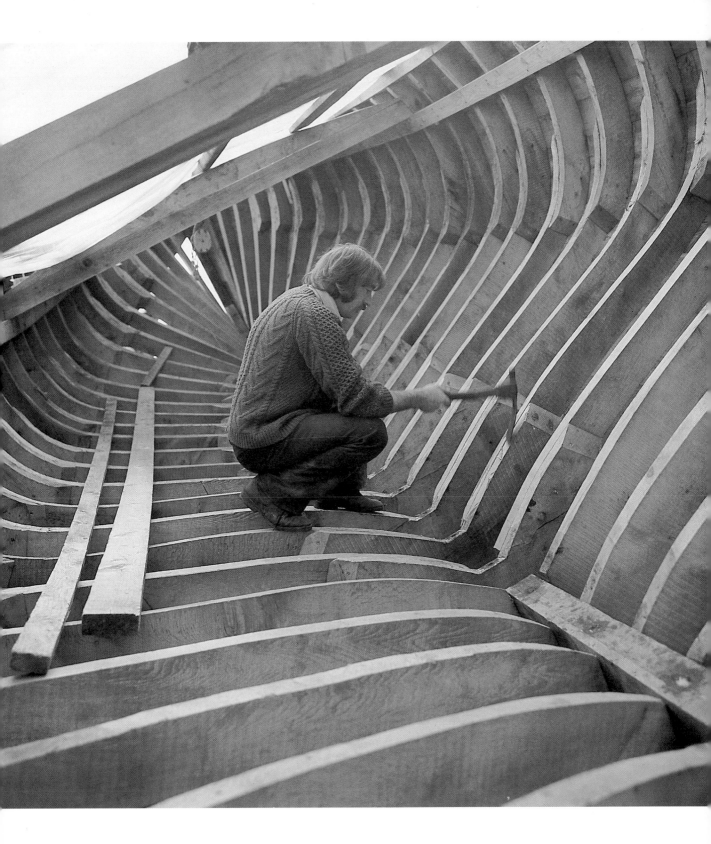

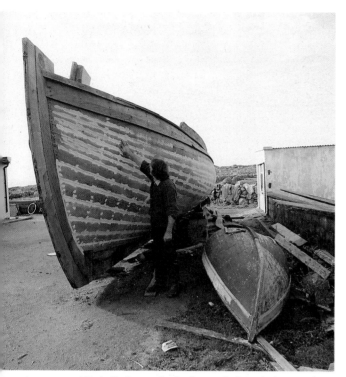

ABOVE *The hull of a smaller hooker ready for painting.*
BELOW *The completed hull of a Galway Hooker*

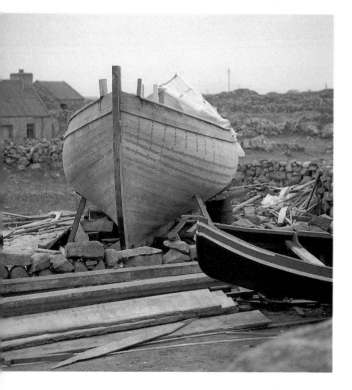

Along the Connemara coastline is made a family of carvel-constructed boats; they are robust and extremely seaworthy, and are used for fishing and transport.

The Galway Hooker is the largest of these boats at an average overall length of 11 m (36 ft), weighing between 7 and 15 tons. She is a half-decked, single-masted, gaff-rigged vessel with a bowsprit, carrying a large mainsail and jib. Originally a transport boat she has for two hundred years plied between the Aran Islands and the mainland principally shipping out turf for winter fuel and carrying back livestock. In the past, Galway Hookers made the long journey by way of Mizen Head in west Cork to the Channel Islands and France to smuggle back wine, brandy, tobacco, jute and other sought-after goods. No young man on the Aran Islands was much thought of unless he had made 'An turas go Geansa': the trip to Guernsey. Could this have been the origin of the Aran Jersey, the Guernsey or gansey?

The pedigree of many of these fine craft is well documented and some are believed to be at least two hundred years old. The Gleoiteog or yawl, a smaller version of the Galway Hooker with the same rig, is a half-decked fishing boat. The Trulight, built by a Mr Rainey, about 1922 at The Long Wall, Galway, is accepted as being a good example of her class with an overall length of 10.4 m (34 ft). Fine Gleoiteogs are also being made on the Errislannan Peninsula near Clifden. The Gleoiteogin or little yawl is the smaller lower-sided sister of the Gleoiteog, with an average keel length of 5.5 m.

The fourth craft in the family, the Púcán, is an open boat with an average keel length of 5.5 m (18 ft); low-sided, she does not exceed 5 tons. She uses the triangular settee or lateen sail of Mediterranean origin. Instead of a gaff the top of the sail is attached to a cleith or club, a spar, connected at its centre point to a halyard which runs through a block at the head of the main mast.

The carvel-built wooden currach, Currach ámaid, is used inshore for lobstering and as a means of transport to nearby islands on expeditions to cut seaweed and collect shellfish.

The Caseys were a well-known family of boatbuilders in the Carna area of Co. Galway and today on Mweenish Island the Cloherties and the Mulkerrins, their cousins, are the principal shipwrights.

Colm Mulkerrins is completing what is reputed to be the largest Galway Hooker since 1911. At 12 m (39 ft 4 in.) long she will draw 2 m (6 ft 6 in.). Construction methods are still very traditional and tools like the adze much in evidence. No elaborate plans are made; the hull is carefully and skilfully built with the use of wooden templates to achieve the correct lines. The planks, lying side-by-side, are caulked with cotton which is forced into the joints with a wooden mallet and punch; a filling is added of a mixture of red lead, paint and putty, and painted over.

CURRACHS Kevin Danaher

Ireland was an island long before human habitation. It had to be reached by crossing the sea, and even the very first people who arrived must already have had considerable expertise in the building and handling of sea-going craft. Later, perhaps five thousand years ago, came the Neolithic farmers, bringing with them over the sea large animals, cows, sheep, goats, pigs and horses, and from this time onwards there is abundant evidence of trade, travel and fishing, all indicating skill and knowledge in the making and handling of ships and boats.

As well as many hundreds of miles of sea coast, full of inlets, harbours and strands, Ireland also has long, deep, slow-flowing rivers leading into the heart of the country – the Shannon, the Erne, the Barrow-Nore-Suir system, the Blackwater, the Bann and many more – all eminently suitable for trade and travel by boat.

With so ancient and so essential a mastery of water transport it is not surprising to find an equally ancient and equally sophisticated mastery of boatbuilding. In every sea inlet and harbour and up every navigable river and lake were to be found handsome and useful boats of dozens of different types, all perfectly tailored to suit local conditions. Most of these were plank-built approximations to conventional types, but, up to recently, there were other, fundamentally different types to be found in Irish water.

There were dug-out boats – literally carved from the solid tree-trunk by axe, adze and chisel; these did not survive the destruction of the woods in the seventeenth and eighteenth centuries – with no more giant trees there were no more dug-out boats. An odd and quite different type is the *cliath thulcha*, the reed-raft boat of which the memory survives along the middle Shannon. A third type, which is still made and used, is the skin-boat, consisting of a light framework with a skin of thin material stretched over it. These are or until recently were in use in several areas of North America, Asia and Europe. Their making is a tradition of such immense antiquity that there is no certainty as to how or when they originated, but they probably date from the waning Ice Age of the Upper Palaeolithic, some twenty thousand years ago. The cave painters of Altamira and Lascaux may have known and used them. And it is an astounding fact that boats of this kind, made by methods and of materials familiar to the Stone Age, were still used by the salmon fishers on the River Boyne up to a few years ago and that there are, indeed, people still alive who could make and use them.

These were very simple craft, merely a wicker basket with a hide stretched over it, but they were made with great skill and care by experts in whose families the craft had come down for long centuries. A few of the good old make still survive, and when we examine them we can only wonder at their combination of simplicity and competence. The builder first marked out an oval 1.8 m (6 ft) long and 1.4 m (4½ ft) wide on the ground with a piece of string and a couple of sticks. Next he took thirty-two hazel rods 3 m (10 ft) or more in length and stuck these firmly into the ground at equal intervals all around the oval. Then he wove strong rods through these along the surface of the ground so that they were all held in a band of wickerwork. Next the long rods were bent over to meet and be bound side by side in pairs to form strong double ribs; eight from one side to meet eight from the other, and seven to meet seven from each end, while the two remaining rods gave strength at the ends. This frame was weighted down with stones so placed as to give the true form needed, and left for several days to set, and when the desired shape was fixed all the crossing points in the ribs were tied securely with strong twine.

Up to this stage an onlooker might well imagine that the builder was making some outsize type of basket, but the next move would both clear his doubts and add to his puzzlement, for the framework was pulled from the ground and covered with the tanned skin of a large cow or bullock. The hide was made soft and pliable by a good soaking in water, stretched tightly over the 'basket' and laced all around the edge with strong twine. Then, after some trimming and tightening, a seat was put in place and the currach was ready for launching. Usually two men worked it in the water, one kneeling in front and wielding a paddle while the other sat on the seat facing backwards and

handling the net. For an unskilled person the Boyne currach was even more unmanageable than other kinds of boats, but the local fishermen handled them with such skilful ease that it all looked very simple until you tried your hand at it and one of the fishermen had to come to your rescue.

The history of these currachs is as old as that of Ireland itself; the earliest writings to have come down to us are full of references to them. Strange warriors come in them from distant lands. Sinners are required to launch out in a currach made of one hide and let themselves drift at the mercy of God, and saints set forth in them to seek the solitude of lonely islands or to bring the gospel to the heathens. Some of them were much larger than the little Boyne craft; we read that the hero Tadhg Mac Céin built a great currach which had twenty-five seats and was covered with forty hides, and that St Brendan made a voyage in a currach which carried ten people with forty days' provisions.

That the knowledge and use of such large wicker, skin-covered boats continued down to much more recent times we know from the account of the retreat of O'Sullivan Beare in 1602. The harried lord of Bearehaven and his little band of fugitives were cut off by the Shannon near Portumna and escaped across the river by killing their horses and making two hide-covered currachs, one small, like the Boyne currachs and the other 8 m long and 1.8 m wide (26 ft × 6 ft). The man who directed the making of the big boat was O'Sullivan Beare's brother Dermot, and it was Dermot's son, Don Phillip, who wrote a full account of the affair, in which he describes the method used – marking out the outline on the ground by the currach makers of Oldbridge on the Boyne in the present century.

Along the west coast of Ireland from Sheep Haven in north Donegal to Kenmare Bay in south Kerry skin-boats or currachs are still in practical use. These differ from the Boyne coracles in being of conventional boat shape, long with pointed bow and propelled by oars. There is one paddle currach, a short, stubby craft, used in a few sheltered harbours in north Donegal, but most are well shaped boats, fast, easily handled and very seaworthy. Round-bottomed and keelless they glide over the water rather than cut through it. Very supple, they give easily in broken water and will

THE BOYNE CURRACH

An oval is marked out on the ground with a piece of string and a couple of sticks. Then hazel rods are stuck into the oval and strong rods woven round the circumference to form a bank of wickerwork.

The long rods are bent over and secured with twine, forming strong ribs. The result resembles an oversized basket.

The tanned hide of a cow or bullock, made pliable by soaking, is stretched tightly over the 'basket' and tied with twine. The seat is for the man handling the net, facing backwards; his companion kneels in the front and wields the paddle.

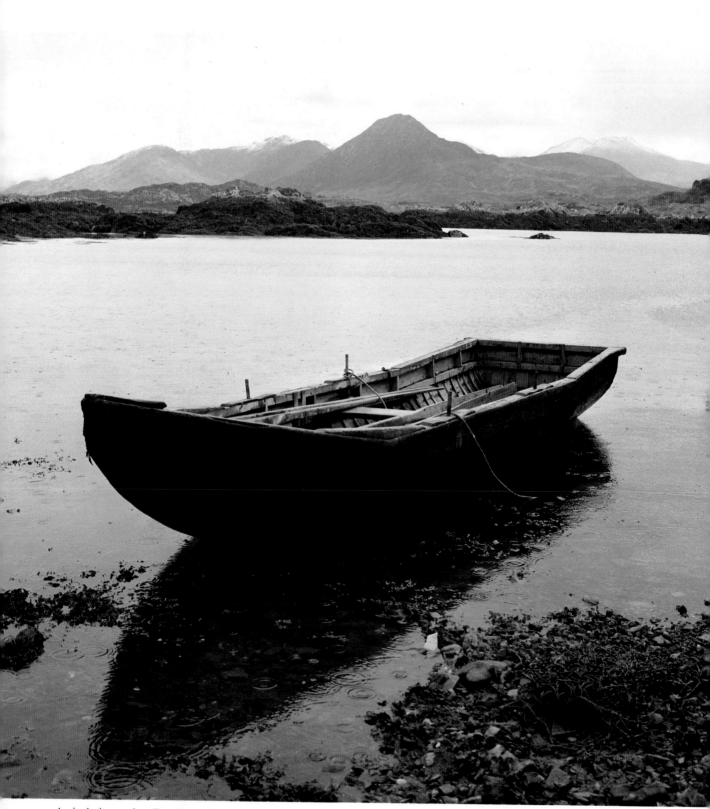

A planked currach at Derryinver, Letterfrack, Co. Galway. The upward rake of the bow is less extreme than that of the Aran currach; the boat is also wider and the stern cut squarer making it more suitable for casting nets. In the background is Diamond Hill with the peaks of the Twelve Pins beyond it.

survive the most violent sea. They are, of course, very vulnerable; the least touch of a sharp rock or a pointed drifting spar can hole them.

Traditions from the past and a few descriptions written down a century or more ago leave no doubt that the sea-going currachs of the west coast were formerly covered with animal skins, usually cowhides, and that the canvas or calico now used to cover the currachs is a recent substitute. In the same way, the framework of hazel rods is known to have been used, in some cases until quite recently, along the west coast. Nowadays, however, the framework is always of wooden laths and the covering is tarred cloth in all the different types from the paddle currachs of north Donegal, which are about 2.4 m long and 1.1 m wide (8 ft × 3½ ft) to the finest of all boats of this kind, the *naevóg* of the Dingle Peninsula.

Curiously enough there is no old tradition of currachs around Dingle, and we are told by Tomás Crohan in his book *An tOileánach*, which has been put into English under the title *The Islandman*, that only wooden boats were used in his early days, and that he well remembered seeing the first currach to come to the district and marvelling at it. This recent introduction, and the necessity of starting a local trade in *naevóg* making, may be part of the reason why the craft reached such a pitch of perfection here, for there is no denying that the *naevóga* of the Dingle Peninsula are not only the best and most seaworthy of all, but also the most carefully made and finely finished, the best proportioned and the most elegant looking.

They are usually 8 m long and 1.4 m wide (26 ft × 4½ ft) in the middle but ride so lightly on the water that a depth of two feet from the level of the gunwale to that of the bottom is sufficient to keep them well clear. There are no ugly angles anywhere, everything is smoothly curved; the stern narrows to a little transom and the bow rises high out of the water. There are four seats for four oarsmen, each of them pulling a pair of oars, and like nearly all currachs of the western Irish coast, the oarblades are no wider than the shafts, about 6.4 cm (2½ in.) wide for an oar length of 3.4 m (11 ft). These oars are not 'feathered' when rowing; they pivot on a single pin which passes through a hole in a boss of wood attached to the back of the oar.

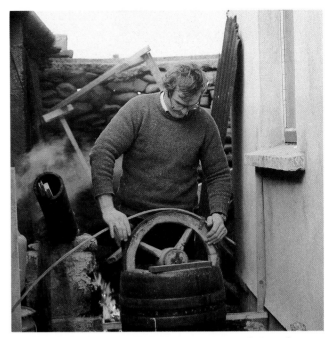

Monty O'Leary bending a lath of ash, hot and flexible from the stem pipe, over an old barrow wheel. It will set in a curve when cool.

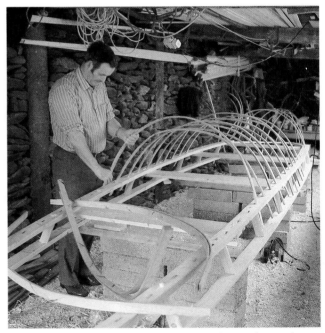

Monty's father Michael O'Leary fitting ash ribs into slots on the second gunnel.

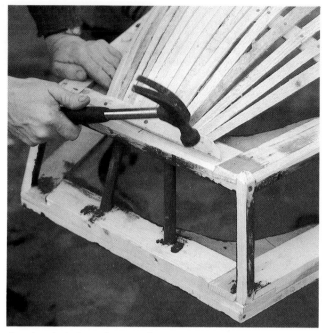

Securing the laths at the stern of a canoe.

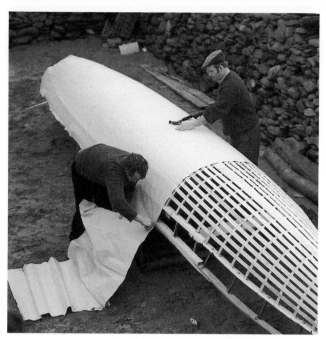

Michael and Monty O'Leary measuring and fitting the canvas to a 7.62 m, four-hand canoe. The canvas will be removed and the seams sewn before being tacked to the frame and tarred.

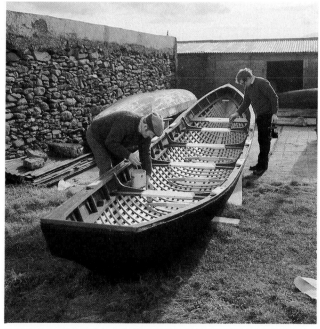

Touching up the inside of a completed Kerry canoe or naevóg.

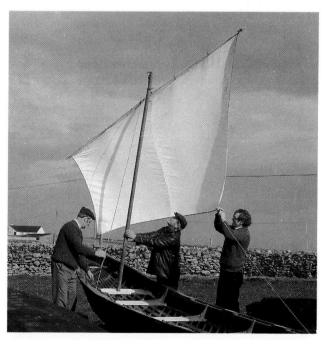

The O'Learys and Michael Spillane, a neighbour, check the rig of a traditional lugsail. Two leeboards will enable the canoe to tack tolerably well into the wind.

James McGonigle and his son James, formerly of Owey Island, in a Donegal paddled currach: a close relative of the extinct River Boyne currach.

A currach being taken down to the sea on Inishmaan, one of the Aran Islands. On land, currachs have to be inverted and carried for fear of damaging their vulnerable tarred surface.

A two-handed naevóg *at Fahamore, on the Dingle Peninsula, bringing sheep out to the Magharee Islands.*

A bullock on its way to the Naomh Éanna.

OPPOSITE *The currach is an integral part of life on the Aran Islands, ferrying produce to and from larger boats. For one of the big social occasions of the year the cattle are shipped to the mainland; first they have to be swum out to the waiting vessel tethered to the back of a currach.*

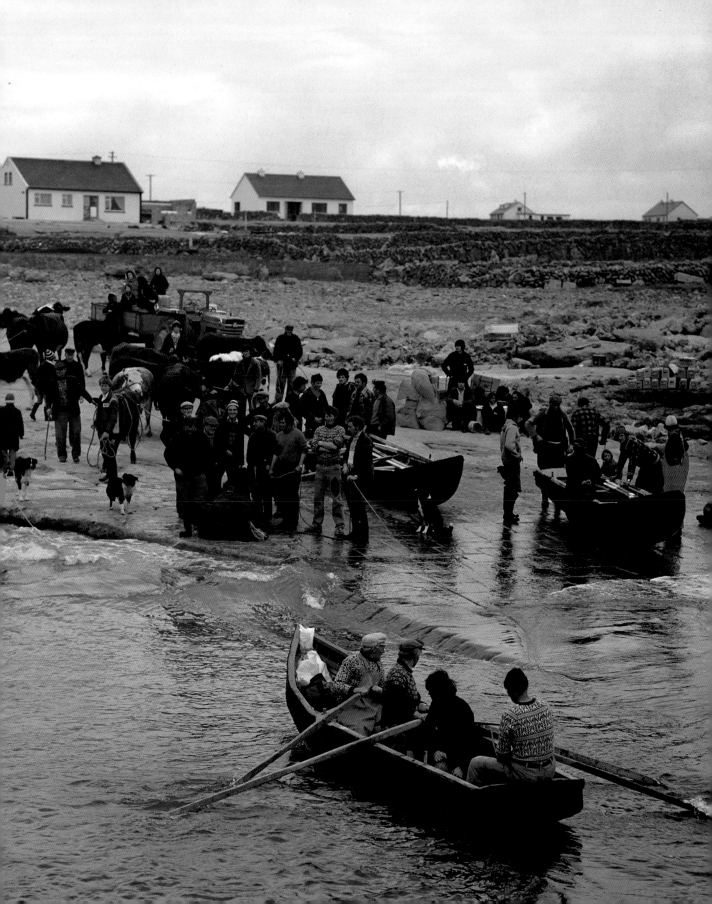

The Dingle *naevóga* differ from most others in that they are fitted with a mast and sail which are used when the wind is favourable.

Sad to say, the use of the currach is diminishing. There are now only about a tenth of the number recorded at the beginning of this century and it is doubtful whether our grandchildren will see any in use. With their demise the craft of building them also dies.

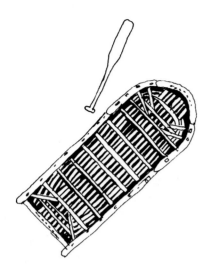

The Donegal paddled currach, a close relative of the River Boyne currach, is still used to set lobster pots and tend fixed 'trammel' nets.

The currach found on the Aran Islands has a high rake to the bow; it is not as well finished as the Kerry naevóg *owing to a lack of suitable material, but is very seaworthy.*

The Kerry naevóg, *queen of the skin- or canvas-covered boats, is the largest built today, being usually some 8 m (26 ft) long and 1.4 m (4½ ft) wide.*

UILLEANN PIPES

The Irish uilleann pipes are by far the most sophisticated member of the bagpipe family and offer the greatest scope for the piper. Considered to be a parlour instrument, they are played in a sitting or fixed position and receive their air supply by way of a bellows rather than directly by mouth. They first appeared at the beginning of the eighteenth century; refinements were made and by the mid-nineteenth century they had broadly speaking reached their present form.

A full set of uilleann pipes comprises bellows, bag, chanter, a set of three drones and three regulators all mounted in a common stock. The chanter executes the melody and receives its air supply through a metal sleeve inserted into the top of the bag. It has a double reed and a conical bore which enables it to pass with ease into the second octave when either stopped or sealed on the popping strap, a piece of leather strapped to the knee.

The three drones – tenor, baritone and bass – play fixed notes and have a straight or stepped bore. Each has one single reed or quill. The tenor and baritone drones are made in two sections, which allows for limited tuning. The bass drone is approximately 1.2 m (4 ft) in length for concert D pitch; in the interests of compactness and to facilitate tuning, this drone is bent back on itself twice.

The three regulators are basically closed chanters lined up with one another in such a way as to allow the piper to play chords. They have a conical bore and a double reed and sets of keys instead of open finger-holes.

The drones and two of the regulators are plugged into the bottom of the stock, which acts as a common support and enters the bag in an airtight junction. The bass regulator receives its air supply through the side wall of the stock and is firmly attached with a brass plate sealed with a rubber or leather gasket.

The word uilleann, from the Irish word uillinn or elbow, is probably a corruption of the name 'union', which is traditionally believed to have been given to the pipes just before 1790, when the first regulator was added. It was the 'union' of tenor regulator and chanter matched in unison that created the name.

Eugene Lambe began playing the pipes when he was ten years of age and made his first practice set of uilleann pipes when he was sixteen. A marine biologist and botanist, he now lives and works as a full-time uilleann pipe maker in the old schoolhouse at Fanore, Co. Clare, an area where traditional music has always been strong.

In making a full set of uilleann pipes the bag and bellows are made first to enable chanter, drones and regulators to be tested.

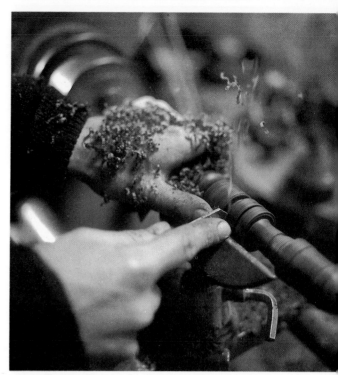

ABOVE *Turning the body of a chanter in African blackwood.*
BELOW *Eugene Lambe fitting a key to a regulator.*

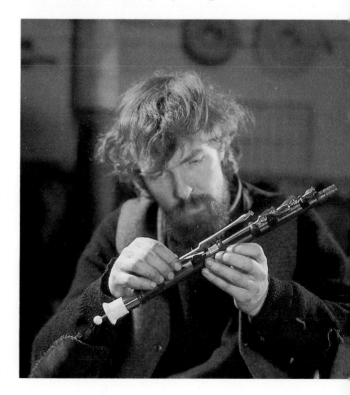

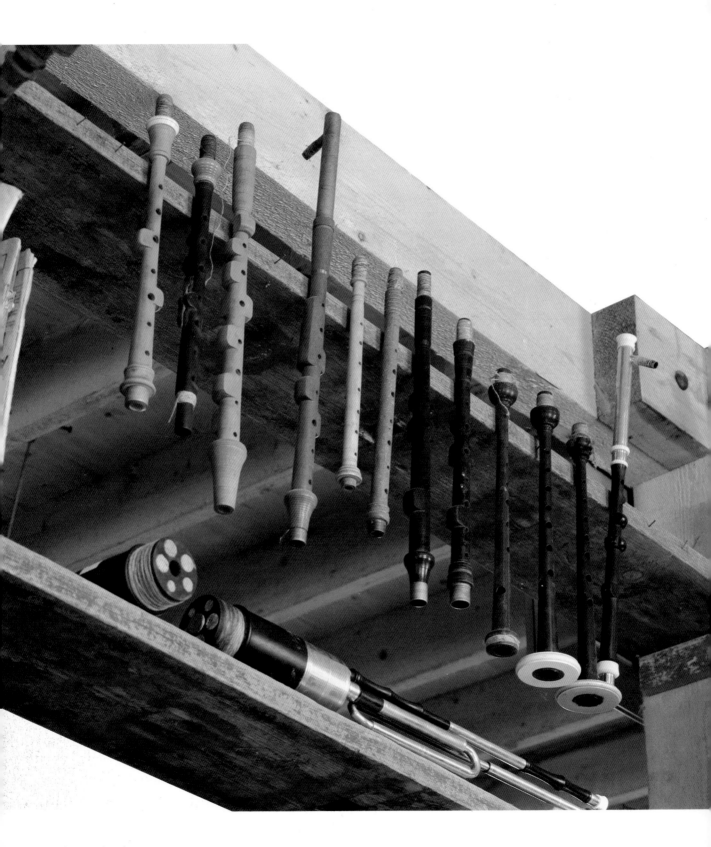

The bag was formerly made from basel, a type of sheepskin. Today vulcanized rubber is used, not because it is cheaper, but because it is easier to make airtight. A length of rubber hose pipe (concealed) links bellows to blowstick and bag, incorporating a 'clack' or non-return valve in the blowstick.

The bag is covered with a traditional green, hand-woven, warp-faced tweed that will not slip under the piper's arm. The boards or cheeks of the bellows are made from native elm, but beech or mahogany serve equally well. An air intake valve is incorporated into one of the boards. The sides are of leather.

The stock is made next. The favoured woods are African blackwood (lignum vitae) or ebony, which are also used for the chanter and other pipes. It is turned on the lathe and has five holes drilled through it with a sixth in the side wall for the bass regulator. A fine brass rod also passes through the centre of the stock attached to a valve which can shut off the air supply. The chanter, drones and regulators are likewise turned. To achieve the conical bore of the chanter and regulators the centres must be carefully drilled out using sets of tapered reamers. Tradition has it that this was first achieved towards the end of the eighteenth century by using a French musket bayonet.

Ivory or ivory substitute is used for the mounts and brass for ferrules, the latter made on a metal-turning lathe; they help to protect the ends of the pipes and reinforce joints. Key blocks on the chanter and regulators are turned as a circular bead and later trimmed and shaped by hand to receive the keys which, if they are not cut out and filed by hand, are cast.

Though it is not necessary for a piper to make his own set of uilleann pipes, a knowledge of reed making is to be thoroughly recommended. Spanish cane (arundo donax) and a few simple tools are all that is required.

ABOVE *A line of completed bellows.*
BELOW *Eugene Lambe fitting a double reed into the chanter.*

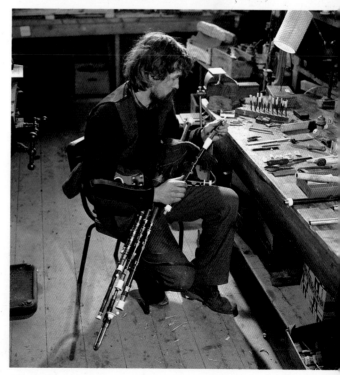

Drones, regulators and chanters awaiting completion. On the lower shelf are two stocks into which the drones and regulators fit.

A section of Spanish cane is cut for the chanter reed and the ends trimmed to a point. The section is then cut to form two matching halves.

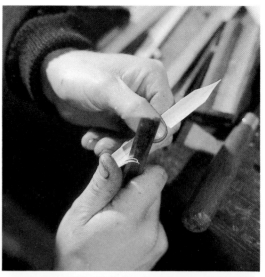

The pointed ends are bound to a copper sleeve with waxed thread, and the reed is fined down with a razor.

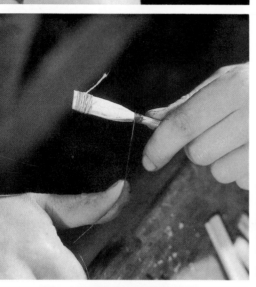
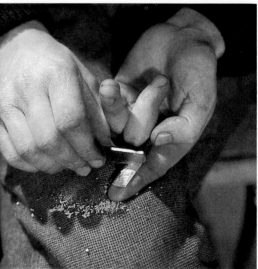

Completed reeds. Quills, single-tongued reeds for the drones, with a slit in their sides.

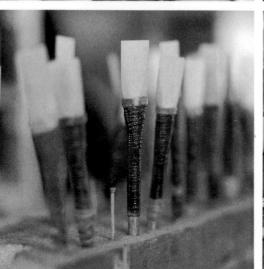

VIOLINS

Violin makers today still base their designs on the magnificent instruments made in the seventeenth and eighteenth centuries by Italian craftsmen such as Stradivari and Amati. A mould or form of the original is cut in plywood using an aluminium template. Various timbers are used, classified as hard (maple) or soft (spruce), in the proportions found by the old masters to be the best.

Six maple ribs are cut and planed to the correct thickness of 8 mm ($\frac{1}{32}$ in.) and six small pieces of willow are carved which will reinforce the corners and both ends. These are glued and clamped around the edges of the mould and strengthened with linings, strips of wood around the inside, top and bottom of the ribs. The back is now marked out and cut to the correct size. This is made up of two matching sections of maple glued together to form a mirror image, so that the grain is similar on both sides. In order to attain the gentle characteristic arch, the back has to be shaped with gouges, thumb planes and ticketers (scrapers). Two channels are cut close to the overlapping edge to allow the 'purfling', a stringing of two outside layers of fibre with a centre layer of wood, to be inserted and glued into them. The purfling is decorative but also prevents small cracks running from the outside edge of the back into the centre. The back is then stuck to the ribs.

The belly (front) of the violin is made in the same manner except that the timber is a close-grained spruce, a soft wood. The two 'f' holes are carefully marked out and cut through; they allow the sound to escape and free more vibrating surfaces. A strip of spruce which runs the full length of the belly is stuck underneath, slightly off centre, positioned exactly under the left foot of the bridge. Its function is to relieve the pressure from the strings and spread the vibrations. It balances the sound-post which is inserted after the box is completed. Once the belly has been glued to the ribs and back, the body is complete. Work can begin on the maple neck which also incorporates the pegbox and a decorative fluted scroll. It will be fitted and glued into a mitred joint at the top of the box.

Up to twelve coats of varnish are applied to give the violin its rich finish; it enhances the tone and brings up and protects the full colour and beauty of the wood.

The sound-post, a small peg of wood, is inserted through one of the gaps in the 'f' holes; it is held in place by tension alone. Besides strengthening the instrument the sound-post transmits the vibrations from the belly directly to the back.

The final assembly, called 'fitting up', involves the mounting and glueing of the fingerboard and nut to the neck, the fitting of the four pegs and tailpiece, as well as stringing and testing.

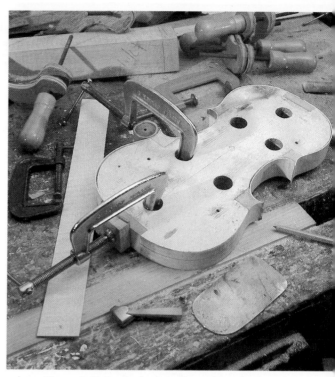

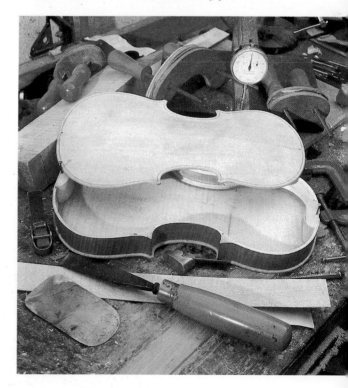

ABOVE *Clamps hold the ribs firmly to the mould as the glue is setting.* BELOW *Violin under construction by John Nash.*

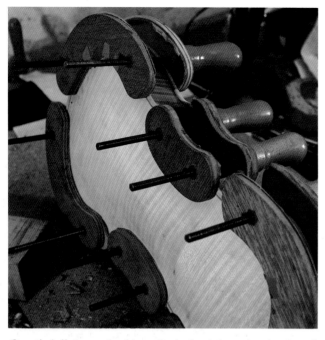

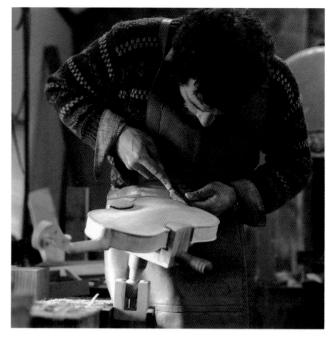

Once the belly is completed it can be glued and clamped to the ribs and back, which are already assembled. The name of the maker and date will have been placed inside.

Violin maker Garry O'Brian of New Quay, Co. Clare. The instrument is held in an ingenious clamp, complete with universal ball joint, invented by Arthur Grayson.

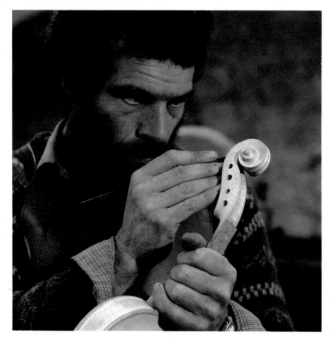

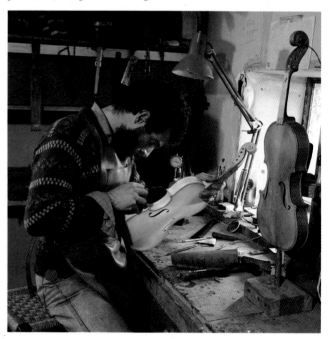

Filing the maple scroll of an instrument.

Garry O'Brian, who is also a noted traditional fiddler, attended the violin making course at the Municipal School of Music, Limerick.

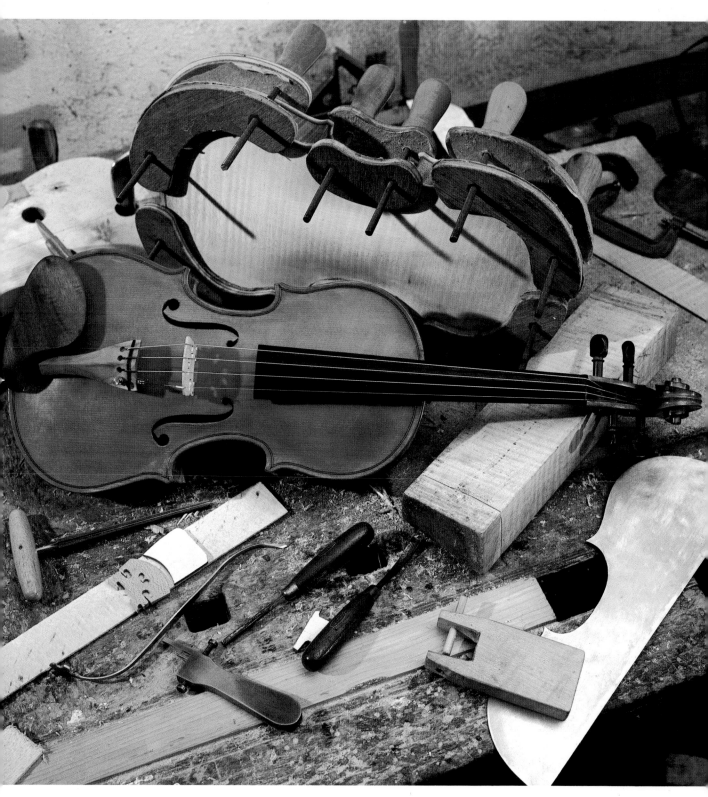

A violin by John Nash after the 'Messiah' Stradivari in the Ashmolean Museum, Oxford.

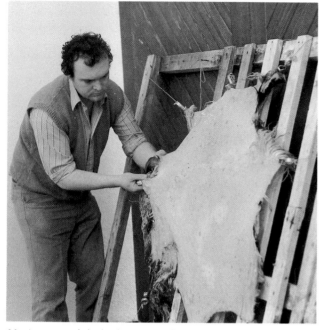

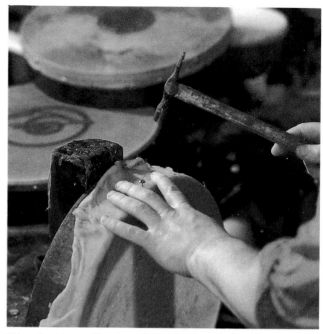

Having removed the fat from a goatskin with a scraper, Malachi Kearns stretches it on a rack where it will remain for two to three days.

When the skin is still moist and pliable it is tacked to a beechwood rim.

The origin of the frame drum known as the bodhrán is obscure. It is thought to date from pagan times, but in more recent years it has become associated with the 'wren boys', an old custom whereby on St Stephen's day a wren is captured and paraded from house to house, accompanied by music.

Malachi Kearns, who lives and works in Roundstone, Co. Galway, is respected as a fine bodhrán maker. The most favoured and common skins he uses are goat and deer; greyhound and donkey hide are also good. The skins are cured in hydrated lime mixed with ingredients that are the close secret of every bodhrán maker; cured thus, they will keep indefinitely. They are then soaked for seven to ten days in a solution of lime sulphide, which softens the skin and partially dissolves the fatty tissue so that fat and hair can be easily removed with a scraper.

After the skin has been stretched on a frame for two to three days and scraped further, a portion of it is removed and tacked under tension onto the beechwood frame of the bodhrán using brass upholstery nails. As an added precaution it is also glued. Next the cross-pieces are fitted. The beater can be turned from holly, oak, beech and even larch.

In the hands of a skilled player it can be a subtle and exciting instrument. The skin is struck in a variety of ways, even using the heel of the hand and fingers; the hand supporting the instrument, tucked in behind the cross-piece, varies the colour and intensity of the sound by pressing on the skin. The side of the beater is also used to good effect on the wooden rim.

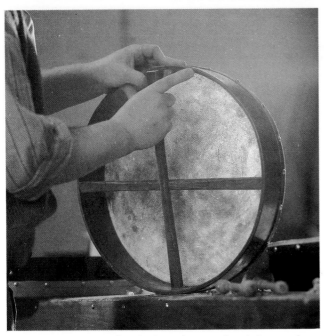

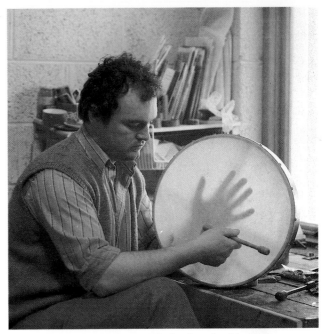

Two cross-pieces strengthen the rim and prevent it twisting out of true. They also make the instrument easier to hold.

Testing a completed bodhrán. The hand is placed inside the cross-piece and is used to vary the tone.

LAMBEGS

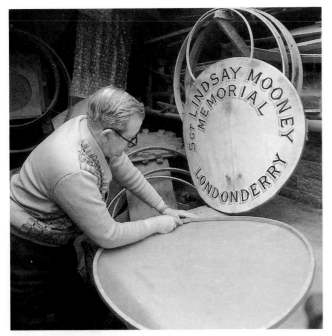

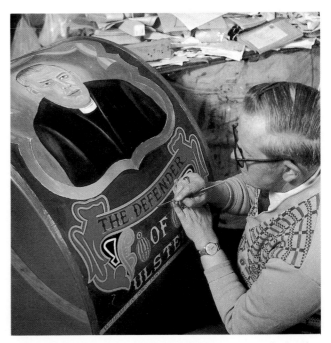

The lambeg, the traditional 'big drum' associated with the parades of 12 July, Orangemen's Day commemorating the Battle of the Boyne (1690) and the defeat of James II by William, Prince of Orange.

William Hewitt of Charles St South, Belfast, carries on the family business begun in 1870 by his grandfather. The portrait is of the Rev. Ian Paisley.

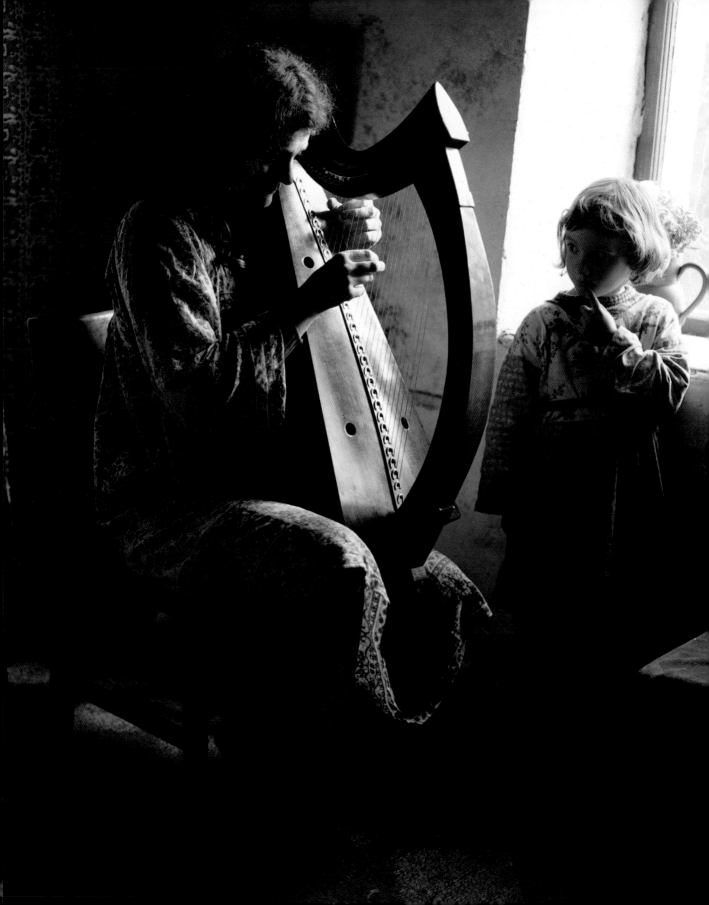

The challenge of researching and making a facsimile of the Irish low-headed harp and of understanding the ancient harpwright's craft becomes a tuning in of one craftsman to another across a great span of time. Fine historical examples of the Irish harp have survived to this day and I have based my design on the 'Brian Boru' harp in the library of Trinity College, Dublin.

When I first strung and played my copy of this beautiful fourteenth-century harp, with its 'dug out' willow soundbox, its taut sculpted form, I realized that encoded in the unique design principles of this small instrument, which was famous throughout Europe in the Middle Ages, was the key to a forgotten sound; its extraordinary bell-like notes alone seemed to justify the claims in the old stories that in the hand of a harper it could create laughter, tears and deep dreaming.

The earliest reference we have to the harp occurs in an account of a battle between the Tuatha De Danaan and the Fomorians fought about 1800 BC; it is described both as the 'durdable', meaning 'the murmur of the sweet apple tree', and 'coircethairchur', a word signifying something having four angles. So it seems that at this stage we had a quadrangular harp with a sweet sound and with as few strings as six or even three.

Quadrangular harp from the tenth-century granite north cross, Castledermot.

In an old manuscript it is related how in c. 541 BC the harp player Craftine, wishing to replace his damaged harp, found a willow tree from which to construct a new one. This was the timber that was used right up to the eighteenth century.

On each of the granite north and south high crosses in Castledermot, Co. Kildare (tenth century AD), can be seen a seated figure playing what appears to be a six-stringed quadrangular harp, though the slightly curved part of the instrument faces towards him. Unmistakable, however, is the triangular harp played by a bearded figure, from a bronze relief on the eleventh-century book shrine Breac Maodhóg.

The triangular harp seems to have been an Irish innovation, appearing as early as the ninth century. By the eleventh century its basic form was firmly established and was to remain little changed for six hundred years.

Dante (*b.* 1265) tells us that the harp was taken to Italy from Ireland, 'where they are excellently made and in great numbers, the inhabitants of that island having practised upon it for many, many ages; nay, they even place it in the arms of the kingdom and paint it on their public buildings and stamp it on their coin'.

In the seventeenth century the old Irish harp and the life style of the harper underwent a radical transformation as a result of political events and changing musical fashions. Previously 'low-headed', the harp became 'high-headed', allowing longer strings in the bass which facilitated the lower tuning necessary for the harmonic progressions of the Baroque.

This alteration produced too great a discrepancy of timbre between bass and treble, and to compensate the box was deepened in the treble and made shallower in the base. These changes had two effects: the characteristic bell-like sound was lost and the basic pitch, or fundamental, of the notes vibrated for longer. This in turn meant that the harper had to develop the difficult technique of damping the strings to avoid note clashes which were anathema to the new laws of harmony. (This would have been much less of a problem before, because the design of the low-headed harp caused the fundamental to quickly resolve into harmonics which blend easily with each other in a gong-like drone above the melody.)

Finally the problem was 'solved' by changing to high-twist gut strings, giving short-lived notes. These low-tension strings required a lighter frame and along with the eventual introduction of mechanical semitone systems, the break with the past was complete and the so-called neo-Irish harp established by the end of the nineteenth century.

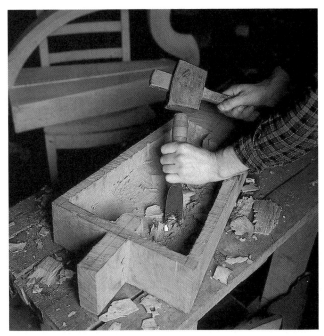

Hollowing out the solid willow sound-box with a gouge.

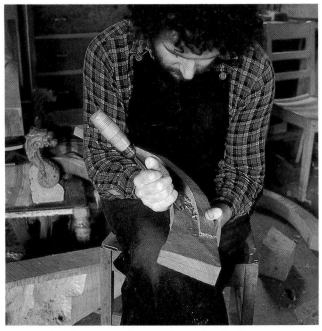

Carving the 'T' section of the forepillar with a chisel.

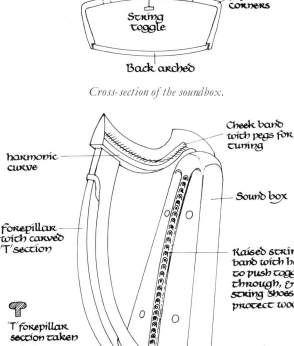

The old Irish harps that have survived have done so because they were important and treasured objects commissioned by kings and chieftains. The harpers themselves occupied a privileged position in society and their instruments were expected to reflect the great value accorded the music they played. It is probable that undecorated instruments abounded, humbler but with the same basic design.

Construction

The soundbox of the harp was invariably hollowed out of a solid block of wood, with a separate board, said to have been made of bog pine, rebated into the back. Four soundholes were cut in the front and there was a raised band of wood down the centre through which holes for the strings were drilled.

The reason for these carved single-piece boxes was not simply the lack of efficient glue. Modern harp boxes are made with laminates, the spruce or pine front acting as resonator, the separate pieces

Stringboard

Top arched

Front soundhole

Flexible corners

String toggle

Back arched

Cross-section of the soundbox.

Cheek band with pegs for tuning

harmonic curve

Sound box

forepillar with carved 'T' section

Raised string band with holes to push toggles through, & string 'shoes' to protect wood

'T' forepillar section taken at centre

Construction of the harp.

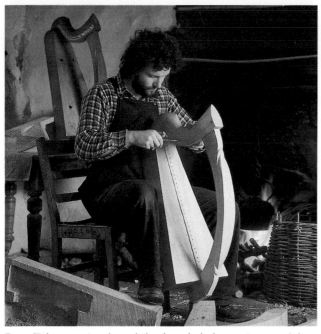

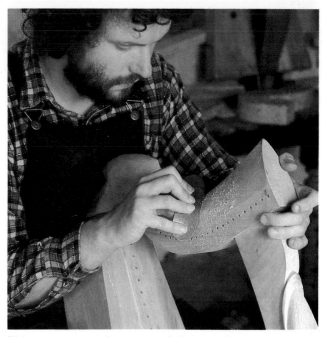

Peter Kilroy reaming the pegholes through the harmonic curve of the low-headed harp.

Using a scraper or ticketer to smooth the harmonic curve.

being glued with rigid joins which 'lock' the corners and prevent it vibrating as a living unit. Spruce and pine are the best woods for sound but are very frail under high stress; photomicrographs show that the cells are round, regular and loose-knit. Willow, on the other hand, has a tightly woven cellular structure which makes it both resilient enough to withstand constant stress and, at the same time, sufficiently light to vibrate easily. This explains how it was possible in 1961 to partially re-string and play the famous Brian Boru harp after six centuries.

My own research and clear evidence from the harps themselves show that the willow front and sides of a one-piece box accommodate the enormous string tension in the following way. The soundboard rises to an arch about 1 inch from the flat. To compensate for this the sides press inwards towards the back and hold the separate pine backboard in a vice-like grip, causing it also to arch slightly. The tension loading is thus spread evenly throughout the box, achieving structural equilibrium. This means that when the instrument is strung, in order to facilitate the replacement of a single string the front has a series of large holes through which is pushed or pulled a toggle which retains the string.

Ancient stories tell of harps strung with gold. It seems probable that this refers to the 'yellow copper' similar to certain types of modern brass. Red copper or bronze may also have been used.

Briefly, the tough willow wood acts as a 'conductor' of vibration to the pine backboard, which being itself unhampered by strings 'pumps' the sound back through the front soundholes, having enhanced it by virtue of its own highly resonant cellular make-up. Thus we have in the old Irish harp a unique and sophisticated concept of soundbox design which can not only carry the thick brass strings referred to in ancient manuscripts but which actually requires their high tension in order to work at all.

The practical advantage of all this to the harper was that his instrument had a sonorous and brilliant tone; it stayed in tune far longer than a modern harp does; and a wide dynamic range was possible, from a quiet tinkling to a strident brazen hammering, free from the 'wow' distortion inherent in the lower-tension strings required for the neo-Irish harp. From the copies that I have made, I have found these to be true characteristics.

The harmonic curve and particularly the forepillar, which absorbed much of the tension of the strings, were sometimes made of denser wood than the box. Extra strength was achieved by carving the forepillar along much of its length into a T-section, in the same way that iron is made into girders to bear weight. This T-section was carved into a serpent or double-headed fish – perhaps the mythical salmon of wisdom, whose upper head draws inspiration from heaven and whose lower transmits it to the earth. This creature set on the arc of the forepillar also brings to mind that primal symbol of eternity, the circle, which was often represented by the serpent biting his own tail. The 'hump' on the harmonic curve rises just at the point where the neck is weakest and suddenly plunges where it is no longer needed. These engineering features and the dimensions are minutely adjusted to the structural requirements of a small wooden frame that must bear the string tension of approximately three-quarters of a ton and at the same time adapt to changes of humidity and temperature. Practical elements are blended into a beautiful and artistic whole.

Assembly

The timber for the harp is willow. The black willow (*salix fragilis*) or the white willow (*salix alba*) – riverside trees which can reach a height of 24m (80 ft) – are both suitable.

The tree is felled in early winter and cut up into thick planks which are carefully stacked and left to season for two to three years. As the soundbox of the harp is made from a substantial piece of timber which must not warp, correct seasoning is essential. The drying-out process can be reduced to a few months if the inside of the soundbox is roughed out. The rest of the soundbox is cut and planed to shape, a raised string band left in relief on the front to reinforce the soundboard, and the lower corners of the box cut away leaving a projecting block. The inside of the soundbox is worked with auger bits and gouge until the walls and bottom are formed; these must be carefully measured for thickness with double-jawed scissor callipers and a graded wedge.

The sides of the box in section are tapered towards the soundboard for reasons of strength and to enable the pine back to arch outwards when strung. This convex shape will create the correct 'focus' for the soundwaves. Scrupulous attention must be paid to the joints between the willow box and the pine soundboard so as to maximize the vibrating surface. Morticing cavities are cut into the top to receive the tenon of the harmonic curve and in the projecting block to receive the tenon of the lower forepillar.

The harmonic curve is then carved, using gouges, round-bottomed planes and scrapers, and a mortice is cut into the end to receive the top forepillar tenon. The forepillar is worked into a T-section, widest at the mid-point, which may be carved into a stylized fish or serpent or simpler form.

The pieces are now assembled. As the joints are not at right angles to each other, quite a bit of adjusting is necessary before they fit perfectly. No glue is used. Finally, the wood is stained, followed by the application of a bees-wax finish. There is evidence that fairly pure varnishes were made, concocted of natural resins, and this type of finish could also be used.

The tuning pegs, which are made of brass, pass through the wooden harmonic curve. They are additionally supported by a pair (one on each side) of curved, and sometimes engraved, bands of brass called cheek bands, which prevent excessive wear by protecting the sides of the harmonic curve. In order to prevent the strings from ripping through the soundboard each string has a brass shoe, shaped like a miniature horseshoe, attached to the raised wooden band of the soundbox.

The instrument is now strung and as it is slowly brought up to pitch the soundboard rises into a graceful arch as though taking a deep breath. The silent wood rings out to the harper's touch as it has for centuries in Ireland.

Willow, Rush and Straw

Basket- or wickerwork is generally acknowledged as being one of the oldest of all traditional crafts. Evidence of its antiquity has been found in many parts of the world: the woven grass baskets of the American Indians, the plaited reed vessels of Egypt, the wickerwork boats from the Tigris and the wickerwork baskets believed to have been important in religious ceremonies in the Graeco-Roman world.

The early inhabitants of northern and western Europe were undoubtedly proficient basketmakers and evidence of their craft shows them to have been makers of many useful commodities. Unfortunately, because of the nature of the materials used, examples of the craft in a good state of preservation are few. In Denmark, containers and fish traps about five thousand years old have been found in peat bogs, while nearer home early examples of basketry were discovered some twenty years ago in bogs in Counties Tipperary, Westmeath and Longford. These objects have been reliably dated to Neolithic times and were made by binding thin alder rods in spiral shapes. The example from Twyford in County Westmeath was described as 'a circular purse-like container.' It consisted of two discs built up from thin rods of wood 'coiled in a flat spiral and bound together into a disc form by looping a woody plant around the rods.' The two discs were then bound together along their edges and handles of thin twisted rods were attached to each side. This example measured about 40 cm ($15\frac{3}{4}$ in.) in diameter.

Coming from less remote times, evidence of basket- or wickerwork is also found in many of the *crannógs* or lake dwellings of Ireland. These habitations generally date from the Late Bronze Age to Early Christian times in Ireland and many examples of wickerwork in flooring, walls and huts have been recorded. In the famous Ballinderry *crannóg* in Co. Offaly in central Ireland, the Late Bronze Age layers, dated between the fourth and the first century BC, revealed a number of small wicker huts and a larger structure which was also possibly of wicker. It has been suggested that the

walls of these huts were smeared with clay and that the roofs were thatched.

The *crannóg* builders show us ways in which the basketmaker put his skills to good use in the construction business. We do not, however, need to delve into antiquity and remote times to see how versatile the worker in rods was. Many examples of the craft, including a large circular base of a basket and dated to the thirteenth century, have been found in the recent excavations in Dublin city. These same excavations also produced tenth- and eleventh-century evidence for the use of wickerwork in fences between plots, walls of houses, pathways, floor mats, internal kerbs for marking off bedding areas within houses and also wicker doors. The main materials used were willow, hazel and silver birch.

Wickerwork has often been called 'the mother of pottery' as evidence of the antiquity of the former craft can be gathered from early ceramic art. Before the invention of the wheel, it is believed that the potter used a basket mould around which he moulded the clay, and sherds of pottery dating from Neolithic times show the wicker imprint.

Similar imprints of wickerwork can be seen today in Ireland in the mortar of castle roofs, the wickerwork in these cases having been used as supports. In the more recent past and also at present, wickerwork walls and partitions are to be found in many traditional houses. The wickerwork chimney was a common feature of vernacular housebuilding tradition and in some cases the wickerwork was extended into loft or storage areas on either side of the hearth. A few records have also come to light of wickerwork floors in houses, though it is to be presumed that these were not sufficiently strong to take the weight of either furniture or humans and that they formed storage rather than accommodation areas.

Many diverse materials are used by basketmakers and wickerworkers, but by far the commonest are the willow and the osier. There are many reasons why these are so popular: they grow easily in most areas; they occur in many varieties and more than sixty have been recorded in Ireland alone; they grow very quickly and rods of just one year's growth can be used; they are relatively durable and resist knocks well; they reproduce themselves quite

Joseph Hogan of Shanafaraghaun, Co. Galway, inspecting his sally garden. He grows a mixture of local sally and common English osier which he will harvest each year by cutting back to the parent stool.

Thomas Joyce of Shanafaraghaun selects sally rods to make a ciseog, *a shallow basket used for straining and serving potatoes at meal times.*

Joseph Shanahan, Carrick-on-Suir, Co. Waterford, using a 'break' to strip the green bark off the sally rods.

Dividing a 'strong' sally rod with a fender or cleave.

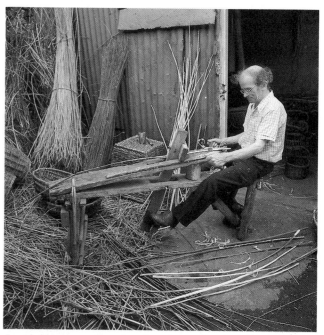

Joseph Shanahan reduces the triangular section of a sally rod on the cooper's mare. Behind him left to right, buff willow (boiled to remove bark), unstripped dried rods and white stripped rods.

rapidly and the worker can always be assured of a good supply; most important of all, perhaps, is that very few tools are needed and generally the rods are pliant enough for the worker's hands to fashion what he will from them.

The word 'willow' is one of the oldest in the English language and the species includes any of the trees in the genus *salix*. In Ireland, when referring to the material used by basketmakers, the word 'sally' is used. In the Irish language this appears as *saileach*, while the *slat sailí* refers to the osier. At one time sally gardens were as common a feature of rural Ireland as the potato plot and as with other crops grown, the sally was planted in springtime and carefully weeded and tended. The planting simply involved pushing cuttings of 25–30 cm (10–12 in.) well into deeply-ploughed soil. Where sally rods were grown in banks and hedgerows, the cuttings were often grouped in threes – one central and two at a 45° angle at either side. This helped the growth of the thick, woody clump which was a common feature of sally growing in Ireland.

As the sally grows easily, it needs little attention other than careful and frequent weeding during the first two seasons and annual cutting of the more tender shoots to promote fresh growth. Harvesting occurs annually and in Ireland the ideal cutting time is between November and February. If left any later the sap will have risen in the rods, rendering them less easy to work. When harvested, the rods are tied in bundles and left in a dry and safe place for a certain length of time. An ideal spot is the loft in an outhouse, where the rods are inaccessible to farmyard animals, sheltered from the elements and in an atmosphere where they will not dry too quickly or too much.

Although the ideal cutting time is in the winter months, there are no hard and fast rules about the preparation of the rods. Depending on the article being made, the rods might be left as they were, or peeled. A basketmaker in Co. Kilkenny in the 1940s reckoned that the best kind of rods were cut during the winter months and stored until springtime. They were then left standing upright in a stream for several weeks, after which they were removed and peeled with an iron stripper or brake. The worker found this to be a more satisfactory method of preparing the rods than by cutting them

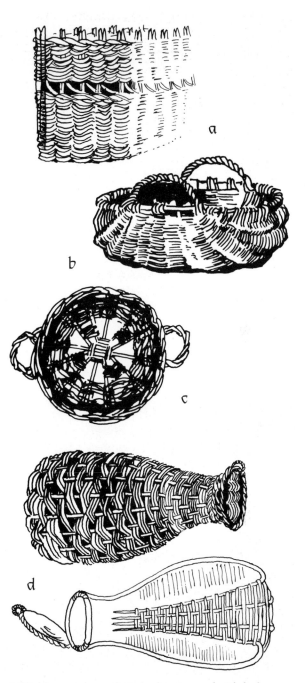

a) Cliabh *or creel, one of a pair of paniers used with donkey or pony for gathering turf. One version has a hinged bottom to facilitate muck spreading.* **b)** Scib *or* cis *(skep), also used for harvesting potatoes. An ancient, more flattened version was used as a battle shield.* **c)** Ciseog *used for straining and serving potatoes.* **d)** *River Suir eel trap (Shanahan Brothers, Carrick-on-Suir). Some regional variations have a longer neck.*

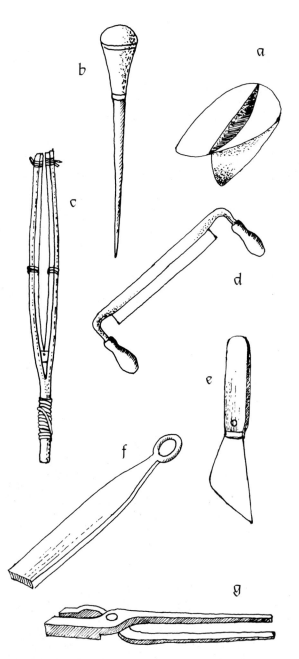

a) *A boxwood 'fender three' or cleave for dividing a strong rod.*
b) *Bodkin, used to open up the weave when inserting the rods.*
c) *A break for stripping the bark of green willow rods.*
d) *Draw knife, used with the cooper's mare.* e) *Picking knife, used to pierce a sally rod for bending.* f) *Beating iron for tamping the weave down.* g) *Crimper, facilitates the bending of Palembang cane.*

during the sap period, i.e. from March to September, and stripping them right away. In Rathsnadigan in the same county at that time, the rods were generally cut while the sap was still in them. They were then peeled with a brake of oak and left in the sun to dry for a day or so. The worker had to be very careful to protect the rods from rainfall at this time as this would render them useless. Rods seasoned in this way were reported to last for years provided they were stored in a dry place.

Some workers would never cut rods for white work in the non-sap period, i.e. from September to March, as their subsequent preparation was quite troublesome in that they had to be boiled for some hours before they could be peeled. The natural dye or tannin in the bark of the rod was also used by some basketmakers and this gave a soft buff colour to the finished product. To achieve this, the rods were cut in the winter season, boiled for about five hours to impart the tannin and then peeled.

For finer and more intricate work, the rods were split into three or more sections. A simple tool called a fender was used for this work; this was commonly made from bone, but some workers used fenders made from beech, horn and even sycamore. One example of such a tool in the National Museum of Ireland consists of a conical piece of horn 5.3 cm (2 in.) long and 3.3 cm ($1\frac{1}{4}$ in.) in diameter at the wide end. Three longitudinal grooves about 1 cm wide have been excavated at equal distances in its side. These coalesce at the upper edge, and at their point of junction three sharp edges meeting at angles of 120° are formed. By nicking the end of the rod and pushing these sharp edges into the splits, the rod was split into two or three parts as required. Using a draw knife and sometimes also a cooper's mare or shaving horse, the inner pith of each split portion was removed, thereby rendering the wood more pliable. Although the worker's hands were his most important tools, he would also need additional simple tools such as a bill hook to cut the rods and a penknife to trim them; a bodkin came in useful when affixing handles.

In Ireland there were as many different types of basket- or wickerwork container as varieties of material which went into their making. Most baskets were made solely from the sally, and

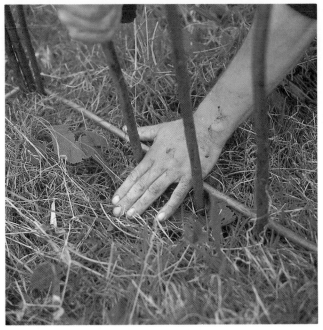

For the creel a template of sally rods is laid on the ground and pointed rods driven in at about a hand's-breadth's distance.

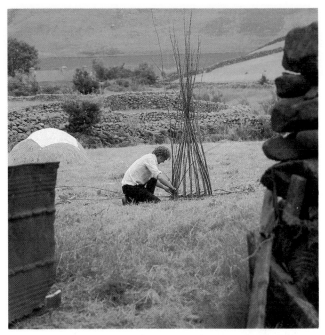

The upright sally rods are at least 300 cm (10 ft) in height. The first stroke in weaving the mouth of the creel is a wale or in Irish buinne béil, *a forward weave using slightly thicker sally rods.*

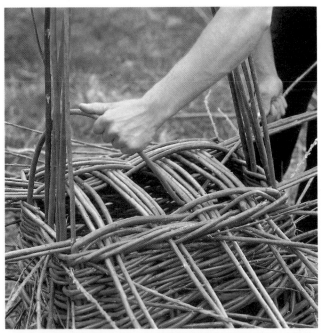

To complete the bottom of the creel the upright rods are bent over and interwoven in groups of four.

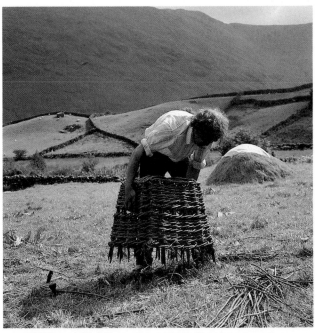

The bottom complete, the creel can be pulled from the ground.

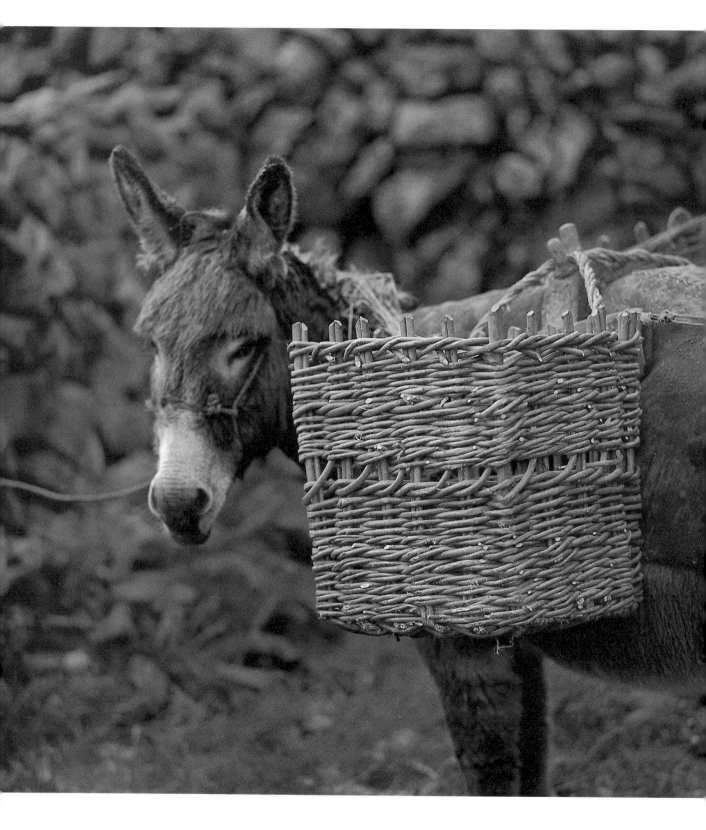

Willow, Rush and Straw

different varieties often had local names such as golden osier, green sally, duck island sally and silver sticks. In other cases material was combined with other woods. For example, potato baskets made in parts of Co. Wicklow had hazel rims, ribs of split oak and weft of black sally. In Co. Longford, boat-shaped potato baskets were made with sally rods and a rim of bucky briar or wild rose. Usually the worker began with the base and moved upwards towards the rim. However, a feature of most of the larger Irish baskets was that the rim was constructed first and the base last.

Irish basket types occur in many shapes and sizes and the greatest variety can be seen in the group of household containers. By far the commonest of the baskets used in and around the house was the skib, which was made from peeled, unpeeled or red and white dyed rods. This basket was also known as a *bascáid geal* in parts of Co. Donegal, a *ciseog* in Co. Galway and a potato 'teeming' basket elsewhere. In former times these baskets fulfilled the function of tables, the potatoes being strained in them and then the basket being placed on the pot in the centre of the floor while the family sat around and ate them. If provided with handles, it was used for bringing washing to and from the line.

Sometimes the skib was circular, measuring about 50 cm (19½ in.) in diameter and 10 cm (4 in.) in height. In Co. Longford, as mentioned above, this basket was boat-shaped with a rim of bucky briar, while another variation known as a *sciathóg* was used in parts of Cork and Kerry. The latter were U-shaped in plan, being deepest in the centre and sloping upwards to both ends. The *sciathóg* had many uses and apart from straining potatoes it was used as a vessel for putting potatoes in when the crop was harvested and as a container for seed potatoes at the time of planting. Average dimensions for the *sciathóg* were 60 cm (23½ in.) in length, 45 cm (17¾ in.) in width and 15 cm (6 in.) at the greatest depth.

Another general-purpose basket was called a *birdeog* and this was also used in Co. Kerry. The *birdeog* was oval in plan and measured about 60 × 40 cm (23½ × 15¾ in.). It was about 25 cm (10 in.) deep. This type of basket was used for carrying in turf to the house, fetching potatoes, straining potatoes etc. A final variation of the potato-straining basket to be

mentioned here was the 'lusset', from the Irish *losaid*, which was essentially a rectangular basket with the long sides made of wood. These had a series of holes on their inner sides through which were inserted the ends of a number of peeled rods which served as warp. On this warp was woven a weft of peeled rods, while in the centre of the warp rod at each end a section was left free of weft to form a handle.

Other than sally, household baskets were also made from straw and an example of one such, peculiar to the Aran Islands, was known as a *ciseán*. These were generally of lipe work, the bundles of rye straw being about 1 cm in diameter and sewn together with strips of bramble using a bone pin. The *ciseán* was used for bringing dinners to men working in the fields and it was preferred to a wicker basket as it kept the food warmer.

In Co. Mayo, a straw basket called a *tiachóg* was used for holding eggs, especially when bringing them to the market. It was made in a similar way to the *ciseán*, using plaited straw rope coiled on itself and stitched with laps of straw. The word *tiachóg* literally means a bag or a pouch, while in parts of the west of Ireland it was a container in which hens laid eggs. In the Erris district of Co. Mayo, there were two other types of *tiachóg*, formed from rush plaits. The rushes were first steeped in water, then beaten and plaited. The plait may have been of any width providing it was made using an odd number of rushes. In one form the rush strips were about 20 cm (8 in.) wide and sufficient in length to form both back and front of the container. The strips were then sewn together along the edges to form a continuous piece which was folded on itself in the form of a sack. An open-mouthed bag was the end product once the two edges were sewn. Generally a hem was turned down and sewn at the mouth, a rush rope being placed in the fold as the work proceeded. This becomes a draw string to close the bag.

Another form of *tiachóg* was made by taking a very long strip of this plait and then coiling it on itself in lipe work fashion as was done with the baskets of straw. This form of *tiachóg* was cylindrical in shape, the edges of the overlapping coils being sewn together with thread. Whatever shape or pattern the *tiachóg*, it always formed a container for

household commodities. It could be a clothes basket which hung on the wall; it could be lined with cloth for holding meal and salt; it could be a hen's nest or an egg basket.

Baskets used around the farm included the once very popular and very practical donkey creels or cleeves used for transporting turf, manure and seaweed etc. They were generally used in conjunction with a pair of straw plaited mats, which were put on the donkey's back, and a wooden straddle provided with wooden pegs on which the creels were hung. The creels were generally made of sally rods and variations did occur. In parts of the country such as Mayo, Sligo, Leitrim and Cavan a creel known as a *pardóg* was made, while a similar type of basket was called a bardock in Co. Monaghan. Essentially, these were creels with collapsible bottoms, the base of each *pardóg* being made separately and hinged to one side of the body of the *pardóg* by two rod hinges. The base was held shut by means of a stick fixed at one side and held in a loop at the other. The advantage of this type of container was that it could be emptied without taking it from the donkey's back.

Other wickerwork containers used around the farm include the large potato-gathering basket, or crandy as it was known in some parts of the midlands; the wheeling basket, which was used with a turf barrow when spreading turf; the very large basket called a kish, which was made to fit into a four-laced car; and the back basket, which was worn in various ways. It was sometimes provided with two straw ropes, in which case it was worn like a knapsack with a rope around each shoulder. If made with just one carrying rope the basket was slung over one shoulder and the weight rested on the small of the back. A third way of carrying the back basket was to have the carrying rope resting on the chest, a method which could be quite dangerous and stories are told of people being strangled when the rope slipped from the chest to the neck.

Fishing was naturally a very common occupation around the coast of Ireland and many items of wickerwork were used by fishermen. These included crab pots, lobster pots, eel pots, wicker fish traps and baskets for holding spillet lines. Of these, the lobster pots had the greatest variety in shape, size and material of construction, being made

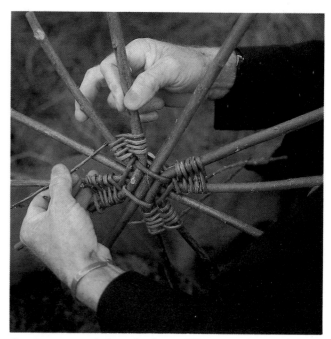

Starting to weave the base of a ciseog. *The centres of two angled rods have been split to allow the other three rods to pass through them at right angles.*

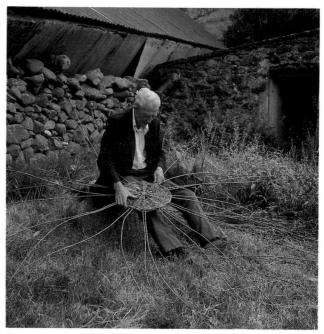

Pairs of long rods are introduced into the weave. These will be bent upright and will be interwoven to form the rim of the ciseog.

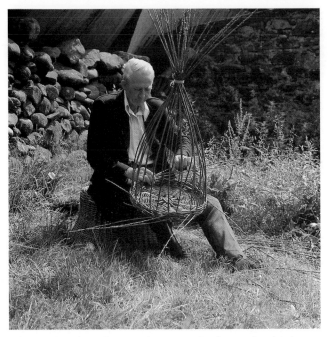

The upright rods are bent over in preparation for weaving the rim.

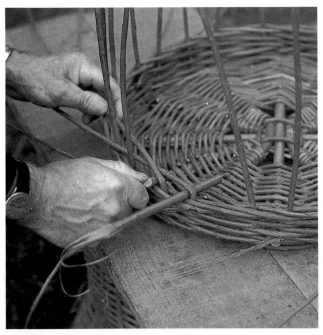

Weaving the side.

from sally rods (with or without galvanized wire), hoops of wood and green netting and also heather. The heather lobster pot was used particularly in north-west Mayo.

Although people were generally able to make baskets for their own needs, basketmaking was also a specialized craft carried out by professional craftsmen. There also used to be many itinerant basketmakers who journeyed around the country and offered their services at a small charge. Good basketmakers were very jealous of their craft and often they would not let anyone see them either starting or finishing a basket. A man from Co. Wexford, whose father was a basketmaker, always remembered that his father would start the basket in private during the day and work away at it in the evening time when the neighbours would gather at the house for a visit. Once the work was started he did not care who saw him.

The making of fancy basketwork from sally rods also forms part of the traditional craft of Ireland and has long been associated with two areas in particular – the shores of Lough Neagh in the northern part of the country and the Suir Valley in the south. Joe and Michael Shanahan of Carrick-on-Suir in Co. Waterford run a basketmaking business which was begun by their grandfather almost one hundred years ago. John Shanahan, a native of Kilmacthomas in Co. Waterford, was apprenticed to a basketmaker in Carrick-on-Suir in 1888. He started his career making potato baskets but he soon became supplier to British Rail of hampers for transporting fowl. John Shanahan died in 1916 but the business was carried on by his son, Edward, father of Joe and Michael. The contract with British Rail expired in 1922 when the Shanahans turned to making cane furniture and yeast baskets which were used to transport yeast from the Watercourse distillery in Cork to the bakeries around the countryside. Although times were bad in the 1920s, a scarcity of containers during the Second World War increased demand from basketmakers and the Shanahans employed up to twenty men at this time. The business has kept going since and Joe and Michael Shanahan today are carriers of a craft which has changed but little over the years and which has remained free of the application of machinery. It is a true handicraft.

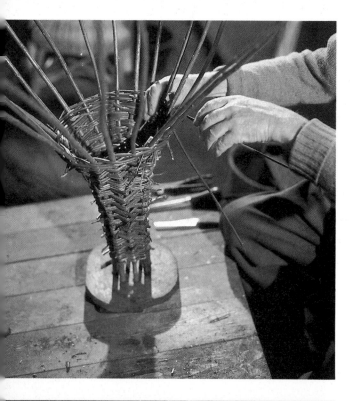

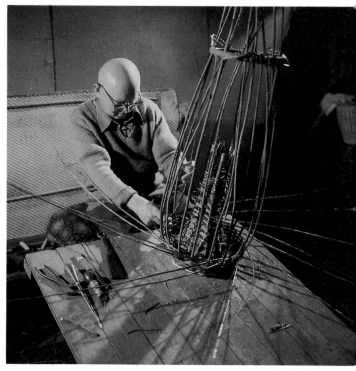

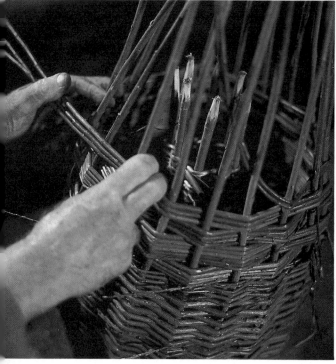

(ABOVE, LEFT AND RIGHT) *Michael Shanahan weaves a River Suir eel trap. A wooden template holds the sally rods in place and will form the neck which is built up using a three- to four-rod slew. The photograph shows the start of a stroke called a wale coming up to the point where the vertical rods will be turned.*

LEFT *Using a three-rod slew on the body of the trap.*

BELOW *Sally garden.*

OPPOSITE *Some of the baskets woven for sale by Joseph Hogan, Shanafaraghaun, Co. Galway.*

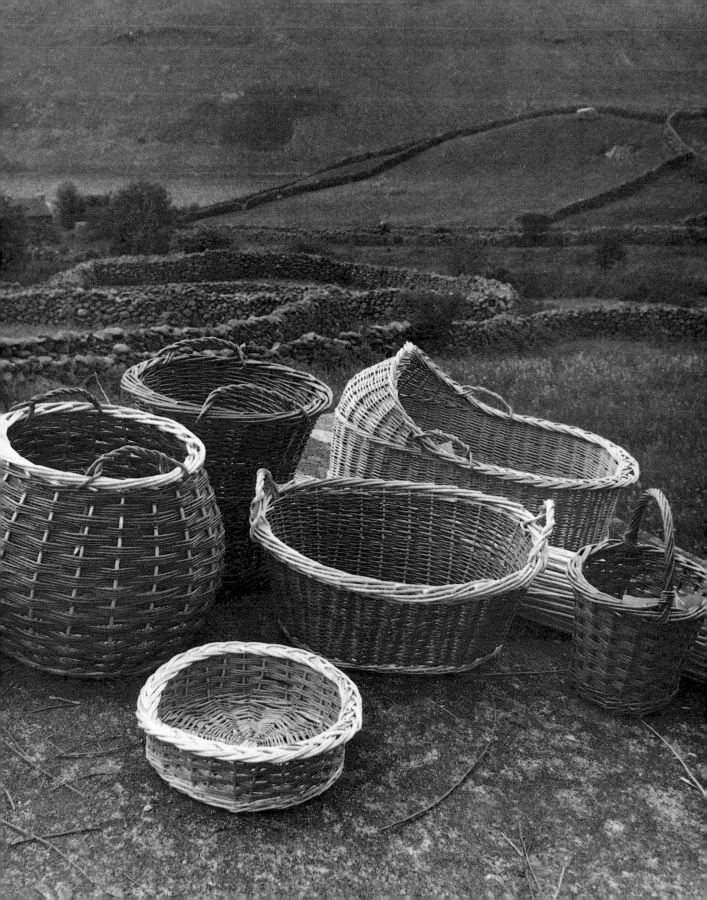

THATCHING Kevin Danaher

Before the development of modern rail and road transport, that is to say up to about a hundred years ago, only the very rich or very powerful lord or prelate could afford to bring heavy loads over long distances. Hence, when the ordinary man built a house he had to use local materials. The type and quality of these materials varied from place to place: some were easy to handle and gave good results, others were less so and made some methods difficult to use and some results impossible to achieve. On the other hand local materials and their skilful development to meet local conditions often led to the creation of forms notable for their beauty as well as their utility.

The Irish climate, mild and moist, demands house roofs which are sloped for the rainwater to run off and, of course, covered with a material which keeps the water out. One system of covering roofs employs a coating of small overlapping plates – familiar to us in slated and tiled roofs. Both slates and tiles have been in use in Ireland since at least the Middle Ages, tiles less frequently – in some towns and on some larger buildings – slates more often, found even on farmhouses and outbuildings in those areas where suitable material could be quarried locally, as in parts of Counties Clare, Cork, Waterford, Mayo and Donegal. In the past, when large woodlands provided abundant timber for all purposes, some roofs were covered with shingles – flat plates of split timber – but with the spoliation of the Irish woods in the seventeenth and eighteenth centuries this craft died out.

The other and much more common type of roof in most parts of Ireland is that which uses a covering of vegetable matter – the thatched roof which to most people is an essential element of the 'traditional Irish house'. (Incidentally, Irish country people never call a farmhouse a 'cottage'. A 'cottage' is a dwelling built by a local authority, such as the County Council, for renting to those who are unable to build their own; a farmer's wrath may well be aroused by the insensitive use of the word to describe his habitation.)

Irish traditional houses are very rarely of any groundplan other than rectangular; thus the roofs are of simple construction, falling into two types: hip-roofs and gable-roofs. In the gable-roof, there are only two surfaces, front and back; at the ends of the house the gables rise up to the ridge of the roof. With the hip-roof there are four roof surfaces; the roof slopes at the ends as well as at the sides. In some cases there is a full hip, where the end walls of the house are no higher than the side walls; other houses are half-hipped, with end walls somewhat higher than the side walls. In Ulster, north and west Connacht and south-west Munster the gabled roof predominates and in many areas is the only kind, while in the south-eastern areas of Ireland the opposite is the case with the hip-roof as the usual type.

Many factors affect the durability of thatched roofs. Neglect causes a thatch to decay and leak; periodic renewal is essential. Skill of workmanship, pitch of the roof slope, local weather conditions, and damaged caused by birds, rats and mice are other factors which may lengthen or shorten its life. Most important of all, however, is the material used. This varies greatly, depending on the crops or wild growths available locally, as well as on the purse of the householder, since the cost of the materials differs from one district to another.

Wheat straw is the most popular material in most parts of the country. In Derry, Donegal and Fermanagh flax is preferred to wheat. It is also used to some extent in Antrim, Armagh, Monaghan and Tyrone, and occasionally in other districts, in spite of a belief that flax is unlucky – a belief arising, according to a Fermanagh correspondent, from the fact that flax is more inflammable than other materials. In many counties rye straw came second to wheat, and some thatchers recommended that a special crop of rye be grown for thatching and cut before the grain had ripened. Oat straw used to be popular too, and took pride of place over wheat in Counties Kildare, Louth, Laois, Offaly and Westmeath. Barley straw is used very rarely. In some counties where reed grows in lakes and rivers it is used in preference to other materials. This is the case in particular in Munster; it was rarely used elsewhere until recently, when new methods of tillage and harvesting have led to a shortage of suitable thatching straw. In mountainous districts, especially in Donegal, Mayo, Galway and Kerry,

rushes and certain tough grasses (*fionán, muiríneach, seisc, cíb*, bent, marrom, etc.) were often used instead of and sometimes in preference to straw.

Opinions vary as to the length of time each material will last. An average of these opinions (for thorough thatching) would be: flax or reed, about twenty years; straw, eight to twelve years (wheat or rye, slightly longer than other kinds); rushes or grass, three to five years.

In most parts of Ireland a layer of grass sod, cut from the surface of the ground, is laid upon the roof timbers and sewn to them using thin ropes. In east Munster and south Leinster, the first layer of straw is sewn directly to the timbers. As for methods of securing the thatch to the roof, three very different ones are used corresponding to quite clearly defined areas of the country.

The first of these is roped thatch. In this, the thatch is not fastened to the roof directly underneath, but is held in position by a network of ropes which runs over the roof and is fastened to the tops of the walls, or to weights along the eaves; this method is confined to the Atlantic coast districts. When a new coat of thatch is being applied, the old ropes are removed. Then a layer of straw (rushes or grass where used) is laid on the roof at the eave; above this, and partly covering it, another layer of straw is laid; this is repeated until the whole roof is covered, each layer of straw lapping over that immediately below it, in order to allow the rain to run off. A quantity of straw is then spread along the ridge; this lies parallel to the ridge and across the layers of straw already laid on to prevent the ropes from cutting into the thatch on the ridge. For the same purpose a light sprinkling of

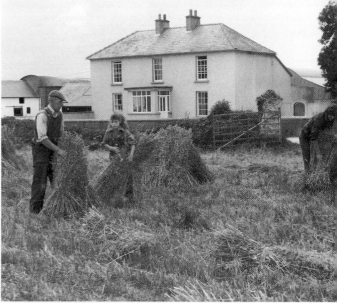

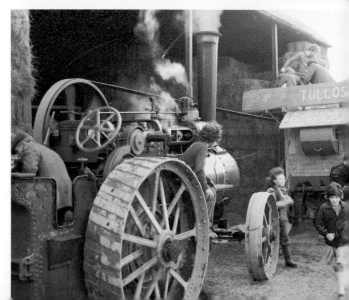

straw is strewn over the roof across the layers of straw already in position.

Then the roping begins. Balls of rope made or bought for the purpose are carried back and forth over the roof from one side of the house to the other, the ends being fastened securely.

Several different methods of roping are used. The distance from one rope to the next is usually from eight inches to a foot, and in some cases the only ropes parallel to the eaves are on the ridge and immediately above the eaves. In other cases there are ropes parallel to the eave at intervals of about a foot over the whole roof. These are fastened to pins or pegs near the tops of the gable walls. The ropes which run across the ridge are tied to pins or pegs set in the wall below the eaves; these pins or pegs may be of wood or iron, or (as in parts of Donegal) they may be thin pegs of stone built into the walls near the top.

An alternative method of securing these ropes is to fasten each to a stone weighing some 1.4–2.2 kg (3–5 lbs). These stones lie on the thatch immediately above the eave, and keep the ropes taut even when they stretch, but cause leaks where they lie on the thatch. In many places thin laths of wood are placed along the thatch just above the eave to prevent the ropes from cutting into the thatch. Sometimes nowadays wire mesh is used instead of ropes, or occasionally an old fish-net.

This method of thatching is hardly ever seen on hip-roofs, as it is confined to parts of the areas where hip-roofs are rare. It is used along a coast which is exposed to strong winds, and therefore probably owes its origin to climatic conditions. In some very exposed places, stout ropes, independent of the ropes which hold the thatch, are stretched over the roof and made fast to strong pegs set in the walls. These serve to anchor the roof against gales.

What we may call 'scolloped' or 'pinned' thatch is by far the most widely practised method of thatching. It can be found in south-east Ulster and north-east Leinster, that is Co. Louth and the adjoining parts of Counties Down, Monaghan, Cavan and Westmeath. It also occurs in south Carlow and south Wexford and in small localized areas of the west coast. At the extreme points of its incidence it co-exists with the other method of thatching.

*a) Needle used to sew sissal rope through the layers of sods or first layer of straw on a new roof. Formerly bog fir and hay (súgán) ropes were used. **b**) Beating pin or spurtle made from a broken hoe and a pointed chain link. Used for driving home the fletch of straw. **c**) Broken pitchfork prevents the bundles of straw from rolling off the roof during thatching. **d**) Mallet for driving home the scallops. **e**) Old rake used for combing out the loose straw. **f**) Pruning knife. **g**) Sheep shears for trimming the thatch.*

In 'scollop' thatching, each portion of the thatch is pinned to the roof immediately underneath, in nearly every case by means of 'scollops' (slender rods of willow, hazel, briars or similar growths, or slips of bog-deal). A small bundle of straw is shaken out and laid neatly on the roof, ear end up and cut end down. This is fastened by having laid across it a straight scollop which is then pinned to the sod or old thatch with two or three other scollops bent into staples. The next portion of straw is put on a little higher up, in such a way that it covers the scollops holding the first portion, and so on until the ridge is reached.

The thatcher begins at the right-hand edge of the roof and works towards the left, completing a strip from eave to ridge and about a foot wide, then moving on until that side of the roof is completed.

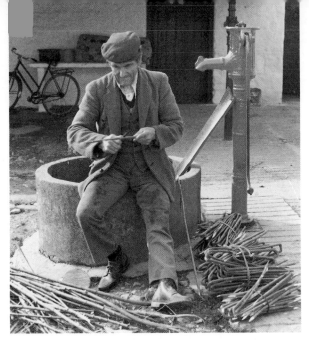

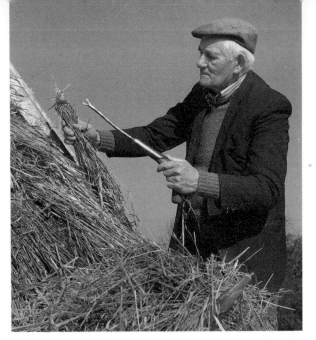

LEFT *Johnny McGrath, of Mulrankin, south Wexford. Preparing sprays or scallops of hazel and black sally for the thatcher. These act as wooden staples and help to secure the thatch at the roof ridge and gable.* RIGHT *Paddy Casey, beating pin in one hand, fletch of oaten straw in the other, re-thatching a house in*

south Wexford. The fletch of straw is doubled and twisted to form a knot which will lock into the old thatch. BELOW *Paddy Casey, re-thatching a hipped-roofed house at Grange South, Co. Wexford.*

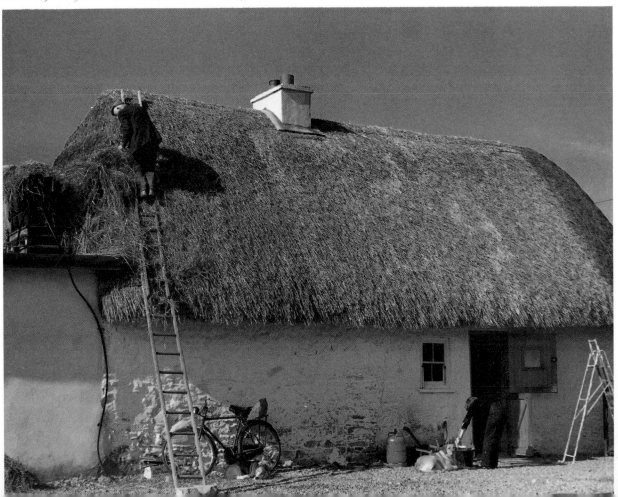

At the ridge the straw is bent over and fastened on each side with rows of scollops. As he works, the thatcher trims the ends of the straw neatly with his knife. In the finished roof the only scollops visible are those on each side of the ridge – these are often worked into a simple pattern of chevrons or lozenges – and, usually, a row at the eave. In many districts a row of neatly twisted 'bobbins' of straw is placed on the ridge. The 'bobbins' are wisps of straw looped and knotted in the middle and strung on a rod which lies along the ridge, the free ends of the wisps are pinned down on each side with scollops.

An inferior type of scollop thatching is sometimes used, in which no care is taken to hide the rows of scollops, and all the fastenings are visible. This is not as lasting as the hidden scollop method, as rainwater seeps in at every scollop staple, thus rotting the thatch and causing the roof to leak.

Scollop thatching varies very slightly from district to district. There are slight differences in the method of using the pinning scollops; and opinions vary as to the best material for scollops, willow, hazel, briar, laurel, split bog-deal and even lengths of iron wire being used according to local taste. Formerly, scollops could be bought by the hundred or thousand at fairs and markets; this still happens occasionally.

The tools of the scollop thatcher are a hand-leather or mallet to drive the scollops (the hand-leather is a sort of mitten made of strong leather), a rake to smooth the thatch and remove loose straws and a knife to trim the thatch. Sometimes the rake has a thick back and can be used as a mallet. The eave is trimmed with clippers or sheep-shears. A helper passes up straw and scollops as required. The scollops are put in a holder made of straw, straw rope or rushes, so that the thatcher may draw them out one by one as required.

The thrust thatch is quite a different method that is used in most of Leinster and in parts of east Ulster. In south Leinster it appears side by side with scollop thatching, but in a large area of north Leinster it is the only method used. In this method the thatcher proceeds as follows. A layer of thatch is sewn to the roof timbers, either directly, or over a sod layer, according to local usage. Then the thatcher takes a handful of straw, twists the ear end

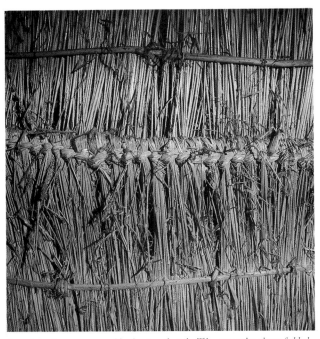

Interior of a 300-year-old wheaten thatch. The straw has been folded and knotted over a length of hazel rod. Also visible are lengths of hazel rod pinned by scollops.

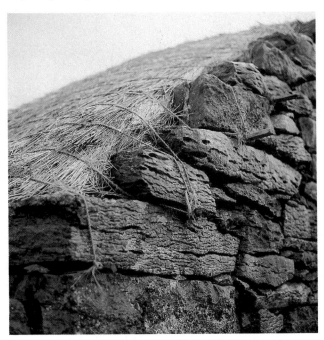

The corner of a rye-thatched, rope-tied barn on Inishmaan, Aran Islands. Note the stepped limestone gable and wooden spars holding the thatch.

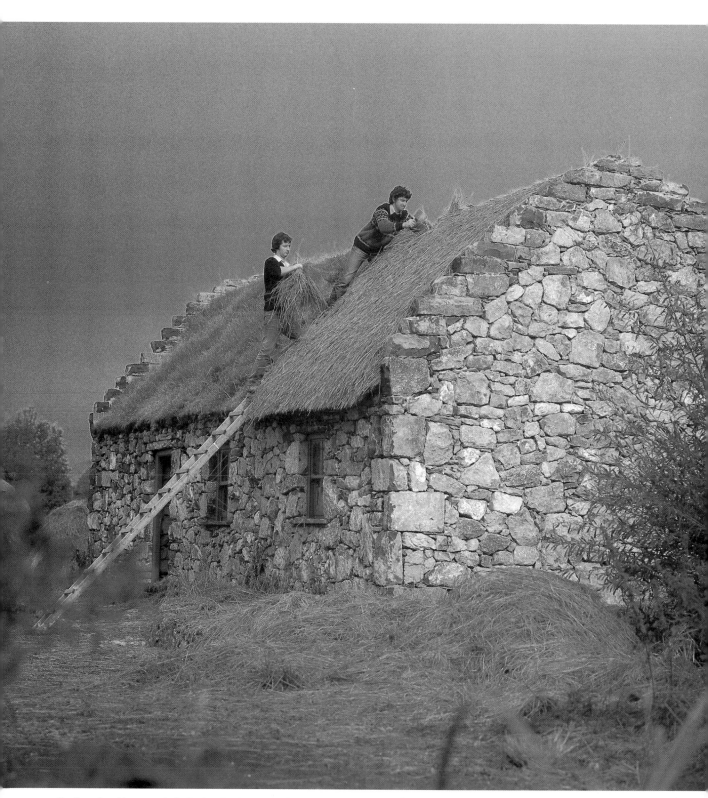

Scollop-thatching a newly-built, kitchen byre-type dwelling.
'Scraws', ribbons of sods, are laid in strips over the roof timbers
followed by layers of field rushes which are secured by scollops
(wooden staples made from twisted willow). (Bunratty
Folk Park, Co. Clare).

Hip-roofed, thrust-thatched house, south Wexford.

Roped thatched house, Inishmore, Aran Islands.

Roped thatched dwelling with stepped gable, Co. Mayo. Stones are used to hold the thatch down and a timber lath prevents the ropes from cutting into the thatch.

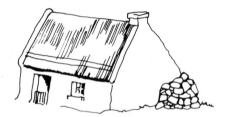

Scollop-thatched house, Connemara.

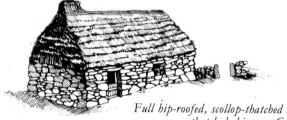

Full hip-roofed, scollop-thatched house with thatched chimney, Co. Galway.

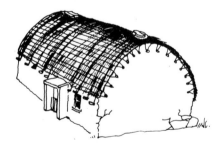

Roped thatched dwelling with typical roof rounded against the wind, Glencolmcille, Co. Donegal.

Roped thatched house with ropes secured to spikes driven into the wall, Inishmaan, Aran Islands.

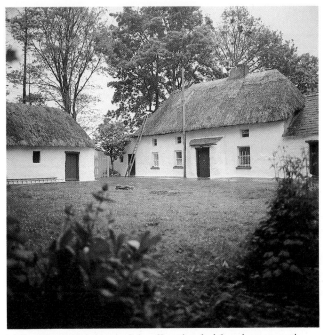

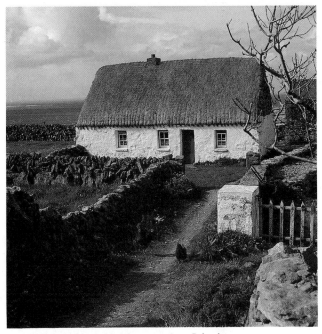

A fine two-storied, hip-roofed scollop-thatched farmhouse near the River Suir, Ballylynch, Carrick-on-Suir, Co. Waterford. The single-storied thatched building on the left-hand side was where the resident farm labourer lived. Livestock inhabited the slated buildings.

Roped thatched house, Inishmaan, Aran Islands.

into a knot and thrusts it into the straw layer already on the roof with a small iron or wooden fork, so that the knot catches in the straw of the roof and is firmly held. He thrusts in other knotted wisps beside the first, making sure they lie tightly together.

When he has covered a strip about two feet wide, he thrusts in another similar strip above it, lapping over the first strip, and so on until the ridge is reached. The straw is well damped and beaten down to make it lie flat. (This damping and beating is not necessary in the other methods of thatching.)

When the roof is thus covered the ridge is secured. This may be done in one of several different ways. Sometimes straw is bent over the ridge and kept in place by a coping of clay or concrete. Instead of this coping, a ridge-board of wood (occasionally sheet-iron) is often used; short lengths of wood projecting from the tops of the roof-principals support the ridge-board in some cases. Often the ridge and eave are secured with

scollops or with lengths of iron wire, and a row of 'bobbins' on the ridge is sometimes seen.

In the above description the present tense has been used, but it should be pointed out that the thatched roof and the thatchers have vanished from wide areas of the Irish countryside. There is the shortage of straw mentioned above; there is a reluctance on the part of local and central authorities to allow the building of thatched houses; there is the refusal of insurance on thatched roofs. As a result of this, thatching as a craft has virtually disappeared. Fifty years ago every rural parish had its thatchers; now there are whole counties without one.

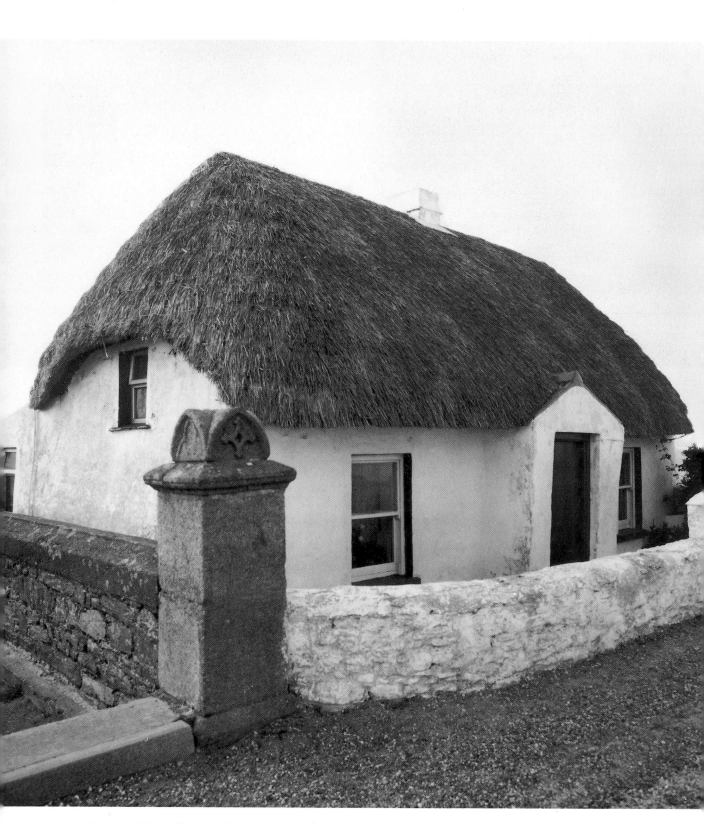

A typical hip-roofed thatched house with loft bedroom. Kilmore Quay, south Wexford.

BEE-SKEPS

Jack Carey, Clonakilty, west Cork, at his kitchen table selecting 'sops' of wheat which he will tie into neat bundles for his bee-skep making.

The heads of the wheat are removed in preparing the bundles. In the old days the sheaf was thrust into the thrashing drum head first to remove the grain and withdrawn to keep the straw intact.

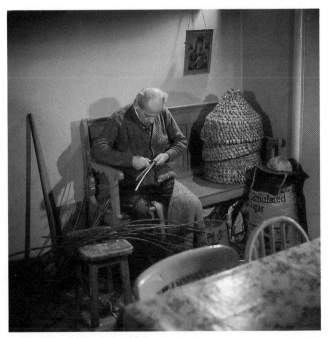

Jack divides the blackberry briars in two.

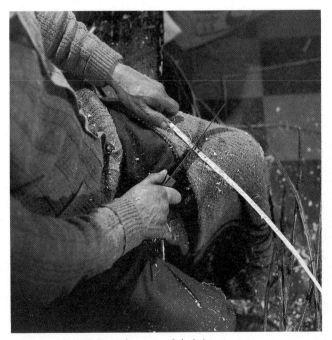

Removing the pith from the centre of the briar.

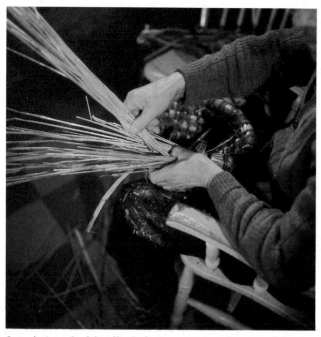

Introducing a fresh bundle of wheaten straw into the centre of the ring (unlike a straw súgán rope the straw is not twisted but bound around with the split blackberry briars.)

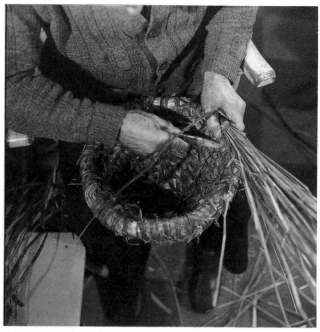

Making the hole for the briar with a pointed wooden stick.

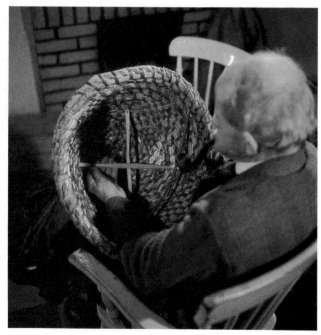

Fixing the crossed sticks inside the skep which will act as support for the bees while they are swarming and a base for their combs.

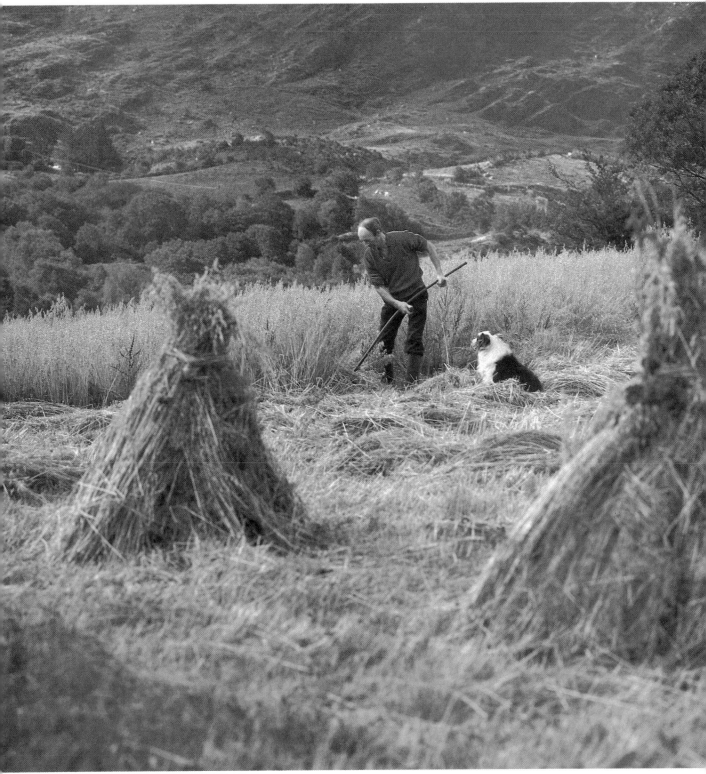

Christopher Sullivan of Droum, Lauragh, Co. Kerry, grows oats for his livestock. After flailing he saves the straw for súgán *(straw rope) making.*

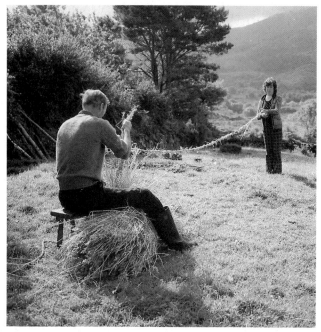

Christie and his wife Noirin twist the straw into a rope about 6 m long. The lengths of súgán *are bound up into torpedo-shaped bundles.*

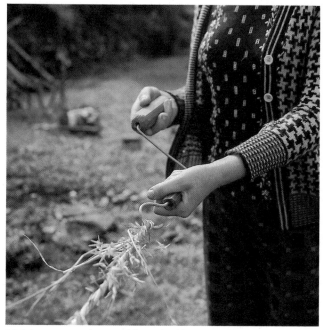

Noirin uses a croakeen, or 'thraw-hook', to twist the straw. It consists simply of a length of wire and two pieces of drilled-out wood which revolve around the wire.

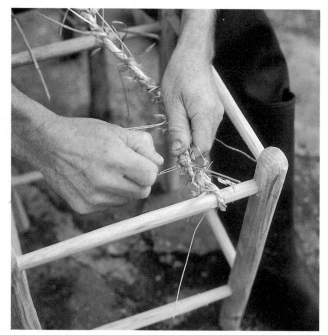

Christie attaches the end of the súgán *to the wooden frame of a stool.*

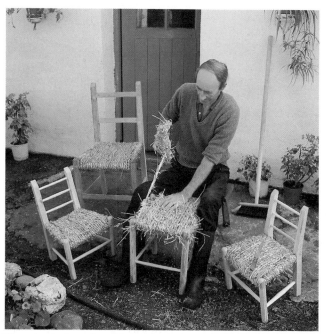

He makes both stools and ladder-back chairs which he seats in súgán.

OPPOSITE *Children's chairs hang in the loft ready for sale.*

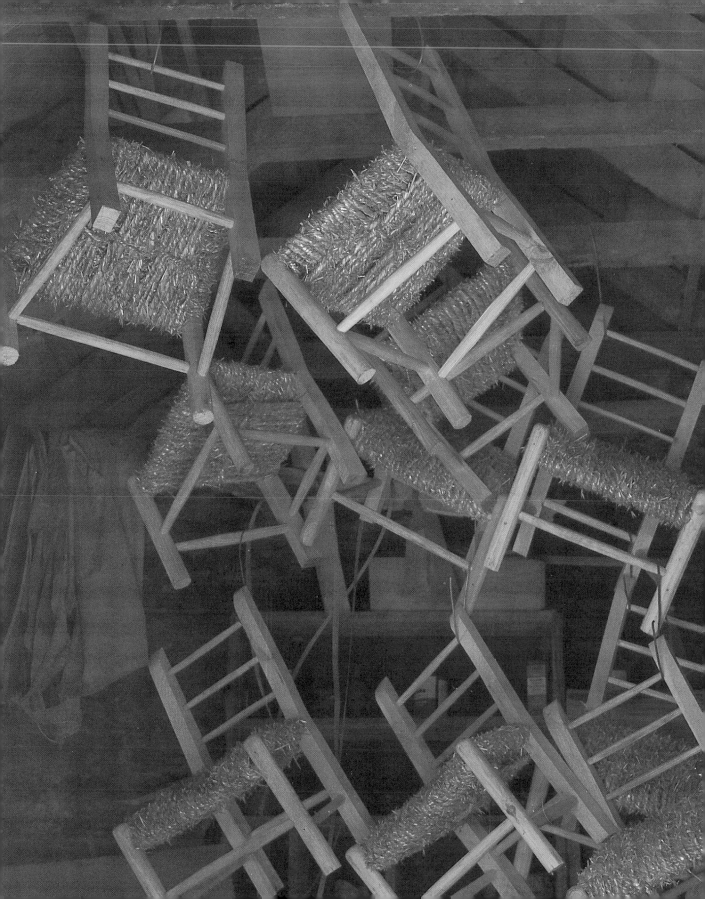

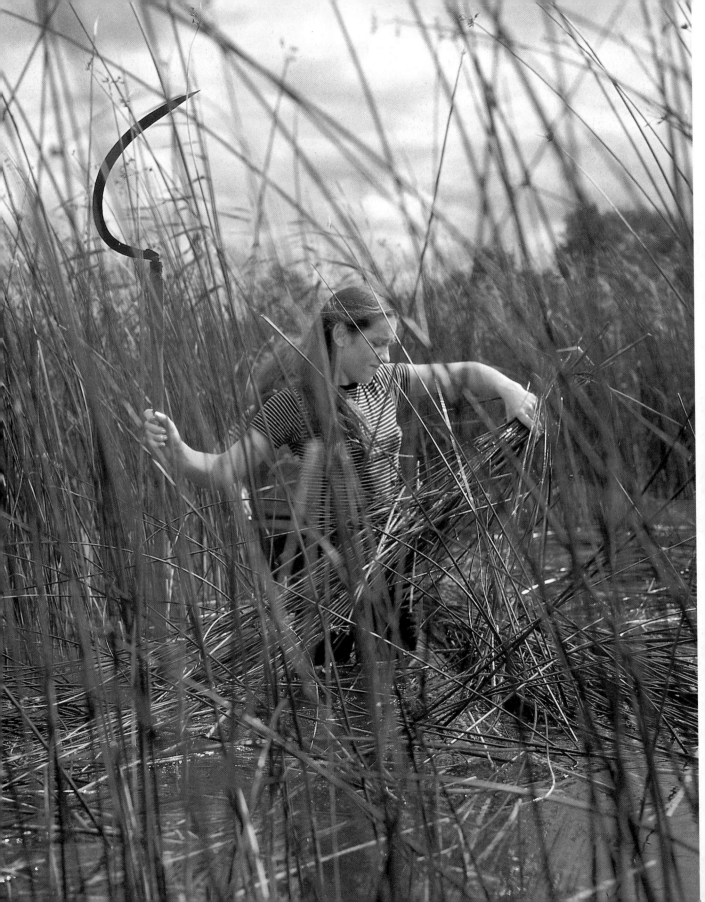

RUSHWORK

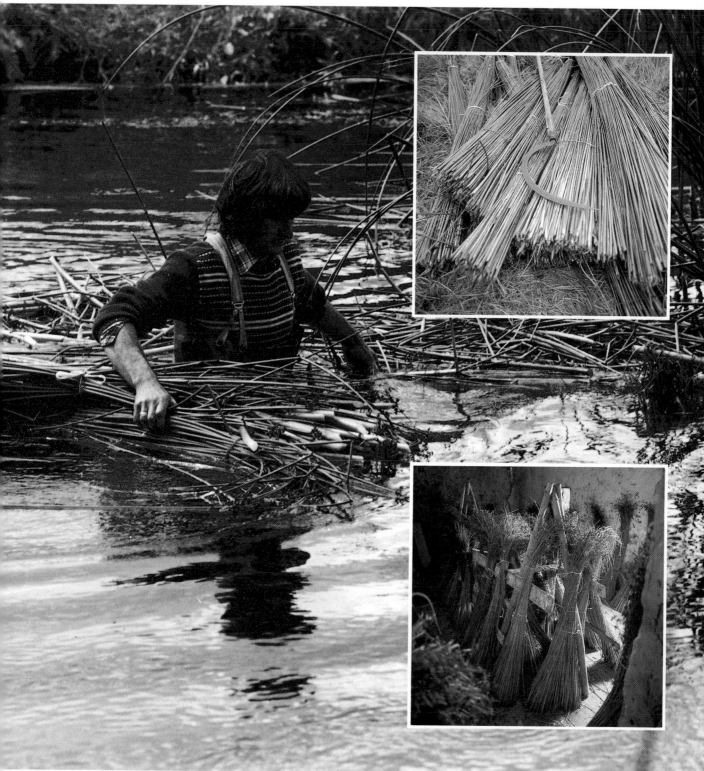

River Suir rushes are much prized for weaving as they are soft and pliable. Stephen Grace floating in bundles near Cashel, Co. Tipperary. INSET, TOP Freshly cut and bundled rushes and a sickle made by the local blacksmith. The rushes are harvested in July when they have reached maturity but before they begin to die back. INSET, BOTTOM Rushes drying in a Strokestown loft. The ties are pushed up and the rushes loosened and turned regularly to allow for the free circulation of air. Curing takes 6–8 weeks.

Mrs Hannah Barry, who lives on the banks of the River Suir near Cashel, Co. Tipperary, collects her own rushes and is a fine rush weaver.

Mrs Barry makes a wastepaper basket using a bucket as a mould. The rushes must be kept damp while weaving.

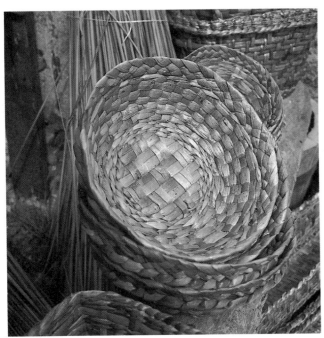

This rush basket alternates tabby or check weave (centre and sides) with pairing or coupling (in which the rushes are worked in pairs and slightly twisted).

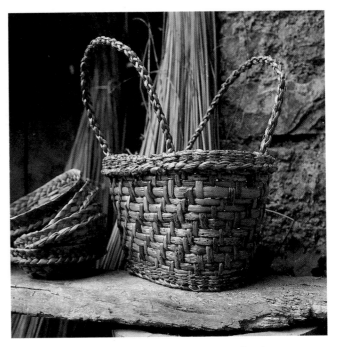

A rush shopping basket. Slievebawn Cooperative, Strokestown.

Leather

HARNESSES AND SADDLES
Mary McGrath

Horses have always been an intrinsic part of Irish life. The rich limestone soil and mild climate, combined with a genuine love of horses on the part of the Irish people, have produced horses of superlative quality at all periods of Irish history. It is not known when or how horses first came to Ireland but bones from small ponies about twelve hands high were found at New Grange dating from around 2500 BC.

In the earliest epic cycles the heroes never rode on horseback: they travelled and fought in chariots drawn by two horses. Finds of bits and leading pieces in pairs, together with illustrations on high crosses, seem to confirm this fact. The horses were harnessed in the same way as oxen, with a wooden yoke over their necks. Choking pressure on the windpipe reduced the power of the horses to one-quarter of their potential and thus limited their use to ceremonial duties, war and sport.

Horse racing was a popular sport in Ireland from the earliest times. Races were run each year at the Aonach Tailtean in Meath, a great pre-Christian festival. Racing also took place at the Curragh in Kildare; *cuirrech* is the word for race course in old Irish.

Riding appears to have been taken up at a relatively late period by the Celts in Ireland, for the Welsh had learnt it from the Romans. The earliest illustration of a man on horseback is in the Book of Kells from the eighth century AD; he has a bridle but no saddle. Similarly the bishop on the high cross at Banagher from the same period has a bridle but no saddle. Some of the bronze bits that survive from this era have hinged harness mounts which were once fitted to leather straps; unfortunately no leather remains.

The horses used for war and hunting at this period were small, light, fast and fiery. Their riders 'neither use saddle nor boots nor spurs, but only carry a rod in their hand, having a crook at the upper end with which they both urge forward and guide their horses. They use halters which serve the purpose of a bridle and a bit and do not prevent the horses from feeding as they always live upon grass' (Giraldus Cambrensis). These Irish horses came to be called 'hobbies'. Their swiftness and manoeuvrability made them popular among the armourless Irish cavalry both at home and abroad.

This situation lasted until the Norman invasion, when many changes took place. Norman horses were large and powerful and carried knights clad in armour who used both saddles and stirrups. The combination of round collars and stronger horses introduced by the Normans revolutionized agriculture and from the Middle Ages on, horses gradually replaced oxen.

With the growth of settled communities harness making as a trade began. Timber was still much used in the making of both collars and saddles but these gradually came to be padded and more comfortable.

The next major change came as a result of the Tudor plantations. Organized hunting was introduced, with the fox as prey for the first time, since the wolf was now almost extinct in Ireland. Ladies rode sidesaddle and quality harnesses of doeskin were much in demand. Derricke's '*Image of Ireland*' published in 1581 contains some fascinating illustrations: the Irish bits and saddles differed considerably from the English, and the Irish still used no stirrups. A small stone equestrian statue from the fifteenth century, found at Kinnitty, Co. Offaly, confirms Derricke's illustrations. The harness appears to be of fine leatherwork; there is a crupper fixed to the saddle but the rider still has no stirrups.

By the seventeenth century an Irish warrior in Stuttgart was illustrated using both stirrups and spurs and having a bridle 'decorated in the Irish manner'. However, it is not known whether this style had become common in Ireland.

Even after the introduction of the full collar by the Normans this type of harness was not universally utilized. In the seventeenth century ploughing by the tail was common. In the north west of Ireland oats was the principal crop because of the damp soil. As oats require only shallow ploughing pairs of horses or even teams were harnessed to the plough by means of their tails. They were led forward by a man walking backwards in front of them.

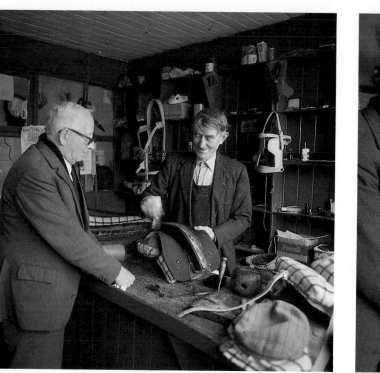

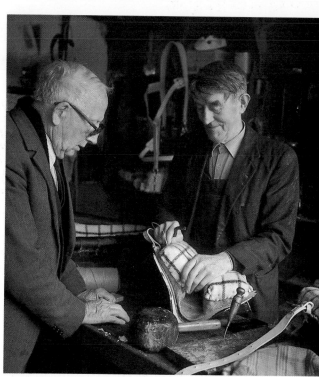

ABOVE *Paddy Crowe talks to his friend James Garrihy as he paints a donkey straddle. Paddy has been working as a collar and harness maker for fifty years from the same premises in Ennistymon, Co. Clare.*

RIGHT, TOP *Sewing a donkey straddle.*

RIGHT, BOTTOM *Completed donkey straddle, lined in check.*

OPPOSITE *Peter Geraghty, collar and harness maker of Shrule, Co. Galway, lining a pony collar in check.*

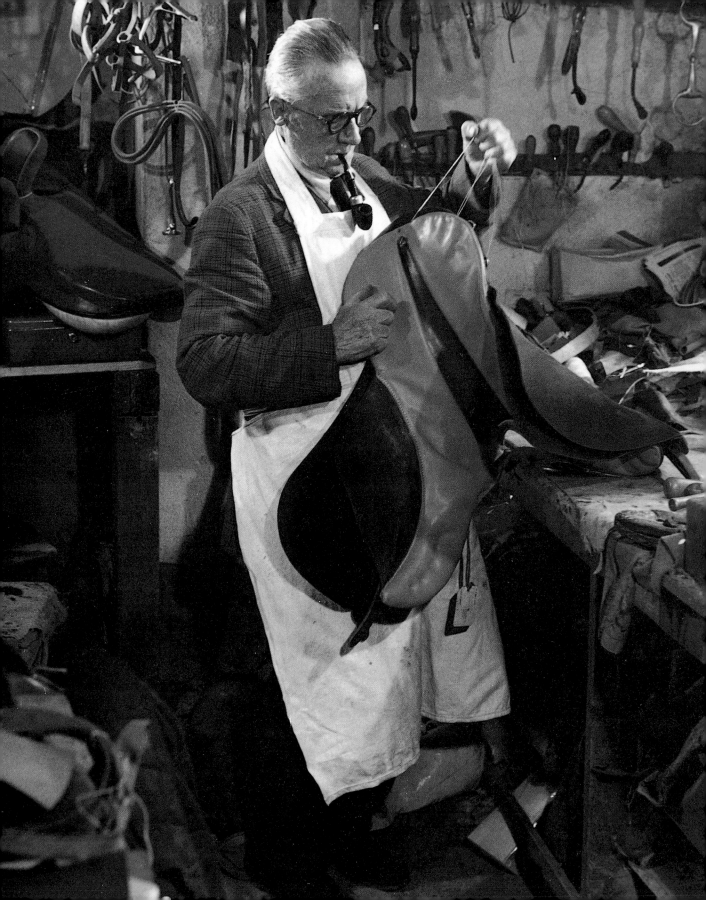

At all periods there appear to have been two parallel traditions of harness making. The wealthy and landed classes could afford fine-quality leather and fine fittings and were willing to pay craftsmen to manufacture saddles, bridles and sets of harness. The small holder by contrast made his own harness with wooden bits and *súgán* ropes.

Throughout the eighteenth century road networks improved and consequently the demand for coachbuilders, wheelwrights and harness makers increased. After the Napoleonic wars Bianconi established an extremely efficient transport network which covered most of the country. From prints published at that time it can be seen that the horses wore full collar harness of the finest quality.

The origins of today's harness makers are to be found in the early/mid-nineteenth century. Berneys of Kilcullen, for example, were founded in 1850; their letterhead at that time described them as 'Racing Hunting and Military Saddlers' and 'Harness Makers to the Carriage Trade'. Initially, their trade consisted of hunting and racing saddlery with some driving and working harness. During the First World War, business was quiet, but the Curragh Camp nearby was a centre for remounts being sent to war. Tom Berney senior, then a boy of sixteen, moved to the Curragh Camp where he worked full-time on the repair and maintenance of military harness. His father kept the shop open.

The demand for driving harness declined rapidly with the advent of the motor car, but up until the 1930s journeymen harness makers gathered once a year at Kilcullen, Co. Kildare, to remake and repair collars and working harness.

Today, Jim and Tom Berney continue to provide specialized saddlery for racing, hunting, dressage and show jumping. One of the great advantages of handcrafted work is that individual modifications can be made. New designs are promoted by international show jumping and dressage riders and the end product is shipped worldwide. At present, thanks to their traditional skills and to their ability to change and improve designs, the Berneys' business is thriving.

Tom Berney, now eighty-three, still does a full day's work alongside his sons Jim and Tom. He does most of the saddle repairs.

In Dublin two old firms of harness makers still survive; Pattersons and Greers of Poolbeg Street. Sam Greer is the third generation to work in those premises. Since the last war and especially since CIE (National Transport Company) and Guinness's dispensed with horsedrawn vehicles, trade in working harness has declined. Lately, however, there has been a great upsurge in show driving, which requires quality black patent harness and repairs to existing collars and tack. The rye straw used to fill the collars is still grown especially in Co. Fermanagh.

Working in Cork is John O'Connell, who was similarly apprenticed to his father as a young boy. For many years he worked in London making fine harness. When he returned home he was forced to seek work on a building site as there was no demand for harness or leatherwork. Some years later Tim Severin began to construct the *Brendan*, a boat made of hides, in which he subsequently sailed the Atlantic. He had enormous problems in assembling the hides but these were solved by John O'Connell using traditional harness makers' tools and skills. His leatherworking techniques were identical to those used when currachs were first made in the early Christian era. Since that time John O'Connell has been constantly in demand as a harness maker – most recently in making and decorating four superb straps for the newly restored Lord Chancellor's coach in the National Museum of Ireland.

The techniques of harness and saddle making have changed little throughout the last century. Both call for the best quality leather. Selected hides are vegetable tanned by a long process in pits, and then curried and finished. A top-quality saddle or set of harness also demands the finest quality workmanship. The leather must be carefully selected and cut, edges must be superbly finished and the stitching must be faultless with well-waxed handmade threads. There can be no short cuts.

Though economics is a controlling factor the future of saddlery and harness making in Ireland seems assured. There will always be a market for quality products and in buying a handmade saddle or a set of harness one has the intense satisfaction of knowing that one is buying directly from the man who made it – an enormous bonus in today's impersonal world.

LEFT *A bridle maker sews the reins directly to a hollow-mouthed bit using two needles. He has waxed and hand-plied his thread. The leather is held in a clam, a special saddler's vice.*

BELOW *A completed show-jumping saddle made by the Berneys.*

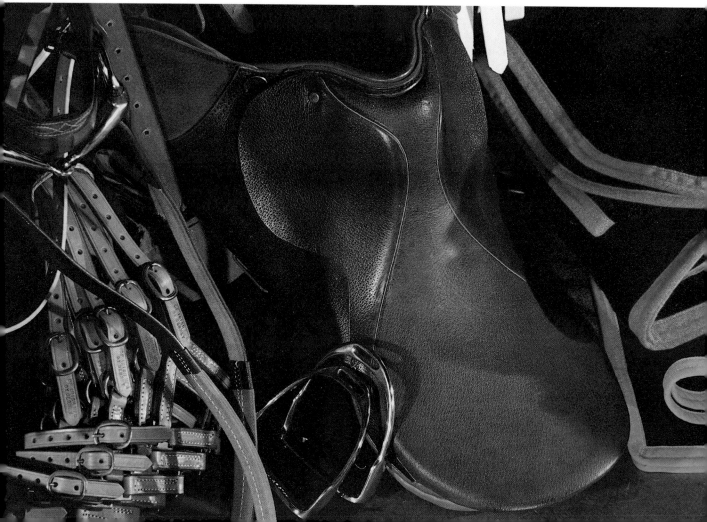

HARNESS MAKING TOOLS

skiving chisel

masher

dog

oval punch

awl

half-moon knife

palm iron

pricking wheel

collar needle

plain knife

single crease

stuffing iron

tack hammer

PAMPOOTIES

ABOVE *The foot naturally makes the most accurate measure for a raw-hide pampootie.* BELOW *A pointed stick makes an acceptable awl.*

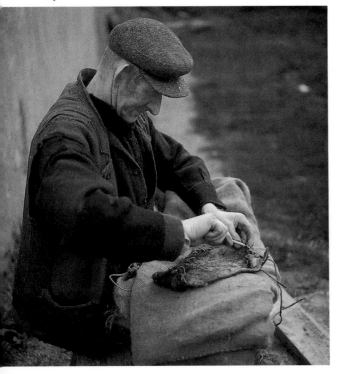

The Aran Islands, Co. Galway, are the only area where the pampootie (in Irish pampúta*), a raw-hide heelless shoe, can be found. At one time, its use must have been widespread and its survival on Aran is due to its suitability in local conditions. Large areas of the islands are extremely barren and covered in razor-sharp limestone rocks. Conventional shoes are quickly cut and scuffed, but the pampootie is ideal for walking and climbing over rocks, making full use of every crack and crevice. It is also useful for clambering in and out of frail currachs, allowing for frequent wettings without coming to any harm. A different style of walking has to be learned, with the weight of the heel thrown forward onto the ball of the foot.*

The pampootie is made from raw cowhide (formerly sealskin) with the hair worn outside. It is constructed from a single piece of hide which has not been tanned in the conventional way, but simply been rubbed with salt. The hide is rolled up and stored in a bag (nowadays polythene) to keep it supple until required.

To make a pair of pampooties, the foot is placed on the hide and an oblong section is cut out, large enough to allow for folding around the foot. Holes are made with a wooden awl every 2 cm around the edge of the hide, permitting a length of light nylon rope (formerly a leather thong) to be threaded through; it acts as a draw cord and is laced over the toes and grips the back of the heel.

Pampooties must never be allowed to become too hard as they will cut the feet. They are frequently soaked in a bucket of water overnight to keep them supple, or dunked in the sea during the day. When in constant use they will last for about one month.

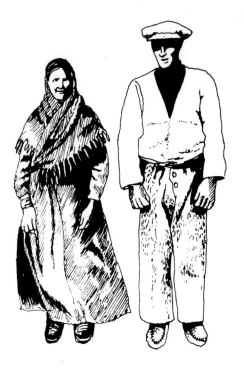

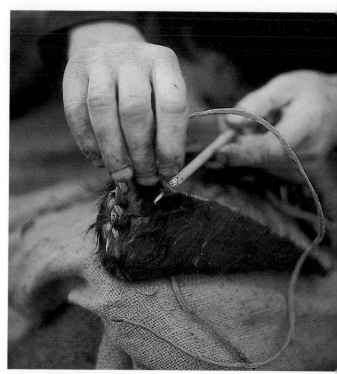

The older generation, especially the women, still wear traditional dress on the Aran Islands. Only the men appear to wear pampooties today – as summer footwear.

ABOVE *Colm Mór Faherty of Inishmaan has always made his own pampooties.* BELOW *Ideal footwear for walking the sharp limestone rocks of the Aran Islands.*

A pair of pampooties.

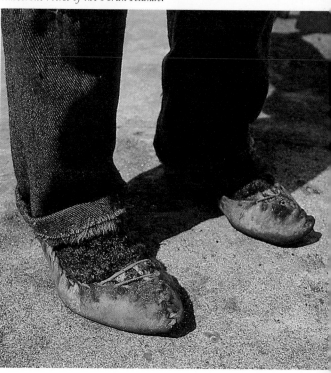

SHOES

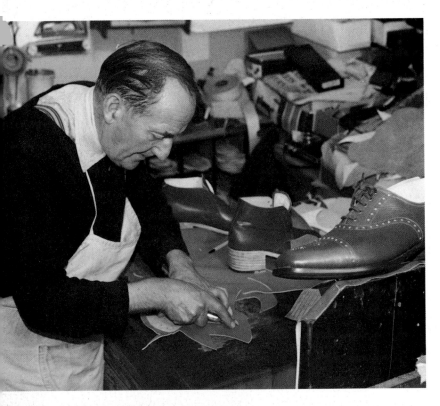

A hand-made pair of shoes calls for a series of minutely accurate measurements. The outline of each foot is drawn on paper and the measurements marked in. A last, a wooden replica of a foot, is selected and 'fitted up' to resemble the actual foot. Pieces of leather are cut and glued to its surface with great attention to detail. With both lasts complete, a pattern or template of the shoe is made in light cardboard, a very skilful business, which must take into account the three-dimensional shape of the shoe and make allowances for the leather to be shaped and stretched.

Edges that will be folded over and sewn are skived, or beveled, so that they appear less bulky. The eyelets and decorative patterns are punched and the uppers and linings glued and sewn together.

The sole is in four sections, all cut from specific pieces of leather with different characteristics; they are sewn, using the last to give the leather the correct shape and support.

The heel is built up in U-shaped sections called split lifts, which help to keep its centre level. A solid piece of leather the full width of the heel and a quarter-rubber finish the heel. The last can now be removed. A final trimming, staining (of the sole), buffing and polishing takes place. The shoe is stamped with the maker's name.

Before the brogues are passed as ready for the customer they are thoroughly inspected. The next time he orders a pair of shoes he simply writes. His name is on the last.

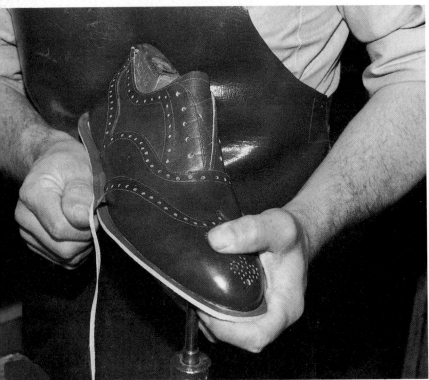

TOP *Joseph Tutty is a 'clicker', called after the knife he uses. He cuts the leather sections which will form the upper part of the shoe.*

BOTTOM *Trimming the insole to size. The shoe will remain on the last until the shoes and heels have been secured.*

OPPOSITE *George Tutty, Joseph's brother, and his son Edward. The family business makes a wide range of footwear, from riding boots to Oxford brogues, but they specialize in orthopaedic shoes.*

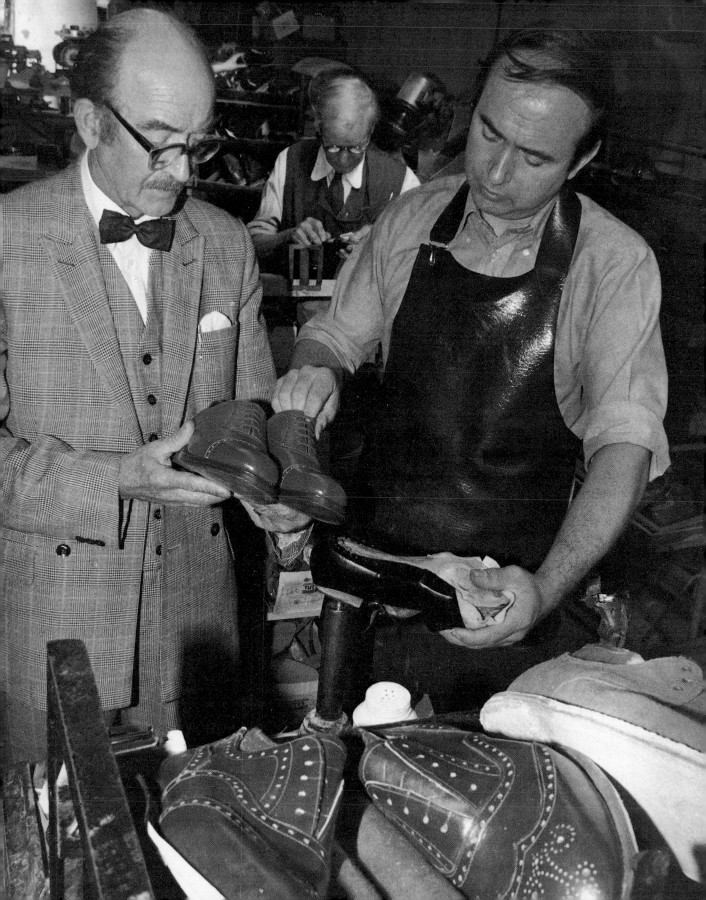

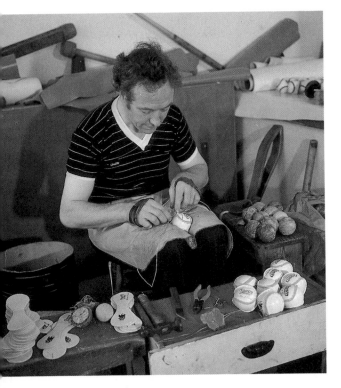

HURLING BALLS

The Gaelic word for hurling ball is sliotar, *which almost certainly comes from the old Irish word for hair:* liotar *(the typical hurling ball was originally made from horse-hair in a pigskin casing). Today laminated Portuguese cork forms the centre which is then spun with a yarn covering and double-dipped in latex. Two pieces of full-grained ox hide form the casing.*

Liam Dargan of O'Neills, Dublin, uses all the techniques of a saddle and harness maker. The thread he has prepared for sewing has a needle on each end and must be plied, rolled and waxed to make it waterproof.

He wears leather-stitching mitts to prevent the thread from cutting into the sides of his hands as he draws the stitches tight. When he has sewn on the covers he places the ball in a shallow depression in a piece of wood and hammers the joints. This flattens the seam and protects the stitches.

Modern sliotars *are now often white, for greater visibility. They are also more streamlined and their greater carry is changing the tactical shape of the game.*

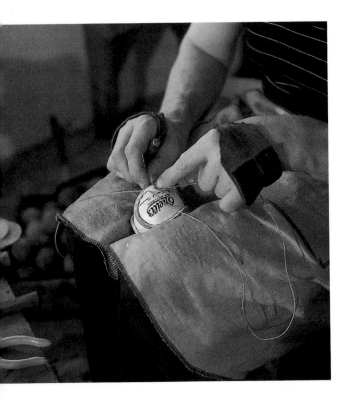

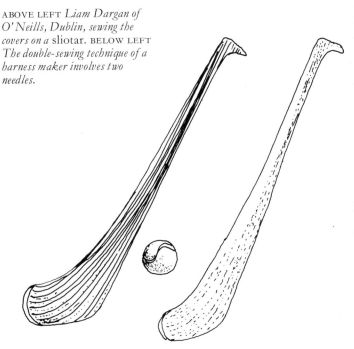

ABOVE LEFT *Liam Dargan of O'Neills, Dublin, sewing the covers on a* sliotar. BELOW LEFT *The double-sewing technique of a harness maker involves two needles.*

BOOKBINDING DESMOND BREEN

The history of bookbinding is inextricably linked with that of writing. The earliest forms of book were first the clay tablet and then the papyrus scroll. With the invention (*c.* 190 BC) of parchment – sheepskin cleaned on both sides – came a major advance in the evolution of the book, which by the fourth century had attained something like its present form of sewn folded sheets with oak boards as a protective cover. In the earliest binderies the wooden boards began to be decorated with a variety of materials: leather, silk and even velvet. Jewels and precious stones were sometimes used to embellish the covers of illuminated manuscripts.

The most well known of Irish bindings are the Irish Parliamentary Manuscript Journals of 1707 to 1801, which were all destroyed in 1922 during the Civil War, though not before they had been photographed. They were bound in crimson morocco and each lavishly tooled with no two alike, 149 volumes in all, 53 × 35 cm (21 × 14 in.). Many eighteenth-century Irish bindings were beautifully executed and, for their time, progressive in design; a few craftsmen signed their work and others can be identified by style or by their decorative handtools. Notable binders were William McKenzie, a bookbinder and seller who had a shop on Dame Street, William Hallhead, also of Dame Street, and George Mullen, who used a blend of blind and gold tooling and worked in Dublin during the first half of the nineteenth century. Following them there were the firms of Caldwell Bellew, Galwey and Cavenagh. There has been a revival of the art in recent times both in conservation and also in modern design bindings.

Designing the binding of a book can take many hours. The book is read through to allow design ideas to form in the mind. A number of sketches are made before the final design is selected. This design has to be made out to precisely the size of the book cover and a pattern is made to work from.

When a book has been taken from its old cover it is stripped of the old glue and sewing thread. Any paper repairs are done at this stage and it is then collated and marked up for sewing. The sewing of a book is one of the most important operations in binding as it determines how well the book will open when covered. Lines are drawn across the back of the sections to show the sewer the position of the sewing cords. If the finished binding is to have a smooth spine, that is if it is not to have raised bands, saw cuts are put into the spine folds to take the thickness of the cords. The sewing frame used by bookbinders has remained the same since before the early sixteenth century. The cords are positioned and set to the saw cuts, the sewing thread is passed in and out through the folded sections and around the cords in the process, tying down to each section at the ends. When the sewing is completed, the endpapers are attached and the spine glued.

Next the edges of the leaves have to be cut, top edge only or all round as required. The traditional method is to use a lying-in press and plough. This is a clamp apparatus which holds the book in a locked position with a slight amount showing above the jaws. The excess is trimmed with a plough knife, which is a very sharp knife that is pushed along a runner beside the clamped book. The blade is screwed in very slightly with every run until it has cut away the desired amount, leaving a perfectly smooth edge.

The most beautiful form of decoration for the edges of books is gilding, which, before automation and mass production, was a trade unto itself. It is a very complicated process and requires great skill and knowledge. After the edge has been cut it is first scraped and brushed over with a filler of paste and black lead (graphite). Then it is covered with a layer of size, made by mixing the white of an egg with a pint of water and then straining it through a cloth. A piece of gold leaf is placed on a cushion made from calfskin with the flesh or rough side uppermost. The gold, which is only 0.0001 mm (1/250,000 in.) thick, is made to lie flat when placed on the cushion by blowing gently on the centre of the leaf. The leaf is cut to the desired size. A well-filled sizebrush is passed quickly over the edge to be gilded and then the gold is lifted from the cushion and on to the book edge on a piece of heavy smooth paper, to which it clings by a smear of grease from the hair or forehead of the gilder. The leaf is applied to the book edge as fast as manageable and when dry (three to six hours depending on the

Teresa McMahon, who has been with the firm of Antiquarian Book Crafts since she was fourteen years of age. She sews the gatherings of a book together on a sewing frame.

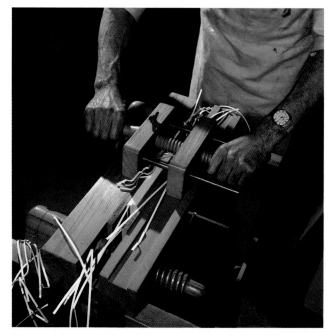

The gatherings are held in the 'lying-in press' and Desmond Smith uses the plough, a type of plane, to shave the top edge of the book regular and smooth for gilding.

Gold leaf is floated onto a chamois pad, prior to being cut into sections for laying on the edge of the book. The jamjar contains glair, an adhesive made from egg-white.

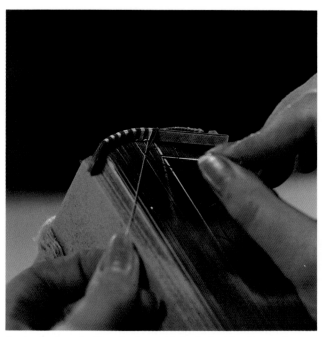

Sewing head- and tailbands of goatskin backed with vellum and whipped in silk of two colours. They give a book strength at a point where it is often gripped to remove it from a shelf.

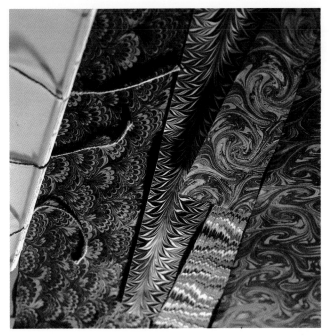

A selection of hand-marbled endpapers.

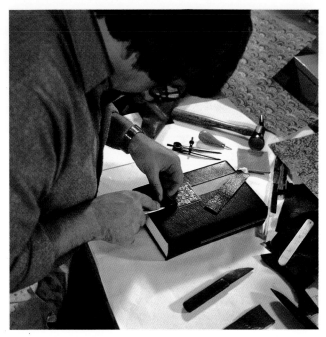

Fitting leather panels or 'onlays' onto the end boards of a bookcover. The small bone folder is a much-used tool of the bookbinder.

A modern binding by Des Breen of the book Letters of St Oliver Plunket, the martyr, *edited by Monsignor John Hanly.*

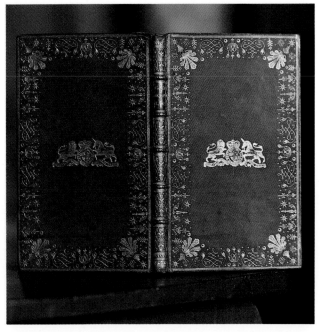

A fine eighteenth-century binding in red morocco with individual (not rolled) gold tooling and stamp of the Royal Hospital, Kilmainham; gilt edges, marbled endpapers. Marsh's Library, Dublin.

atmosphere of the room) the gold is ready to be burnished. The edges are first rubbed over with a waxed cloth to give the polishing tool a smooth run. The latter is an agate stone with a long handle held by the hand at the stone end and supported by the shoulder at the other. It is pressed firmly and pushed across the edge; a solid gold finish results.

The spine is then rounded by being tapped with a hammer while it is lying flat on a rounding block. Jointing or backing is the next process. The book is put into a backing press in its rounded form and screwed up tightly, leaving the thickness of the covering boards showing above the lips of the press. The backing hammer is brought down on the spine with a circular motion striking along the centre folds of the spine and spreading them towards either side. Progressing towards the outside folds an overlay is formed for the boards to lie into. The book is taken out of the press and an envelope of paper is tightly wrapped around the book to protect the gilt edge when covering.

The original purpose of headbands was to help withstand the strain on the book when taken from a shelf. They are thin strips of vellum which are stuck to goat-skin or cord and sewn onto the head and tail of the book. Silk or cotton thread is used to wind around the strips and is frequently sewn down through the folds of the sections of the book. They can be made very decorative by using different coloured threads.

The boards are next cut to size leaving a neat overlap of the edges for protection. If the boards are to have recesses or different levels they are sculptured at this stage to the outlines of the design pattern. The boards are punched near the spine so that the cords can be laced into them. The strands of the cords are separated, to allow them to flatten when attached to the boards.

A hollow or tubular spine formed with paper is glued to the spine of the book so that when covered with leather the spine is smooth and even. When the book is opened the outside of the tube falls back and prevents the leather from creasing along the folds.

The leather is next cut to size, allowing for turning-in around the boards. It is very important to pare away the leather at a slope along the edge, because that will determine how neatly the leather forms around the shape of the book.

The leather is pasted well, using rice paste, and drawn over the boards and spine of the book. The edges are neatly turned in, the headcaps are shaped and the leather is brushed over with a damp sponge to remove any surplus paste.

During the finishing processes the book cover is protected with a piece of lint or a soft cloth. When locked into the finishing press for spine tooling it is sandwiched between lint-covered boards. The easiest form of finishing is with blind tooling, that is impressing the handtool (usually heated) without using gold leaf. Dampened leather can be impressed with hot tools, which darkens the leather and gives a sharp definite impression.

Tooling in gold leaf is a very skilful art; accuracy in positioning, impression, gauging temperature and dwell (the length of time the tool rests on the leather) all have to be considered with the use of each tool. The design to be transferred in gold to the cover of the book is traced onto the leather and blind tooled. The blind impression is glaired in and when dry given a touch with a piece of greased cottonwool to hold the gold leaf in position. When the leaf is applied it sinks into the blind impression showing the outline and so giving a guide to the finisher when applying the heated tool. Handtools are never large as it is extremely difficult to get a clear and sharp result from a large tool.

Most of the work of finishers consists of applying the titles to bound books. Lettering by hand is not so common now; titling is done with a kind of movable type similar to that used for printing, except that finishers' type is made of brass. Bookbinders' brass type is very expensive: an entire font of printers' lead type can be purchased for the cost of a few characters of brass type. A spring typeholder is used to hold the type and it is used in exactly the same way as a handtool.

These are the processes involved in binding a book in leather with a modern design. Although technology in the twentieth century has disposed of the necessity for hand bookbinding on such a large scale, there will always be a demand for the hand craftsman who is skilled in the binding and restoration of individual books.

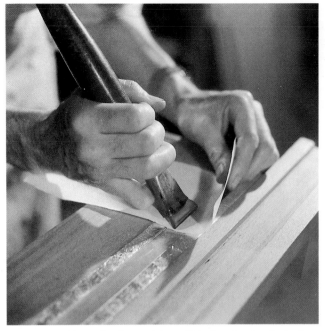

Agate-tipped burnisher for applying gold leaf to the edge of a book. The surface has been lightly rubbed over with beeswax as a lubricant.

Late nineteenth-century hand tools for finishing, some in the Celtic Revival La Tène style.

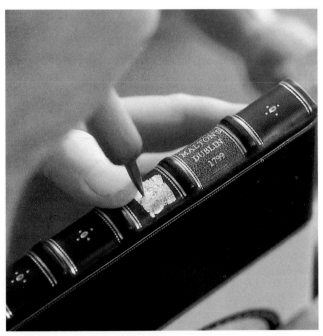

Applying the decoration in gold leaf with a hand tool to the spine of a book. The correct temperature of the tool is critical.

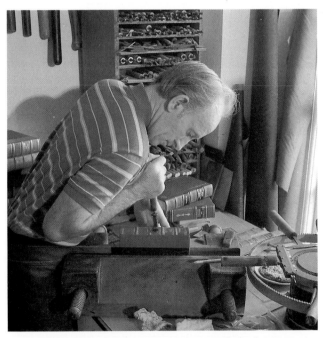

Noel Dunne blind-tooling the spine. Sometimes the leather is carefully damped with a fine paintbrush before the heated tool is applied. This darkens the leather.

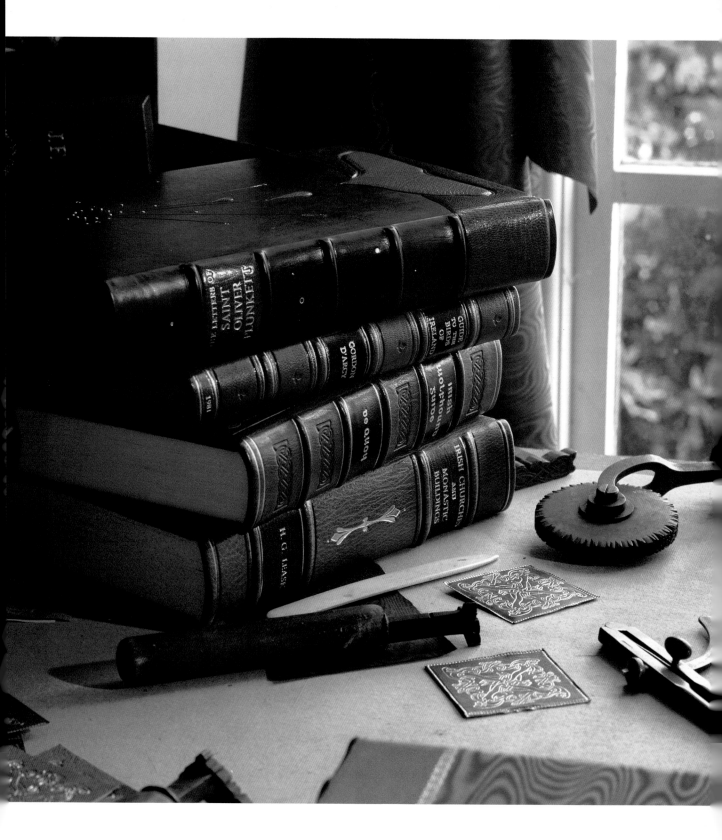

Metalwork

BLACKSMITHING Patrick F. Wallace

Up to the late 1950s, and in places possibly later, almost every parish in Ireland had at least one forge and a blacksmith. The word 'forge' was generally preferred to the more English 'smithy' and though strictly speaking a 'blacksmith' dealt with ironworking and a 'farrier' shod horses, the Irish country and village blacksmith performed such a variety of tasks that that seems a more appropriate term for him.

The blacksmith's work ranged from repairing agricultural implements, shoeing wheels, and making gates and railings, to shoeing horses, ponies, mules, jennets and donkeys. He thus provided a service for all classes of farmer, from the landed aristocrat with his hunting horses and advanced agricultural machinery to the farm worker with the tools he needed to care for his plot. In Munster and Leinster schoolboys had their hurls banded or hooped at the forge. Even tinkers with their untidy horses, waggons, cars and caravans were among the varied social groups who called at the forge. Tinkers were one of the few groups who could fit their own horseshoes and were most often looking for cheap seconds (or 'slippers' as they called them) rather than for sets of new shoes. The importance of the blacksmith in Irish society is well known. Apart from his iron working and horseshoeing, the blacksmith was known to have pulled human teeth and the water in his trough was a favourite cure for warts. The smith was also called on to treat horses. The countryside and its people could scarcely have survived without their blacksmith and he certainly could not have lived without their patronage.

Some forges were neatly constructed of dressed limestone with a wide ornamental doorway in the shape of a horseshoe in the gable wall. These were often connected with a large estate and may have been built under the patronage of the local landlord. More usually, the town and country forge in Ireland was a fairly small building with a dark interior characterized mainly by a large raised hearth around which most of the life of the blacksmith was conducted. The fire was fanned by a hand-operated bellows. This was either a huge pear-shaped, black

leathered 'melodion' or a hand-wound metal machine with numerous internal rotary blades which stood on a metal pole. A long bench stood against one of the side walls and on it were mounted drills and edging stones; leg and clamp vices were attached. Other tools were suspended from wall pegs, though many larger tools like sledgehammers, wrenches and dogs were ranged about the anvil in the centre of the floor.

A water-filled iron trough or tub into which satisfactorily shaped objects were rapidly plunged for tempering was located near the anvil. The anvil had one beaked end with a flat working face on top which was silvered from use. A chisel was seated in a toe-hole at its other end. The same hole also occasionally accommodated a small anvil or 'bickern'. The anvil was mounted on a large cylindrical wooden block, the bottom edges of which were nailed to the floor. Around the hearth were the necessary pokers, shovels and tongs.

Brought up as the son of a blacksmith, the forge provided me with some early impressions. Two principal smells, each related to a vivid image, come readily to mind. One is of the burning hoof keratin as the hot shoe was applied to it and the resultant off-white smoke which went out of the doorway. The other is of the horse dung which occasionally fell on the clean wooden floor. Two distinctive sights also stand out. On a bright day the sunlight pressed through a chink in a wooden shutter in the wall and like a cinema projector spotlighted thousands of dust particles which normally floated in the air undetected. The other followed the removal of the red-hot iron from the fire. It was cut or beaten on the anvil where, when first hit, it made a soft yielding thud rather than the more musically defined chime as it hardened. The first blunt thud or two also led to a spread of large orange-red flake-like sparks from the red-hot surface. These usually blackened before they hit the floor where they became part of the ever-accumulating pile of metal dust.

The constant sweeping of the dung to the same corner of the forge, and its attendance by its very own species of fly which nature camouflaged in a sympathetic orange-brown hue, are other memories. Oat seeds passed in these droppings were an unfailing source of seduction for local hens who

The bread stone or harnen *stand allowed the blacksmith to demonstrate his skill and imagination. Oat cakes were baked on a flat metal bakestone and then placed on a* harnen *stand in front of the fire to harden or toast.*

Iron rush and candle holder, Co. Donegal, height when fully extended 95 cm, Folk Life Collection, National Museum of Ireland. Iron rush and candle holder, Co. Cavan, height 38.5 cm, NMI. Fir split holder, Co. Antrim. Iron rush and candle holder, height 37.5 cm, NMI.

wisely usually confined their attentions to the yard outside where they wove their way between the legs of horses with great dexterity. The floor-sweepings after every shoeing, which included flakes of rasped metal and hoof as well as snapped off nail points and large hoof-pairings, also made their way to the unsavoury rubbish pile in the corner of the floor.

On a busy day customers tended to form into chatting groups either inside or outside the forge as they waited their turn, while their horses craned their necks between the machines to which they were tied to nibble at the tender moist grass which grew up between the more permanently parked machines or gates. Except on a busy haymaking or harvest day during a fine spell, when the farmer's 'boy' was dispatched to the forge by bicycle for a quick repair on the finger-blade of a mowing machine or the pin of a slide, they seemed to relish the delay and the opportunity of an extended chat with old friends – the forge, like Sir Roger de Coverley's Church, being a social institution. Forges were inevitably located on streets, near the sides of roads or at crossroads. It is no wonder that they became such great meeting-places and venues for political discussion. So significant was the forge as recruiting centre for popular movements that an Irish publisher has named his press Anvil Books!

The ritual of shoeing began with the untackling of the horse from whatever vehicle it was attached to. The heavy straddle and bellyband were often taken off, but the breeching and neck-collar were left on the horse as were the winkers and mouthpiece by which the horse was tightly held while being shod. In the case of a new set of shoes, four suitable lengths of iron of the requisite gauge were cut from a long bar. More often only second-hand shoes, or 'removes', were required; the hooves were in this case pared and refreshed, and the old shoes fitted tightly back on. The hooves were done one by one and each was held by the blacksmith between his thighs while being shod. The old shoe was removed with pincers, after which the hoof and frog were cleaned and pared with a bone-handled drawing knife while the new shoe length was being prepared in the fire. A medium-sized hammer was used to beat the shoe into shape. A number of nail-holes were punched through the shoe with a handled punch or pritchel. A toe-clip was beaten up from the edge of the shoe on the point of the anvil and the outside end of the shoe was either thickened up from the shoe or perforated to take a stud to prevent slipping.

Most of the shoeing iron came with pre-forged channels to take the nails but it was also possible for the blacksmith to groove the iron himself by using a fuller. He usually had to make several trips between the fire and the anvil with the shoe gripped by the tongs before the shaping was satisfactory.

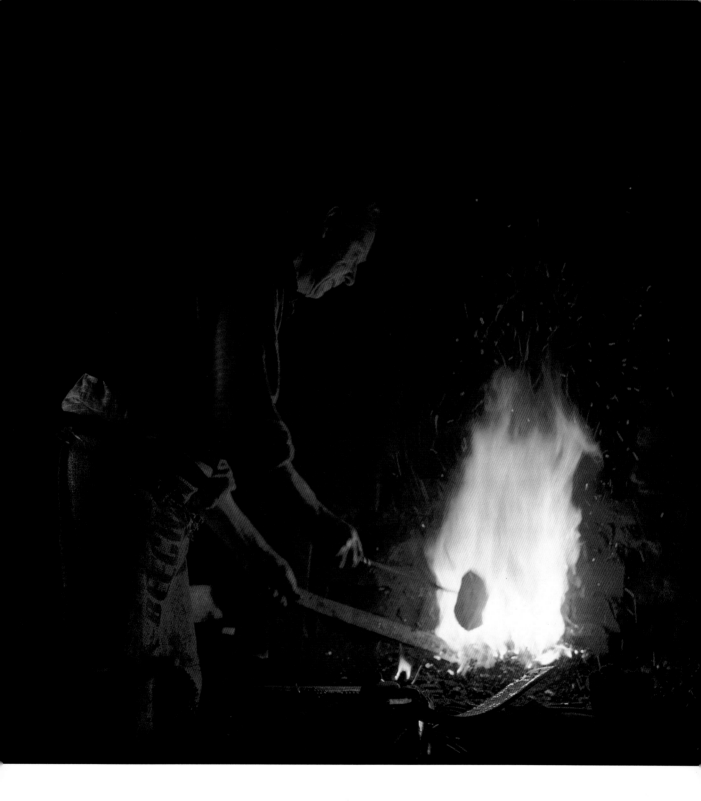

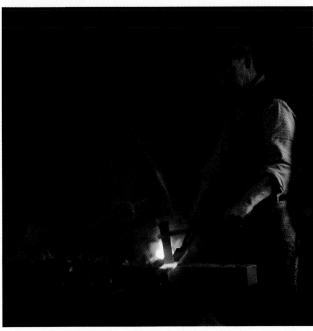

John and Paddy Moloney are third generation blacksmiths in
Ennistymon, Co. Clare. They are trimming a roof tie on the anvil.

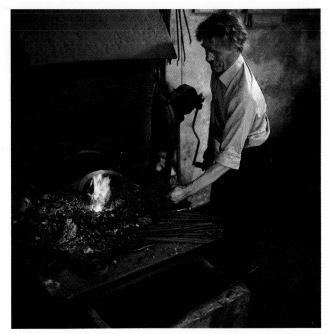

Jimmy Kerrigan and his brother Dan, of Slatta near Rooskey, Co.
Roscommon, still make loys, slanes (for cutting turf), sickles,
pokers, tongs and gates. They continue to work as farriers.

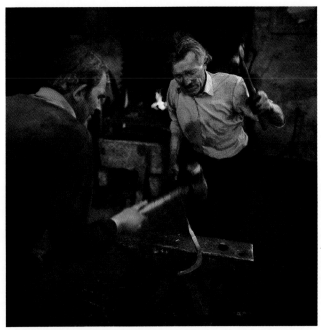

Forming the blade of a sickle on the anvil, one of the most ancient of
tools. This double-hammering technique calls for perfect timing.
Later the delicate tip of the sickle will be drawn out.

Adjusting the curve of the sickle blade on the anvil beak. The tool
will be tempered, sharpened and set in a long handle to be used locally
for cutting rushes for basket weaving.

Eventually the stage was reached at which the hot shoe was gripped by a punch suitably struck in a nail-hole so that the shoe could be fitted to the now prepared hoof. Very often further adjustments were necessary before the first nails were driven. Even then, fitting corrections were possible until the last nails were driven home. The nails were driven in at an angle so that they emerged through the hoof at a distance above the shoes, the end of the new nail being cut off with the claw end of a light shoeing hammer. A buffer or the jaw end of the pincers was used as a support under the nail while the smith clinched the end with his hammer.

Each hoof was brought to this stage of completion before the smith did the rounds of hooves again when he rasped the hoof flush with the outer edge of the shoe to prevent it from getting caught and being pulled off. The rasping also made for a superior all-round appearance. Most tools in the forge – with the obvious exceptions of the chisels, drills, vices and swage (where used), were made by the smith himself, as were wrenches, dogs and other tools. In respect of making his own tools the blacksmith was unique among craftsmen. He also made, repaired, sharpened and pointed tools for other craftsmen such as carpenters, stonecutters, masons, wheelwrights and harnessmakers, as well as for farmers.

Farm machinery was constantly in need of repair. Pins of swathturners, wheel-rakes and slides, as well as socks and coulters of ploughs, were among the most common repairs. Finger-bars and knife sections of mowing machines and reapers often gave trouble also. Horse-drawn vehicles needed constant attention to their shaft staples, iron harness hooks and traces and especially to their wheels, which had to be shod in iron bands or tyres. The variety of wooden wheeled vehicles included traps, dray or common cars, back-to-backs, roadmen's carts and wagons and even wheelbarrows.

Some farm machines rarely travelled on roads and had cast iron wheels. Wooden wheels not only had to be shod in iron but also had stock bands, axles and lynch-pins which were made or repaired at the forge. In wheel-shoeing the old band was removed and the wheel laid on a large iron, stone or concrete disc or wheelplate. A small iron disc or traveller was rotated around the outer edge of the wheel felloes to measure the size of the required band, a chalk mark on the wheel enabling the rotations to be counted. The red-hot iron band was lowered over the wheel, levered tightly in place by huge iron jaws or dogs, and secured by the blows of a sledgehammer. The wheel and tyre were immediately cooled with a bucket of water to contract the iron and expand the wood into an even tighter fit. Iron bands and 'S'-hooks had also to be made for and applied to wooden swingles or quins by which a horse was harnessed to farm machinery.

Price scales for blacksmithing were occasionally fixed by common consent. Between sixty and seventy master blacksmiths met on a September Sunday in 1872 at Nenagh, Co. Tipperary, and agreed on a range of prices which included 3/6 (17½p) for a set of new horseshoes, 1/9 (8¾p) for removes, 2/- (10p) for a set of shoes for mules and gennets, 1/- (5p) for removes and 1/6 (7½p) for a set of shoes for mules and gennets where the iron was supplied. Almost fifty years later, blacksmiths at Birr, Co. Offaly, agreed £1.00 for a set of new horseshoes and 10/- (50p) for removes, 5/- (25p) and 3/6 (17½p) respectively for new sets of shoes for gennets and donkeys.

Some idea of the range of work covered can be obtained from an examination of blacksmiths' ledgers. The following extracts from an account drawn up in 1943 for a farmer in Munster reveals a regular visitor to the forge.

May	7	Set of removes to big horse	8/0	(40p)
	17	Pointing both ends of pick	1/6	(7½p)
	19	Set of shoes to bay cob	14/0	(70p)
	30	Repairs to scuffler	7/6	(37½p)
June	15	Set of removes to bay cob	7/0	(35p)
	21	Repairs of mowing machine	15/0	(75p)
		& Supplying new fitting	£1/1/0	(£1.05p)
The bill for a nine month period totals			£10/19/6	(£10.97½)

The nature and scale of this account and the frequency of the farmer's visits to the forge may be contrasted with that of a carpenter at a North Tipperary forge from March to August 1911:

March 16	Pointing harrow	2/8	(13p)
20	Racks and crooks to Darcy's car	5/-	(25p)
30	Removes to mare	1/3	(6¼p)

May	5	Mounting Miss Slattery's trap	12/—	(60p)
	27	Shoes on mare	2/6	(12½p)
	27	Crooks and shoeing wheels for car	5/6	(27½p)
Aug	3	Shoeing Wheels	4/—	(20p)
	16	Racks and crooks to donkey dray	2/—	(10p)
			£1/14/11	(£1.75)

The similarity of the ledgers is remarkable in their layout, their descriptions of jobs and general terminology. It seems as if an apprentice blacksmith was shown how to keep a ledger in addition to learning ironworking and horseshoeing skills and techniques.

There are very few smiths of the old type left today. In just a few years they seemed to have disappeared along with their forges, which not so long ago were such a conspicuous feature of the countryside. The livelihood of the traditional blacksmith was threatened by the invention of the motor car and even more so by the introduction of tractors, excavators and bulldozers, all of which became gradually more widespread in Ireland after the conclusion of the Second World War. The subsequent recovery of the world economy was reflected in Ireland by the expansion of the economy and the growth of prosperity at the beginning of the sixties. The number of horses declined. Old farm machinery was literally ditched, to be replaced by tractor-driven implements constructed of metals for which electric welding equipment was necessary. Foundry-built welded tubular steel gates replaced riveted forged gates. The electric welder arrived in the wake of the rural electrification of Ireland in the late fifties.

Many blacksmiths retired; others were compelled to seek alternative employment or to emigrate. More diversified and came to grips with electric welding and the distantly related garage business. Others concentrated purely on farriery where that was possible and a few opened up ornamental ironworks. The economic recession of the late seventies and early eighties encouraged the exploitation of local, traditional resources and stimulated a revival of interest in the ancient craft of blacksmithing that gives hope for the future.

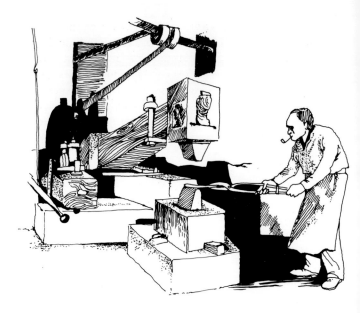

The late Arnold Patterson plating the blade of a spade at the Coal Island trip-hammer. Permanent exhibit, UFTM.

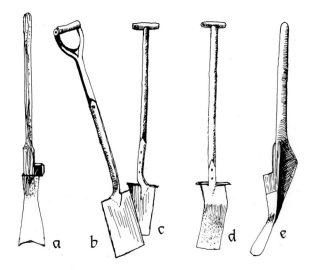

a *Kerry spade (a type of loy).*
b *English type*
c *Wexford spade.*
d *Bent ridging spade, Co. Fermanagh.*
e *Loy, Co. Leitrim.*

The spokes (made of oak or ash) are held in place by felloes (ash) around the rim. Knocking a felloe onto the spokes of a light gig wheel at Breen's Carriageworks in Enniscorthy, Co. Wexford. Any irregularity in the wheel will cause undue wear and discomfort.

Pat Sludds the smith measures the circumference with a traveller. He notes the number of revolutions of the smaller wheel and transfers the measurement to the wheel band in order to cut it to the correct length.

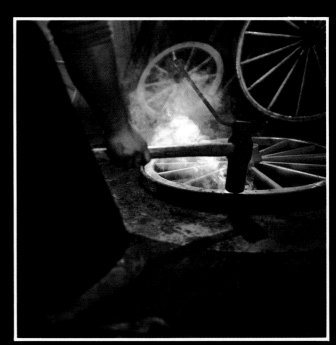

The wheel band or shoe must be heated until nearly red-hot before it can be fitted to the wheel. Pat Doyle turns the wheel with a wrench to allow it to heat evenly.

When the wheel band has reached the correct temperature it is placed over the felloes and hammered home. The wheel is held securely in place on a metal platform.

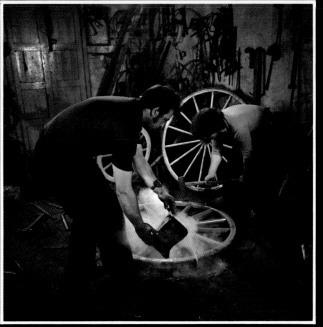

Once in place the wheel band is quickly cooled to prevent it burning the wood. The cooling metal shrinks, gripping the felloes tight. Only if the wheel becomes excessively dry will this band come loose.

Much of the distinction of these carriages depends on the finishing. Colm Breen, who with his brother Kevin owns the carriageworks, lines a wheel.

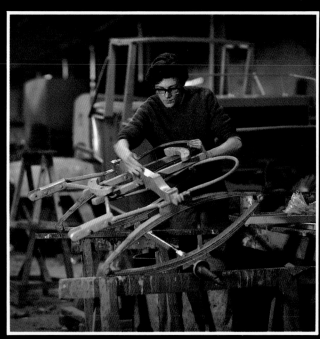

The lining brush consists of a small quill handle with long hairs of sable, and the lines are drawn not with a fine tip but with the full length of the brush hairs. No task calls for a finer hand or steadier eye.

Billy Brooks, the owner's nephew, sands down a gig fore-carriage for painting. Between ten and twelve coats of paint may be applied, and always brushed on rather than sprayed, to give the desired depth of paint and mirror finish.

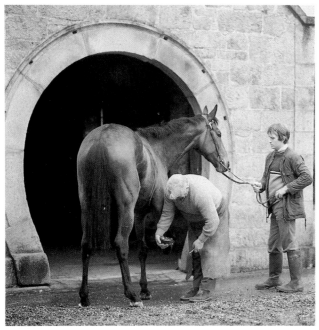

Ben Ryder, blacksmith and farrier, shoeing a horse for Norman Doolin. The granite-built Enniskerry forge was erected in 1843 as part of the Powerscourt estate.

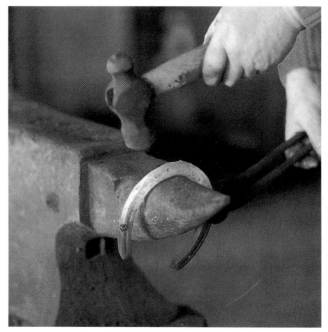

Shaping a horseshoe on the beak of the anvil.

Jack Furlong of Bray, Co. Wicklow, now eighty-two years of age, making an 'S' scroll on a former for a gate. The iron does not have to be red-hot at this stage.

Detail of a gate made by Jack Furlong; the leaf design is deliberately reversed to avoid a rust trap.

GOLD- AND SILVERSMITHING
DOUGLAS BENNETT

Articles of gold and silver have been made in Ireland from very early times. Four thousand years ago, from the beginning of the Bronze Age, gold items, consisting mostly of pieces for personal adornment, were made and worked with considerable skill. These include collars or lunulae, bracelets, torques and girdles. After the introduction of Christianity in about AD 500, articles of mixed metals were extensively produced with a versatile skill which has never been rivalled since. During this period, which lasted until about AD 1500, such well-known items as the Ardagh Chalice, the Cross of Cong, the Tara Brooch and shrine of St Patrick's Bell were manufactured in a combination of gold, silver, bronze and other metals. From AD 1500 silver was the metal most commonly used, the church being the great patron of the silversmiths. The vast bulk of vessels which have survived from the period 1500–1600 are chalices.

The guild system entered Ireland about 1169 after the establishment of the Anglo-Norman settlements, and a list which probably dates from the end of the twelfth century names Roger and William as goldsmiths. The fact that goldsmiths played a prominent part in the Corpus Christi pageant of 1498 suggests that they were established in a guild of their own by then. A minute of the Common Council of the City of Dublin in 1557 acknowledges that the goldsmiths – a term which incidentally also applies to silversmiths – had a charter prior to this date and that it had been accidentally burned. In 1637 Charles I granted a charter which established the Company of Goldsmiths of Dublin and gave it wide powers to control the manufacture and sale of gold and silver in Ireland. This charter came into effect on 6 April 1638, when the first piece of silver was assayed and hallmarked. It made the use of sterling silver compulsory in Ireland. Sterling silver is metal of not less than $92\frac{1}{2}\%$ pure silver. The metal for the remaining $7\frac{1}{2}\%$ of the alloy was not prescribed; it was usually copper.

It also prescribed two marks for silver: the goldsmith's proper mark and the harp crowned.

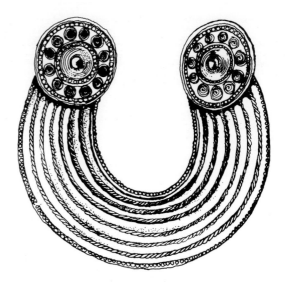

Gold gorget in repoussé *work from Gleninsheen, Co. Clare. Late Bronze Age. NMI Collection.*

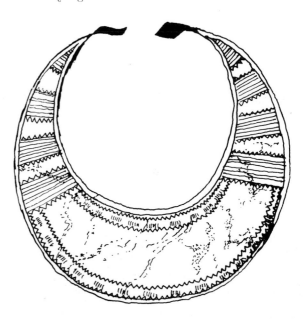

Lunula in beaten and engraved gold from Dunfierth, Co. Meath. Early Bronze Age (National Museum of Ireland Collection).

The goldsmith's proper mark is the maker's mark, and the charter ruled that the punch of the artificer must be impressed on each piece of silver. This was usually done before it was sent to Goldsmiths' Hall for testing. Each silversmith had to register his

Blocking up a silver dish on a tree block using a ball-faced hammer.

RIGHT *Silversmith Tony Marshall piercing a dish ring.*

Raising the dish on a metal stake, called a horse, using a buffalo-horn mallet.

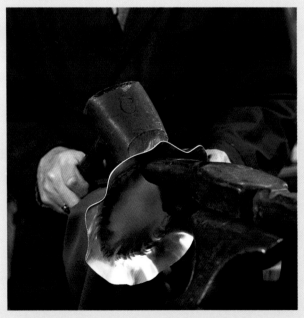

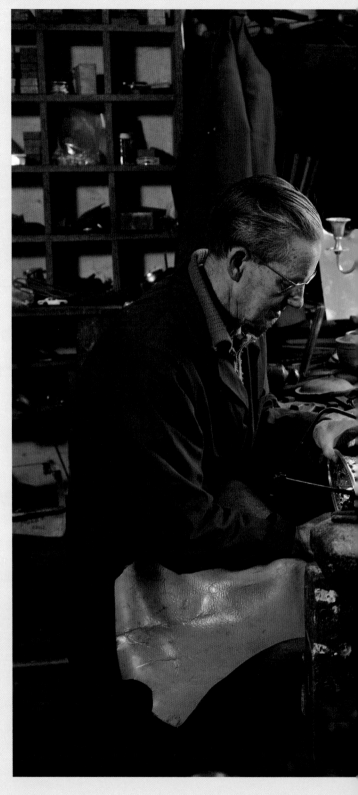

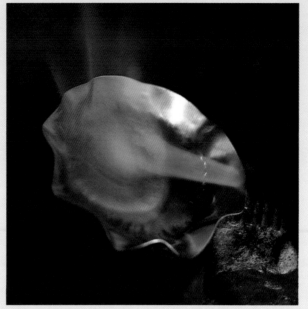

Annealing prevents the silver becoming too brittle and cracking. It is heated until it becomes red-hot and plunged into cold water to make it malleable once more.

Chasing a dish ring (see p. 184); repoussé work by Aidan Breen.

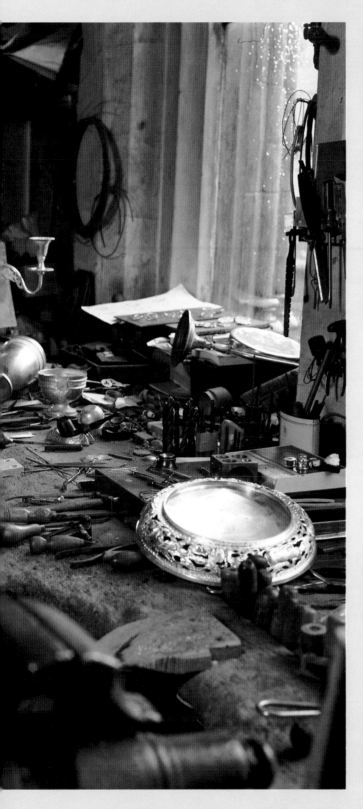

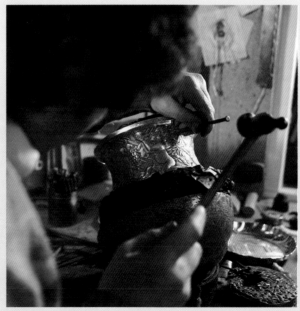

punch with the Master and Wardens of the Goldsmiths' Company. When the article was submitted it was tested and if found to contain the correct alloy it was stamped with the fineness mark in the form of the harp crowned. If the silver content was below $92\frac{1}{2}\%$ the vessel was smashed, cut into pieces and returned to the manufacturer. The same procedure applies to the present day.

Together with the harp crowned and the maker's mark, a date letter was used from 1638. There was no provision in the charter for this mark. No doubt it was adopted to keep a proper record and it had the advantage of establishing an actual time of manufacture. In 1730 a fourth mark, the figure of Hibernia, was added to certify the payment of a duty of 6d an ounce. In 1807 a fifth mark, the sovereign's head, was introduced for the same purpose and increased the duty from 6d to 1s per ounce. The Hibernian mark continued and gradually came to be regarded as the town mark of Dublin. The sovereign's head mark, Queen Victoria's at that time, was discontinued in 1890, when excise duties on gold and silver wares were abolished.

Irish domestic silver was at its most restrained from about 1705 to 1740, being manufactured by craftsmen using heavy-gauge metal. It was a time of plain surfaces and elegant proportions. The Rococo period was late to arrive in Ireland: it was established in England in the 1720s, but the earliest-known Irish piece with Rococo chasing is dated 1740. This was a time when the argument 'Nature abhors a straight line' was the order of the day and this asymmetrical period lasted from 1740 to 1770. The Adam style of Neo-classicism first made its appearance in Ireland about 1770 and lasted into the 1800s. There is no special Irish version of this classical influence. It is probably best remembered in Ireland for its beautiful bright cut engraving. A seven-year apprenticeship period led to extremely high standards of craftsmanship during the seventeenth and eighteenth centuries.

The nineteenth century opened in Ireland with the disastrous Act of Union which saw the abolition of most tariffs, enabling silver to be imported fully assembled into Ireland and sold as being of Irish manufacture. In spite of enormous competition from England, there arose a small group of dedicated craftsmen working in Dublin whose work was manufactured and decorated almost entirely by hand. It was a time which was similar in many ways to the Rococo period of the eighteenth century – decoration ran wild with a combination of birds, flowers and foliage. By 1850 the silver trade was at a very low ebb, but in that year the Tara Brooch was found. Two copies were made and sold to Queen Victoria at the Great Exhibition of 1851. This helped the silver souvenir business, which was being influenced by the new celtic revival and an interest in Ireland's past.

By the third quarter of the nineteenth century, celtic interlaced ornament, shamrocks and harps together with wolfhounds began to appear on most silver, and silversmiths copied most of their designs from the past. This same trend persisted into the twentieth century. After the 1916 rebellion the silver trade settled down to an uneventful fifty years, hampered by shortage of materials during the war years of 1939–45. A special hallmark to commemorate fifty years of independence in 1966 gave a welcome boost to silver manufacture and many interesting and unusual wares were commissioned during that year. Another special hallmark was introduced in 1973 to celebrate Ireland's entry into the EEC and this helped to create a further interest in Irish manufacture. That year an ice cube container, decorated with the arms of the Dublin Goldsmiths' Company, was presented, on their behalf, to the late President de Valera for the nation.

Today there are over 250 makers of gold and silver registered at Goldsmiths' Hall, but only a tiny number of these can be said to be producing gold and silver in commercial quantities. Over the years workshops come and go. Inflation and the very high price of precious metal have hit manufacturers in recent years, but there has always been, and still is, a small core of dedicated craftsmen who carry on the centuries-old craft.

In the method by which a piece of silver is 'raised' by hand, the craftsman uses a section of a tree trunk with a shallow depression sunk into it to start the shaping of the body. A disc of silver cut to size is placed over the trunk and hammered with a ball-faced hammer. The craftsman works round and round the disc, gradually moving towards the

The firm of Alwright and Marshall was established in 1929 in Fade Street, Dublin, when it took over the premises from West, Wakely and Wheeler, who had been working from there as silversmiths since the end of the nineteenth century.

Silversmith Tony Marshall has been with the firm for fifty years since he left school at the age of fifteen. He has the distinction of having made the first copy of the Aga Kahn Trophy in silver gilt in 1937, when the original was won outright by Ireland. The Nations' Cup, it is presented at the Dublin Horse Show, one of the world's top show-jumping events, in August each year. Tony Marshall made further replacement cups in 1975 and 1979. He also made a facsimile of the twelfth-century Cross of Cong, which is now at Knock shrine, Co. Mayo. It was executed in 14-carat gold from melted-down pieces of jewellery donated by pilgrims, and took four years to complete.

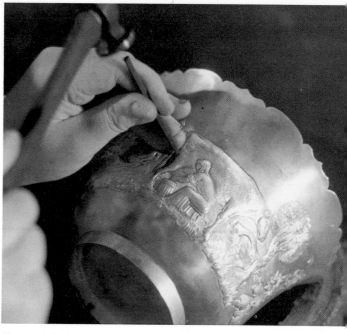

Chasing the body of a silver teapot. The shape of the object and design follow the tradition of the late eighteenth century in Ireland. Royal Charter Silver Ltd, Dublin.

Hallmarks from left to right: 'P', date letter for 1811; the harp crowned, a fineness mark applied to 22-carat gold and sterling silver of a standard of 925 parts fine silver in each 1000; Hibernia, duty mark introduced 1730; Sovereign's head, George III, new duty mark introduced 1807; another version of the harp crowned.

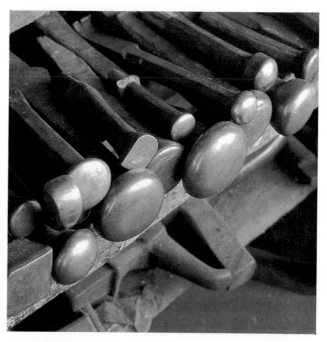

A selection of stakes. A raising stake is a small anvil over which the disc of silver is placed for hammering into the required shape.

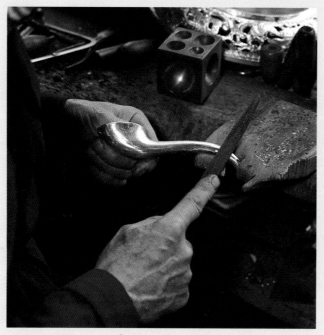

Filing a teapot spout. A leather pouch in front of the craftsman collects the filings and waste scraps of silver which are sold back to the bullion dealer for re-smelting.

Buffing a large silver bowl with a walrus-hide buff and pumice powder. A chased design must be 'stopped off' – protected by applying cold water cement which sets hard and is later washed off.

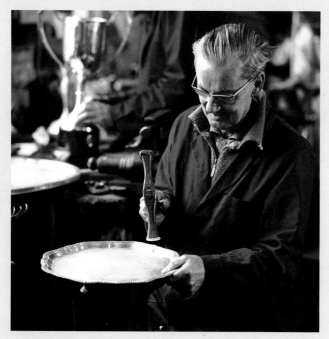

Hammer marks are removed by planishing: placing the object over a smooth, polished stake and beating with a flat hammer (one end generally fitted with a leather cap) over the entire surface.

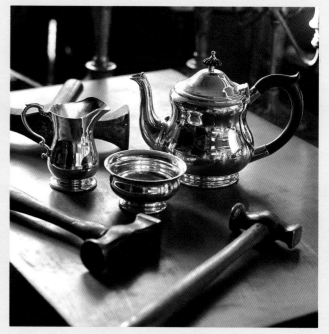

A plain silver milk jug, sugar bowl and teapot by Alwright and Marshall Ltd, Dublin.

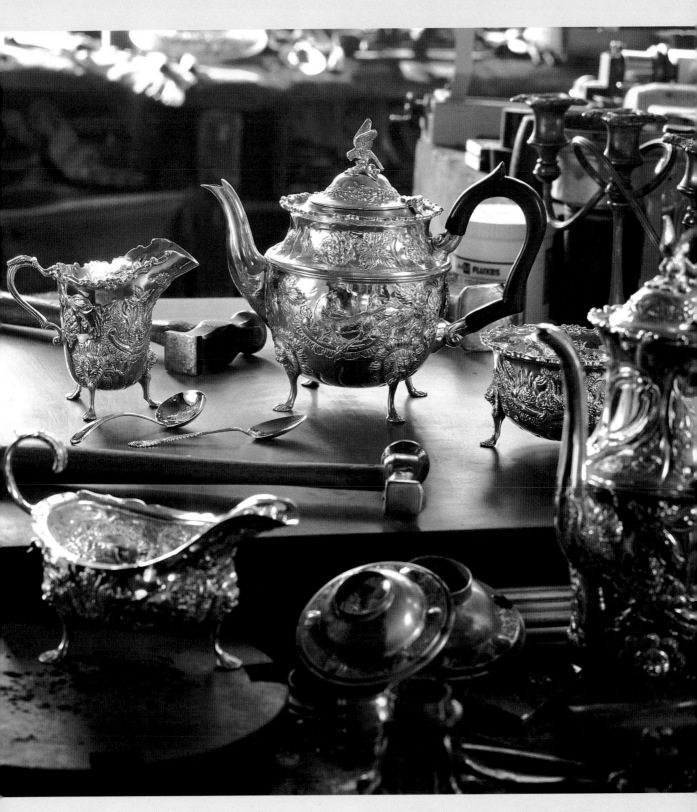

Tea set: milk jug, teapot and sugar basin. In the foreground a sauce boat and coffee pot. Repoussé *work. Alwright and Marshall Ltd, Dublin.*

centre, by which time he has raised the flat disc to a saucer shape. With this amount of hammering the atomic structure of the metal has changed, making it hard and brittle, which necessitates annealing with a flame until it glows red. The disc is then dropped into cold water to restore the malleability of the metal. The next process is to place the disc over a small anvil, known as a raising stake, when another hammering process takes place, this time from the centre outwards, the silversmith stopping to anneal when necessary. This hammering continues until the required shape is formed. At this stage the vessel is covered with rather obtrusive hammer marks; to remove them requires yet another technique, known as planishing, in which the body of the article is hammered with a flat hammer, often covered with a heavy leather cap, leaving tiny regular indentations over the entire article. This gives hand-raised silver its character.

A much quicker method of making a similar item, but without the same effort, is by spinning. Because the spinner has first to turn up the shape in a boxwood chuck or former, this method is used mostly for batch production. The process consists of placing a silver disc against a chuck attached to the spindle of a lathe which is rotating. The disc is then forced over the chuck with a long-handle chisel tool. Again, like hand raising, the metal is annealed continually to overcome hardening. A shaped article, such as a coffee pot, requires several chucks of various sizes. As with hand raising, the finished product is then highly polished; the spun piece has a hard mirror-like finish, as opposed to the softer patina of a hand-raised item.

According to taste and fashion, silver may be decorated and various methods are used. There are two types of decoration by removal. In the first, saw piercing, a hole is drilled in the silver, a saw resembling a fret saw is inserted and a design cut out. In the second, engraving, a pointed steel tool, fitted in a small round handle, cuts a channel in the silver. This was used for bright cut design in the Adam period and is the way that inscriptions are put on wares today. Another form of decoration is that of chasing, which is done in two ways, flat chasing and repoussé work. With flat chasing, a design is tapped onto a surface with a steel tool hit with a hammer. In repoussé work the design is raised from the inside to show in relief on the outside. The instrument used for this is a snarling iron, a long steel tool fitted into a vice over which the body of the vessel is placed. The shaft of the tool is then struck with a hammer and the vibration causes the object to bounce on the upward facing point of the tool so that the decoration appears on the silver. The best examples of chasing in this country are to be seen in the Rococo period of 1740–70.

Casting is a method used for making models or small objects such as feet for bowls, handles and charms. Again, there are various ways of doing this. Sand casting is carried out in an iron mould filled with oiled sand. A model is made and the two parts of the mould closed over it. The model is then removed, the sand baked to the shape of the indentation, and molten metal poured through a prepared hole and channel. When set, it is removed and then very often chased up to give a sharp definition.

Another method, which goes back at least 5000 years, is the lost wax method, which was known to the ancient Egyptians. In essence it involves making a model of wax and surrounding it with a heat-resistant material. The wax is then lost by heating in an oven and molten metal poured in to replace it. A similar method, which is just as ancient, is where the wax is removed from the mould by centrifugal force and the metal thrown through the same hole as the departing wax in a continuous operation.

Over the years very little has changed. For annealing and soldering charcoal fires have been superseded by gas and sometimes electricity. Silver is now delivered to the workshop in sheet or granule direct from the bullion dealers. Lathes formerly operated by foot treadles were geared to steam power in the nineteenth century and are now electrically driven. Most of the craft is still done by hand with silversmiths and goldsmiths in small workshops. The production of silver has been reduced in the 1980s to a trickle, mainly as a result of the high price of the metal. But there have been problems in the trade since 1800 and it has managed to survive: problems caused originally by competition from Birmingham and Sheffield and now, because of the EEC, from Europe also. What started 4000 years ago is likely to continue. Like so many old crafts it is ailing but very far from dead.

Pottery

The craft of pottery in Ireland is as old as the art of farming. Both activities date back to the Neolithic period which began approximately 6000 years ago. The first farmers buried their dead in megalithic tombs. When archaeologists excavated these impressive stone monuments, they found sherds of locally made, hand-built wares. At times the pottery fragments were found with other grave goods in a cairn or entrance. Sometimes Neolithic farmers cremated their dead and placed the ashes in a piece of pottery inside the actual burial chamber.

Pottery is of great importance to archaeologists and they study even the smallest fragments of coarse ware with care. As broken pots are replaced, decorative techniques and forms change. The first undecorated, shouldered bowls are replaced by new and decorated forms. Such changes may provide clues about chronology and so help date associated finds. Changes in pottery techniques may also provide evidence of trade, contact or migration. The earliest Irish pots to be thrown on the wheel, for example, date to the thirteenth century and historians think this new technique was brought to Ireland by the Anglo-Normans.

It is perhaps ironic, when we consider the techniques of the archaeologists, that we know so little about the locally made domestic earthenware that ordinary people used in Ireland in the comparatively recent past. Attention has focused on fine ware; the everyday has often been neglected. Yet there is evidence that in the nineteenth century small potteries producing earthenware and terracotta for household and garden use existed in at least twenty-five different regions. Around Coalisland, Co. Tyrone, in the 1830s there were no fewer than nine small potteries. There were three in Armagh. An intriguing reference from the turn of the century states that people of Tory Island were making their own cooking pots from local clays of different colours. Other counties with potteries include Wexford, Limerick, Cork, Meath, Down, Antrim, Roscommon, Kilkenny, Fermanagh, Monaghan, Leitrim and Derry.

The number of nineteenth-century pottery centres makes it hard to believe the accepted lore that all were introduced at the start of the century. Indeed, sources for the eighteenth century show that there were potters producing domestic earthenware in Armagh, Cork, Down, Waterford and Tyrone. Further back, the search is harder still but there were certainly potters in Dublin, and the Egmont papers for 1682–3 mention a flowerpot maker, pipe maker and potter who served all of Cork. For this region the production of domestic earthenware is nothing new.

What did the eighteenth- and nineteenth-century potteries produce? They made tall crocks glazed on the inside for storing buttermilk, wide pans for storing cream, bowls used for everything from mixing dough to hand-washing, bread crocks and pea dishes. They produced hand-thrown terracotta flowerpots, pigeons' nests, chimney cowls and chimney pots. In this century they still made coarse brown and yellow slipware chamber pots for the workhouses.

Descriptions of these potteries are few and today most of them have closed. However, one still survives which provides an interesting insight into the nature and history of the making of domestic earthenware. Carley's Bridge pottery is set beside

ABOVE *An example of Carrowkeel ware found at Tara, Co. Meath. Late Stone Age,* c. *2500–1800* BC.

RIGHT *Bronze Age vessel after the find at Barnasrahy, Co. Sligo.*

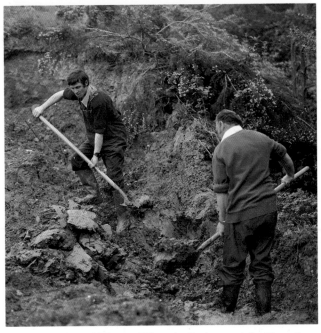

Paddy Murphy and Tommy O'Rourke digging marl. Paddy prefers to dig his clay by hand to avoid contamination from the gritty subsoil which could cause his pots to explode during firing.

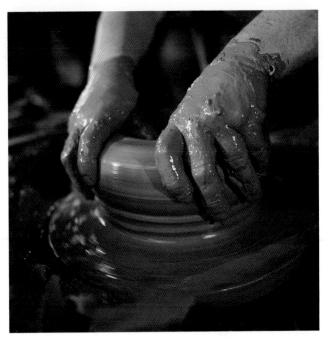

Starting to raise a large pot.

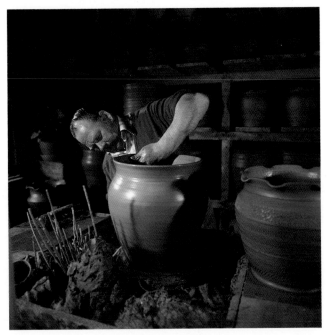

Paddy Murphy, master potter, shaping the rim of a large pot.

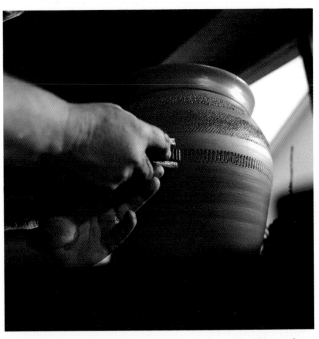

Applying the design to a large pot with a wooden roller. This tool belonged to Paddy's uncle Martin Brickley.

the clear water of the River Urrin just outside the town of Enniscorthy in Co. Wexford. It is said that the pottery was founded by two brothers called 'Kerley', who came from the south of England in 1659. In time, the name 'Kerley' became 'Carley' and at some time around 1748 the Carley family were joined by marriage to another – the Owens. The descendants of the Carley-Owens still have a farm and run the pottery today.

The story of the Carley-Owens is enmeshed with another family history. Sometime before 1835 a potter with the surname 'Brickley' came from the nearby townland of Coolnamurry to work at Carley's Bridge. His son Samuel Brickley followed in his footsteps. This remarkable master potter, who liked fishing and small canaries, is shown in an early photograph working with his barefooted sons in the brickfield next to the pottery. He worked at Carley's Bridge for about ninety years and was in time succeeded by his great-grandson, Paddy Murphy.

In Carley's Bridge the production process begins where Paddy believes all potters should begin – in the marl field. Marl is the local name for the clay that Paddy uses. He has learnt to avoid clay mixed with excess lime or gravel, both of which will cause problems in the firing. The clay, a blue marl, is dug from a depth of 2–2½ m (7–8 ft). The labourers dig the clay in summer, for in winter it is too soft and the pits are treacherous.

Hard clay lacks plasticity, so the labourers spray it with water. Then they turn it, chopping it with small wooden spades. This makes sure that the water penetrates the whole heap. Now the clay is left to weather. Winter frosts break down the particles and increase its plasticity. Finally the clay is covered with damp sacks and polythene and left to rest for as long as possible.

When the clay is ready, it is brought to the pug-mill. It is first squeezed and pressed between rollers. Compression gives clay strength and removes the air pockets which can make a spinning pot wobble on the wheel. In days gone by, clay was milled in the brickfield. The clay was fed into a churn-like container filled with blades. The mill was worked by a horse, blinkered against dizziness, which walked in a continual circle, pulling a pole attachment. These pug-mills were not unusual in

Ireland and the remains of them can still be seen in nearby Davidstown and at Coalisland.

Once milled, the clay is ready for Paddy Murphy. Paddy wedges the clay for a few minutes – a process similar to kneading which further helps compact and mix the clay. Then he forms the clay into balls, estimating the size of ball by eye. (This is different from the practice at Coalisland, where balls were weighed against stone weights and pots sold according to the weight of clay in them, a full piece crock being one using 60 lbs (27 kg) of clay, a half piece 30 lbs.) Next, Paddy puts the ball of clay on the wheel head. He starts the motor and damps his hand in the warm water he keeps by the fire. He now begins to make an 18-inch (45 cm) garden pot.

Within twenty seconds Paddy has 'straightened' the ball of clay so that it spins true. He opens the ball with his thumb and makes the base hole. He pulls up the walls with both hands, then shapes the top. It is only one minute thirty-five seconds since he started and the pot is ready for finishing. Paddy smooths the walls and neatens the base with the help of a rib. He uses small cog wheels to make bands of impressed decoration. Finally he makes small lips around the rim. After only five minutes and twenty seconds the pot is complete. Paddy attributes his speed to the piece-work pay system of his youth. Then he made fifteen hundred 3-inch (7.6 cm) flowerpots in a day, or sixty to eighty 18-inch pots. His grandfather, too, was fast and he used a hand-turned wheel. A 'chap' or boy of 14–15 years of age turned the wheel. If the potter was fast a second lad helped prepare the balls of clay and lift the pots from the wheel to the board. (This was always known as 'passing'.) Here's how Paddy describes the scene:

The potter stood here. There was a hole in the ground next to him, and a young lad stood in the hole and turned the handle of the wheel. There was also a pottery board with clay on it, and for small plain pots just at the last stage the lad would let go of the handle of the wheel, turn round, get marl in, and have it up there on the board ready for the potter to take it and slap it on and make another pot.

The boards of grey pots now go to the drying shed. Here there must be free circulation of air and

pots must be regularly turned around. A pot that dries too quickly or unevenly will crack. In winter, the potters used to return to work on frosty nights to light braziers in the drying shed, for frost will shatter unfired pots. The largest pots remain in the drying sheds for five or six weeks. They are then ready for 'burning' or firing.

The kiln at Carley's Bridge is a circular beehive kiln built in 1945. It holds about 20,000 pots of varying sizes. Willie Cogley, the foreman, usually begins 'setting' or filling the kiln on a Monday morning. The pots are stacked upside down, one on top of another. The largest pots go at the top where the heat is greatest. On Wednesday the kiln is full. The entrance is closed up with firebrick and mortar. Willie Cogley sets light to the coal in the fireholes around the kiln and he makes sure the heat builds up slowly and evenly. The hot air rises up between the inner and outer kiln wall, reaches the dome and is sucked down through the floor and away through a tall chimney. This is a downdraught kiln. On Wednesday, Thursday and Friday Willie stokes the kiln. By Friday it has burnt three or four tons of fuel. Willie climbs to the top of the kiln and looks through a firehole. From the colour of the heat and three small collapsed sagger cones he sees that the correct temperature of about 1200° Centigrade has been reached. Gradually the fires go out. The kiln is left to cool down slowly and it is not until Monday morning that Willie Cogley empties the kiln of the bright red terracotta pots.

For Paddy Murphy the burning of kilns played an important part in the rhythm of his early life. Here is how he describes it:

> When there was a firing, my grandfather'd look after it in the day and when 6 o'clock came, himself and the potter'd come home here. He'd go back after tea and one of his other sons'd go down about 10 o'clock and the two of them could stay down there till maybe 4 o'clock in the morning.
>
> Me mother'd let me go with them down as far as the pottery. They had a little lantern for walking along. There were no cars on the road at that time and the road was all holes and stones. I was so small I used to have to hold me hand up like that for the bottom of the little lantern would

A few of the potter's tools; a selection of rollers.

> hit the ground. And I used to be with them every night at that time sitting on a pot in front of the fires.

Today Paddy Murphy makes bulb bowls, seed pans, chimney cowls, parsley pots and all shapes of decorative and plain garden pots. Before the 1940s the pottery also made glazed ware such as milk crocks, pans and jugs. Like all potters, his family made things for their own use. Paddy remembers that the potters had one of the first radios in the area, and how when a match was on, their friends gathered to drink beer from the small mugs his grandfather made. He remembers too the ornamental candlesticks, thatched cottages and money boxes that his uncle made.

Paddy's uncles were the last generation to make buttermilk crocks and milk pans. In many places the end of these forms and the advent of press-moulded flowerpots signalled the end of country pottery. Paddy's story is of great interest, for he is the last traditional potter. He still works near Enniscorthy today, but he has his own Hill View Pottery, just beside Carley's Bridge.

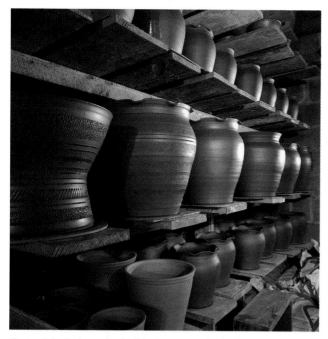

Part of the day's work; freshly thrown pots in the drying shed.

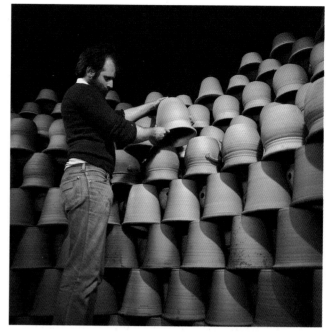

Inside the Bee Hive Kiln, Paul Moloney carefully stacks the pots to be fired. When correctly filled the kiln will hold 24,000 items.

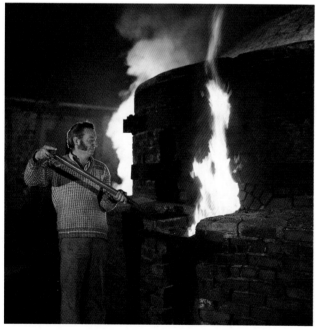

After thirty-six hours the kiln is at its hottest. Willie Cogley, foreman and experienced fireman, carefully controls the heat. This is the leaside of the kiln, hence the slight blow-out of the foreground fire.

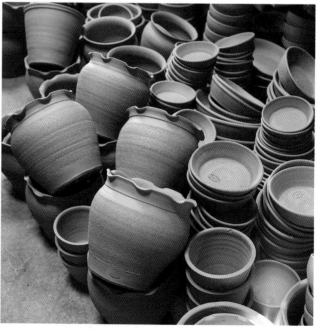

Some of Paddy Murphy's completed pots.

Despite what could be interpreted as disinterest in ceramics in Ireland throughout the historical period, there seems to have been a demand always for imported fine wares. It may be argued that this was to satisfy the ambition of some who believed that the possession of expensive, fragile items denoted a refined upbringing and personal wealth. In fairness the demand may have been due also to a real appreciation of the best-made ceramics available.

Even from Roman times tableware, as well as containers and storage jars, was imported from various parts of that empire. Their well-potted dishes seem to have been much appreciated, as sherds of them, possibly those treasured for years, were discovered in later stratifications in recent excavations.

The Anglo-Normans demanded a high standard from their specialist potters in Ireland, yet they also looked for the luxury of ware with bodies, glazes and decoration from other countries. Colanders, money-boxes, candlesticks, children's toy horns and jugs were imported particularly from Britain and western France. Archaeological finds show that in the medieval and late medieval periods Irish people imported tin-glazed earthenware from Italy, Portugal, Spain and Holland; fine white pottery from the Saintonge district in France; a variety of slip, sgraffito and lead-glazed ware from Britain as well as Bellarmine jugs and other stoneware from the Rhineland and, later, London.

The removal of the fireplace from the middle to the side or end of the room about the late fifteenth century brought a division in styles between utilitarian kitchen and decorative tableware. This, combined with more reliable trade-routes and a large immigrant population in the seventeenth century all ensured a demand in Ireland for the fine ceramics which were available in other countries. It is not surprising, therefore, that Chinese porcelain was in use here by the mid-seventeenth century, as was suggested by the sherds recovered by David Sweetman in his excavation at Kilkenny Castle. Chinese porcelain seals of the late seventeeth

century found throughout the country, but traced by one writer to a Cork tea-importer, suggest that porcelain was available, even to the less wealthy, by the end of that century. Indeed the novelty had worn off porcelain so much that shortly after, Jonathan Swift could comment on porcelain cups used as candlesticks!

In the early eighteenth century Ireland received regular supplies of oriental and, when invented, European porcelain. Some importers disposed of their wares quickly at auction but by the 1760s it seems that even they were forced to offer customers such extra inducements as guarantees of warm auction rooms! By that stage it was china merchants who supplied most of the home market and, indeed, most of their imports were for special orders. An important section of this trade was to replace the metal tableware melted down to finance the wars in the seventeenth century. Some Irish families ordered complete table services through the East India Company. Considering the time needed for transport to and from China, as well as the production and hand-painting of, say, five hundred pieces, it is surprising that many of these services were supplied within about two years. However, even if porcelain was readily available, a number of contemporary recipes for 'mending china' suggest that people were still more familiar with wood and metal tableware.

Although permission was granted to establish a stoneware factory in the Dublin area in the late seventeenth century, the industrial approach was introduced into Ireland by the delftware, or tin-glazed earthenware, potteries established in Belfast about 1688, Dublin about 1735 and afterwards in Rostrevor, Limerick and Youghal. These potteries produced ware to uniform shape, thickness and decoration and in styles which were expected to compete with Chinese porcelain and foreign delft. They were fired in new-style kilns and, for the first time here, saggars or casserole-type boxes were used to protect the pieces during firing. The standard achieved was high. For example, the ware produced at the Dublin potteries receives acclaim today because of the hand-painted decoration, much of which was done by young artists trained in the Dublin Society schools. John Brooks of Dublin contended that it was he rather than John Sadler of

Liverpool who developed the method of transfer-printing on ceramics, but it was Michael Hanbury of Dublin who promoted this 'new Invention for ornamenting China and earthenware with great Dispatch' in this country. The plates from Limerick dated 1761 show the high standard of transfer-printing and enamel-painting achieved.

Like other master potters, Henry Delamain, the proprietor of the Dublin pottery from about 1753 to 1757, spent much time in scientific experimentation. He considered different methods of grinding flint, which suggests that he attempted to make stoneware or creamware; he developed a tin glaze 'which could withstand boiling water' and tried various clays but remained faithful to the white clay exported through Carrickfergus to his competitors in Liverpool, Glasgow and Bristol. Delamain's proudest boast was that he designed a kiln which was fired with coal rather than turf of charcoal. For a country with little coal-mining this development was problematical. The Irish delftware potteries had other difficulties such as the import of large quantities of delftware from England, Holland and France, in spite of the fact that Delamain's pottery exported ware to Germany, Spain, Portugal and the West Indies.

Delftware which chipped easily was little competition for porcelain except in price. However, the fashion for tea, coffee and chocolate drinking created a demand for fine cheap ware. To satisfy this demand Staffordshire potters produced cream-coloured earthenware. By the 1760s Josiah Wedgwood perfected that creamware and added a strong glaze which withstood the wear of spoons and cutlery. This he called Queen's Ware. By adding calcined flint and china clay to the Queen's Ware body he later developed Pearl Ware, a ware ideal for transfer-printed decoration.

There were many attempts to make creamware in Ireland, from Jonathan Chamberleyne's reputed bid at Great Killiane, Co. Wexford, in the early eighteenth century, to the successful attempts at Doneraile, Co. Cork, about 1750, Dublin about 1759 and especially the Downshire Pottery, Ballymacarrett, Belfast, from about 1770 to 1795. The Dublin Society offered inducements for the production of cream- and pearlware too and about 1773 were patrons of the Queen's Ware

Manufactory in Dublin. It was claimed that both useful and ornamental ware were made in that pottery 'in the highest Perfection and Taste; and the Proprietors having lately engaged several of the best Workmen from England, they have now an elegant Assortment of said ware for sale, both gilt and plain, made entirely of the Materials of this Country; and they flatter themselves said ware will be found equally serviceable, and of as elegant Workmanship as any imported, and at Prices much more reasonable than the English'.

The late eighteenth century witnessed Irish potteries trying to compete against mass-produced imported ware. Although Irish clays were used by French, Dutch and Staffordshire potters, the prohibitive cost of importing coal, the difficulty of purchasing expertise from competitors for each stage of the then more sophisticated techniques, and an unfaithful buying public created problems for the industry. Wedgwood opened a shop in Dublin for a few years from 1772 and again from 1808. Some struggling potteries closed when faced with this strong competition. Some pottery owners, like James Donovan, fought the inevitable by continuing to produce pearl and creamware. They also decorated replacement or special order pieces. By the 1830s even they tried no longer and, giving up their muffle-kilns, sold imported ware only.

Throughout the nineteenth century many reports were published on the value of Irish clays for pottery, methods of importing coal economically and the importance to the economy of an Irish ceramic industry. It seems to have been the Great Famine (1845–7) which gave some landlords the necessary impetus to start potteries. The most successful of these in the production of fine ware was Belleek, established 1857. That pottery was fortunate in having its own local clays as well as convenient kiln and mill power, ample capital, the genius of R. W. Armstrong, their first Art Director, and the advice of the Irishman W.H. Kerr of Worcester. Belleek's finances were assured when they won the contract to produce telegraph insulators when the telegraph network was being extended throughout the country.

Their main production line, however, was glazed earthenware. This was sold in local shops, at fairs and by pedlars. Porcelain, their main export ware,

Rolling a chain of clay which will form the base edge on the bottom of a basket.

Plaiting the base of a basket. Gum arabic is added to dry ground slip to give strength and elasticity. The resulting dough is beaten with oak clubs to obtain the correct consistency.

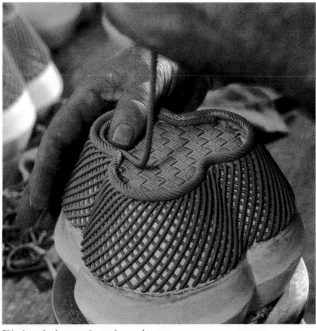

Fitting the bottom inner base edge.

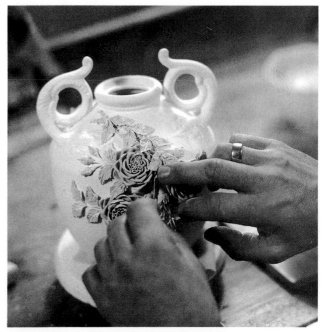

Placing a leaf on a Rose Isle vase. The main body of the vase has been cast in slip (liquid clay).

Slip is a creamy mixture of china clay, feldspar, ground flint glass and frit.

Completed leaves awaiting assembly into a floral decoration.

Glaze-dipped bowls; the blue colour will disappear during the glost firing.

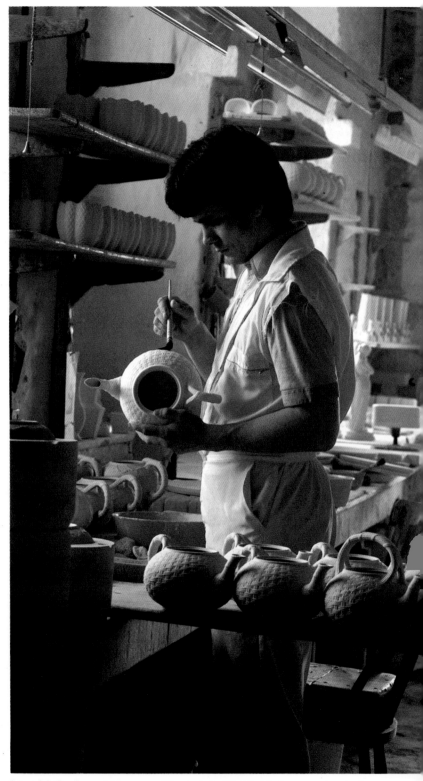

Liam McCawley, a fettler, assembling teapots. 'Fettler' is the name given to the person who assembles the articles ready for the furnace.

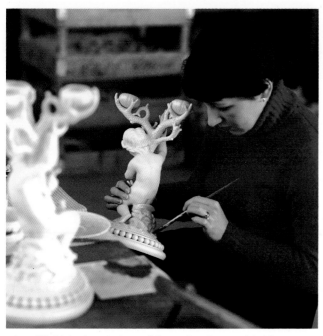

Anne Walsh in the painting and decorating shop applying lustre to a candelabra.

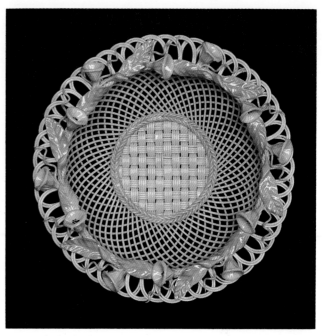

A convolvulus basket, 23 cm (9 in.) in diameter, in Belleek Parian ware.

ART POTTERY

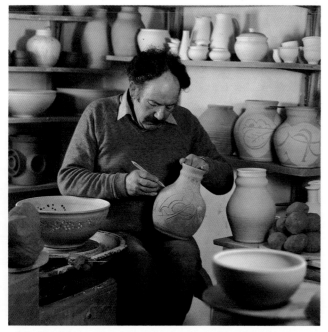

A leading figure in the post-1940s resurgence of hand-thrown pottery is Peter Brennan of Dún Laoghaire. Here he applies sgraffito decoration.

A sgraffito-decorated bowl by Peter Brennan. The technique involves scratching through a skin of slip to expose the colour of the clay below.

won major awards, art critics' acclaim and influential patronage. Armstrong, like Delamain earlier, spent much time in laboratory experiments. He developed his own stoneware bodies, and varieties of porcelain, including the soft-paste porcelain body which now bears the town's name. He experimented also with a variety of glazes, and decoration including photography and raised motifs.

When David McBirney, the proprietor, died in 1882, he left the pottery to his nephew. In a period of uncertainty when the new owner proposed to sell the works, many master potters transferred to potteries in Coalisland, Co. Tyrone, Trenton, New Jersey and Glasgow, bringing with them not only the body recipes but also some moulds. After Armstrong's death in 1884 the pottery was bought by a consortium of local businessmen who reduced the staff drastically, cut wages and only introduced a few new designs. Without an 'Armstrong' the concern made little progress. When faced with closure, the pottery was bought in 1919 by four businessmen whose families form the present company, The Belleek Pottery Ltd. To them is due the survival and present standard of 'Belleek'. They introduced many new designs over the years, including Celtic motifs. Since 1947 they have concentrated on porcelain only and they changed from coal and water to electrical power in 1955.

Ireland entered the studio pottery movement when Frederick Vodrey opened his works in the rear of a warehouse in Moore Street, Dublin, about 1873. There his potters produced ornamental ware using, he claimed, Irish clays. Although his art pottery won acclaim because of its design and strong colours the public demand was for his cheap glazed earthenware tea-services and ornaments with applied flowers.

The idea of studio potteries and potters working in co-operatives was encouraged by the Department of Agriculture and Technical Instruction and by others in the early twentieth century, but with little real success. For many decades the only official encouragement given to individual potters in Ireland was the Taylor Scholarship, which was presented by the Royal Dublin Society. Two recipients of this award were Kathleen Cox, who was the first in the country to use an electric kiln,

and Peter Brennan who, about 1941, started teaching pottery in Carlow Vocational School. Although pottery had been on the school curriculum previously, these were the first formal classes. Victor Waddington, the gallery owner, who promoted the artist Jack Yeats, brought Irish pottery into the fine-art scene by commissioning Peter Brennan and his friend John Ffrench to present special exhibitions. Grattan Freyer, who came to Ireland about 1951, also increased public awareness of art pottery through his exhibitions.

Today there are many potters who have been trained in Irish colleges and schools working in various parts of the country, producing table, ornamental and souvenir ware. Although some still show the influence of potters such as Bernard Leach, most Irish potters are now experimenting with bodies, natural glazes and ornamentation. Bórd Fáilte, The Craft Council of Ireland, The Cork Craftsman's Guild and the Industrial Development Authority's Craft Development Unit have all given encouragement to Irish potters.

The Carrigaline pottery, established in 1928, was the first of a new phase of Irish ceramic factories which made inexpensive tableware and souvenirs as well as art pottery. Due to the government's industrialization policy and especially the availability of electrical power, modern ceramic factories were established. Arklow Pottery Ltd (1934) produced domestic earthenware, art pottery and some bone china, and Royal Tara, Galway (1953), produced bone china. In 1963 Ceramics Ltd, Kilrush, began production of earthenware table and gift pieces for export and in 1977 Noritake, Arklow, produced porcelain for export and the home market. Today Ireland exports about £7 million of ceramics annually, principally to Britain and other EEC countries, the USA and Canada.

Jackdaw chimney cowl: one of the many functional applications of pottery.

Glassware

WATERFORD CRYSTAL IDA GREHAN

It might seem paradoxical that so small a country as Ireland should boast of having the biggest craft industry in the world. Say 'Waterford' and the response will undoubtedly be 'glass'. Glass making, or more correctly, full lead crystal, would seem an oddly exotic art for a remotely situated, agricultural country not blessed with abundant mineral resources. To go beyond the mere availability of materials to the mystique which has grown around Waterford is to encapsulate a thousand years of Irish history, including the arrival of the Celts who brought with them their artistry in metalwork. There was much gold and copper but no precious stones, so, to highlight their delicate artefacts they used the millefiori method of fusing glass rods to make jewel-like inserts.

In the early ninth century Ireland embraced Christianity with great fervour and it inspired her craftsmen's rich artistic talents. The prestigious exhibition 'Treasures of Early Irish Art, 1500 BC to 1500 AD', which toured the USA in 1979, opened many eyes to the perfectionism of those early craftsmen, especially during the Middle Ages when so much of Europe was in cultural eclipse. This perfectionism sprang from the worship of God so that when the superb Ardagh Chalice was made it was lavishly ornamented not only outside, but also on the underside of the foot. All was done for God's sake, whether it was the famous Book of Kells or the Tara Brooch with its inlays of coloured glass and rock crystal.

The Norman invaders brought with them advanced building skills in stone and they are credited with the introduction of window glass. From that it was a short step to the use of drinking glasses. The first mention of glass making comes late in the sixteenth century, in the reign of Queen Elizabeth I, who gave various entrepreneurs patents to set up glasshouses in Ireland. At that time wood was used for the furnaces and it was a way of saving English wood for Elizabeth's armadas – as well as burning Irish forests and smoking out the rebels.

The first glasshouse recorded is still known as Curryglass, not far from Dungarvan where Waterford has its second factory. After Elizabeth's time coal began to be used for furnaces and there are records then of the glass made at Ballynegeragh, also near Waterford.

The outstanding English glass maker George Ravenscroft switched from the fragile soda glass used by the Venetians to flint glass, which produced a more durable vessel, and this was the formula used in the first glasshouses recorded in Waterford city in 1729 when a local merchant, John Head, advertised his wares. Earlier, Captain Philip Roche, one of the 'Wild Geese' who fled to France following the defeat of James at the Boyne, returned with a knowledge of glass making; after several trials he set up his furnace in the heart of Dublin, a successful venture which he passed on to his partners, the FitzSimon brothers.

As the age of elegance advanced, the demand for fine tableware grew, as did the number of manufacturers. There was the Cork Glass Company and also in that city the Waterloo Glass House. There were several companies making glass in Belfast, in Newry and around Lough Neagh. Meanwhile, several more glasshouses had opened in Dublin; the most enduring was owned by the Pugh brothers.

The eighteenth and nineteenth centuries, when England was fighting expensive wars in Europe and America, were difficult times for businessmen. Parliament passed a number of Excise Acts imposing heavy taxes and restricting exports. Few Irish glasshouses survived for more than a generation. Because these Acts were first imposed in England many craftsmen emigrated to the Irish glasshouses where there was still work. In fact, until the Acts were imposed in Ireland there was much cross-fertilization so that, apart from the lack of a distinguishing mark, much of the early Irish glass has come to be described as Anglo-Irish.

Potash, ultra-white silica sand and powdery red lead oxide. These are mixed with cullet (discarded slivers of broken crystal); when heated, the cullet melts first, helping the other chemicals to fuse.

The 'lump' or 'gather' of molten glass comes out of the furnace at the end of the blowing iron (a hollow metal tube) on its way to be shaped, blown and moulded.

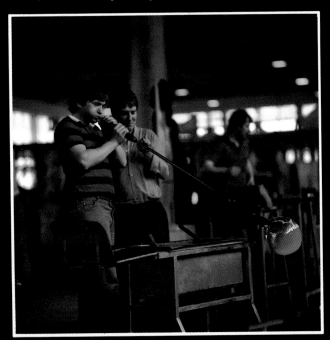

Tony Cooke, master blower, controls the compressed air inside the molten glass. The blowing iron is steadied in a rest.

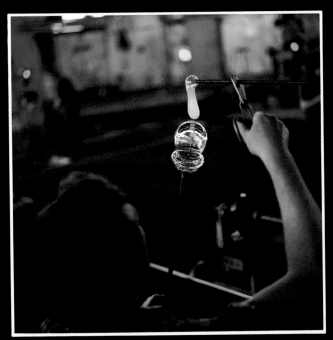

The molten stem of a glass being added to the body. Behind glow the ports of other furnaces.

The completed piece must now pass through a large annealing oven which brings the crystal close to melting temperature and releases the inner tensions so that the parts fuse, guaranteeing perfectly married joints.

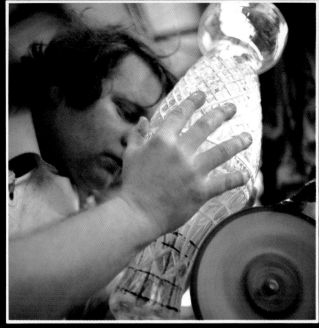

With expert precision a large trophy is cut by Tommy Kirby, master cutter. The black lines on the blank crystal indicate where the cuts are to be made.

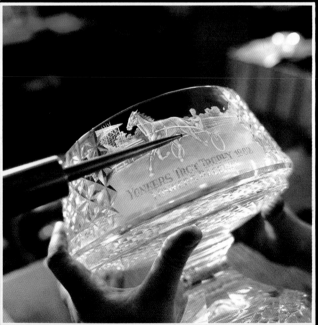

Engraving calls for a high degree of skill and a good eye. Only a comparatively small amount of Waterford crystal is engraved – mostly limited editions and special trophies.

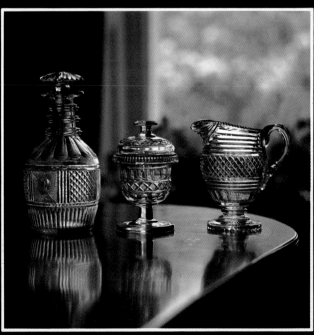

Early nineteenth-century Irish glass, Waterford. Left to right: three-ringed Captain's Decanter, pickle jar, jug.

Fifty years after the first glasshouse had been closed the Anglo-Irish Penroses opened in Waterford in 1780. Their glass reached such excellence that according to Dudley Westropp, who wrote the first definitive book on Irish glass: 'It is usually said Waterford produced all the old glass now found in England and Ireland'. By this time, too, Irish glass was sparkling on the tables of American connoisseurs, and in the West Indies and elsewhere. Exports flourished until free trade was abolished and heavy taxation killed off the Irish glasshouses as well as the linen and tweed industries.

Waterford had achieved a prime reputation, and despite crippling taxes it struggled bravely on until 1851 when the Waterford Flint Glass Warehouse put out its fires. Its reputation lingered on in the folk memory and one hundred years later, when self-government was achieved, a group of patriot businessmen relit the furnaces. In the late 1950s the mystique of Waterford was on the way to realizing its astounding potential. So great is the demand for this old craft that, despite an ever-expanding workforce – three thousand in 1982 – because it remains a true handcraft, it can never meet the demand.

Apart from a mystique there has to be a formula. A strange thread of history runs through the Waterford saga from the craftsman who was brought over from England by the Penroses who left suddenly in a fit of pique, but handed on the secret of the glass to a young clerk called Gatchell who eventually took over the firm. Compared to some old pieces modern glass scintillates with a white fire. This is because today the mixture is scientifically measured. As regards the exact formula all they will reveal of the chemical make-up of the crystal is that it is composed of red lead (approximately 30%), silica sand, potash and some cullet, i.e. slivers of glass from earlier firings. All these ingredients have to be imported, but not the artist craftsmen who blow the glass, engrave it and cut it. In the early days skilled artists were brought from war-wrecked Europe to train the men from the fields and the fishing ports who revealed an amazing depth of artistry.

Few of the continentals remain. Miroslav Havel, who came from Czechoslovakia, is now the Chief Designer. Bobby Mahon who has been blowing for over twenty-five years says: 'You don't come into a glass factory in the morning and just switch on a button. There's much preparation to be done beforehand with the tools and the heavy ceramic pots full of molten glass which is brought up to 1200°C.' The art of glass blowing has changed little in two hundred years. A lump of molten glass on the tip of the blow rod is shaped on wooden blocks. The rod is turned in a wooden mould while the blower controls the compressed air inside with accuracy born of experience. There is a team of three who add stems, handles, lips and so forth. They have grown together as a team – the vital factor is rhythm so that everything is put together at the right temperature to ensure fusing.

Because the fused sections have cooled at different temperatures the pieces have to be annealed to strengthen them. This means moving them slowly along and through the oven, bringing them up almost to melting-point before cooling them down again.

The blower continually examines and if necessary rejects his own work. Then comes the inspection for flaws, and a bonus for the successful team. At this stage stemware and bowls are mostly spherical and an industrial diamond is used to cut off their caps. There is much trimming and polishing before the crystal blanks are ready for the cutters. The patterns are based to a large extent on those used in the earlier Waterford works.

There are two types of cutting: flat, which is costly and slow, and the wedge, which creates the light-diffusing prisms. The team of cutters and apprentices follow the rough guides made on the blank by a felt pen. They work in teams of six or three. There are seven hundred cutters and only when the apprentices pass their five year bowl do they qualify. There is the big incentive of a huge rise in their salary.

Michael Ryan, the Assistant Cutting Manager, is very keen on the new section where they blow and cut special collectors' pieces designed by Miroslav Havel. 'They are all trained in drawing and it's another opportunity for the cutter to express himself', he says.

Tommy Wall, the Senior Engraver, is yet another of the earlier employees whose son has come into

the glass industry. When he first came he was able to draw but he was also quite happy to turn his hand to putting the new engraving machine together or cementing the floor! A comparatively small amount of Waterford crystal is engraved. It is a difficult technique requiring great patience, skilful fingers and excellent eyesight. The tiny wheels used for incision are made of copper coated with a paste of carborundum powder and linseed oil. 'Engraving is like no other job', he says. 'You serve your time but that's only a beginning. In this job nothing is automatic. Each piece is intricate and different, especially the huge sports trophies and the world globe.'

Conditions have greatly improved. Air conditioning, space, and scientific aids have helped to make glasshouse work a healthier and less laborious vocation. The pay at Waterford is excellent and there are splendid community and sports facilities. Many of the employees are top golfers, swimmers or footballers. They take great pride in their work, especially when they go abroad on holiday and see their creations in the windows of Bond Street or Fifth Avenue shops.

As a spin-off to the great success of the Waterford revival a number of glass factories, small and big, have been set up throughout the country. The main ones are in Galway, Cavan and Tyrone. The smaller ones import the blanks for cutting and engraving. Simon Pearce of Kilkenny, who studied at Venice and with Orrerfors, pioneered modern studio glass on his own. Now he has graduated to Connecticut and the vacuum he left behind is being slowly filled by other individual glass blowers. Keith Leadbetter has come to the congenial Kilkenny neighbourhood where he has the Jerpoint Glass Studios at Stoneyford. Paschal Fitzpatrick specializes in decorative glass at the Crafts Centre at Strokestown, Co. Roscommon. At Kerry Glass of Killarney they blow tiny ornamental, colourful objects such as birds and flowers. There is movement in the Irish glass blowing industry.

Candlemaking

Robert Lappla hand-casting a beeswax church candle.

Hand-rolling beeswax candles on a marble slab.

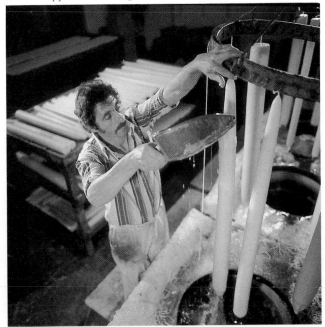

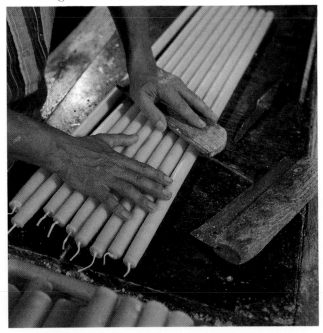

The Rathborne family, from Chester in England, established themselves as wax-chandlers in the Wyne Tavern Street area of Dublin in 1488. The firm still exists, though now in amalgamation

with another, Lawlors. Rathbornes follow an ancient tradition of making church candles by a method that has not changed in centuries. Church candles must be made from a high percentage of pure beeswax.

Fly-tying

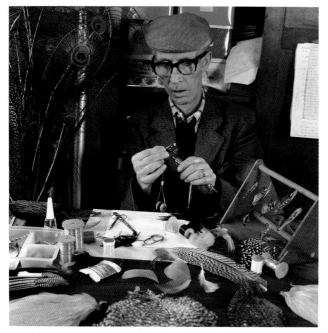

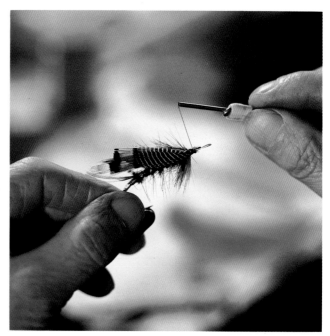

Ned Maguire, a fisherman and fly-tier of note, has been an avid collector of the traditional patterns of Irish trout and salmon flies all his life. He now re-creates the old patterns of yesteryear, even to the gut eyes, as collector's items.

Durham Ranger (Irish version). Tying in a speckled teal, which forms part of the wing.

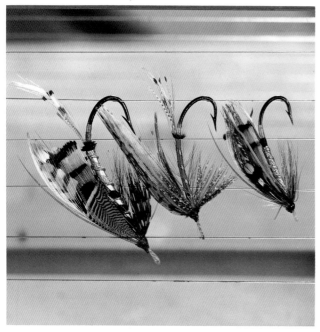

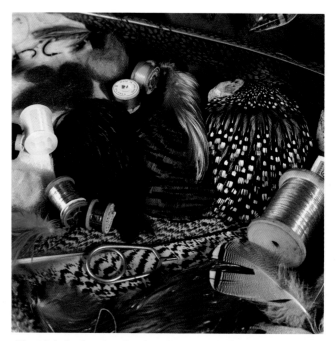

Modern copies of late nineteenth-century gut-eyed salmon flies.

Materials for fly-tying. Jungle cock cape (right-hand side above the gold tinsel) is now a protected species. In the foreground, resting on top of a male silver pheasant's tail feather, are hackle pliers.

Rural life

Life and craft on a Co. Fermanagh Farm
BENEDICT KIELY

Although the environment that nurtures craftsmanship is vanishing inexorably, occasionally in some remote part of the countryside you can come across a place where a half-forgotten way of life still endures at the edge of the twentieth century. It will be associated with old people who have failed to relinquish the austerities of the past.

One place where tradition, along with the old unbroken respect for craftsmanship, will survive for just a few more years, is the Mulholland farm that lies in the rough brown countryside north-east of Lisnaskea in Co. Fermanagh. Not only has life in this homestead remained relatively unchanged for the past fifty years, but it repeats a pattern that was familiar for many years before that. The meadows where Frank Mulholland walks have been farmed by his people for generations.

Today five Mulhollands live here beside Eshbrally mountain. Of ten children in the family four went out into the big world, an exact way to describe leaving a place so blessedly secluded and so self-contained. Six stayed behind, four brothers, James who has since died, Frank, John and Daniel, and two sisters Mary and Margit. They are strong quiet people, whose hearts are bound closely to the homestead, the land around and the fruit of that land. They may have missed the opportunity of marriage and the expansion it would have brought to their lives, yet they maintain a close family circle, keeping alive the old ways. The Mulhollands appear to be content, although their lives are hard and they follow old wearying farming routines without modern aids.

The farm has no electricity and the cows are hand-milked. The free roaming hens, ducks, the flock of geese and a pet of a gander feeding out of a pot are rare sights nowadays in rural Ireland. The house is pervaded with the good smell of currant bread-baking. Butter is still churned with the muscles of the arm. The churn in the home dairy has been in the family for a century. Mary Mulholland handles the dash and the joggle with an ease and skill that is instinctive, at least inherited, in the latest of those endless churnings and rinsings and scaldings and coolings and saltings with a scallop shell.

Among the Mulholland men the link with craftsmanship lies with their calling as stonecutters. They make whetstones or scythestones and circular grinding stones for the farmers of Five Mile Town, Grogey and other places in this corner of Fermanagh. Tools for their trade are fashioned at their forge – not a customary piece of equipment on an Ulster farm. Frank says that the family never bought a hundred of coal in their lives except for the forge. Tools are forged with the aid of the circular fan that tempers the heat to suit the nature of the metal used. A different heat moulds a different metal, and raw material will be picked up from anywhere. Scraps or bits of a dismantled car will go into the making of a punch that will mark the pliable stone as exactly as a pen.

Most mornings after the farm chores are done and the tea is taken, the Mulholland brothers walk to the quarry a mile and a half away. The dogs that race ahead of Frank, John and Dan may well be the descendants of those dogs that accompanied their grandfather, Jem Mulholland, along this same path. Their goal is a small pocket of sandstone on the fringe of the Erne basin which is composed mainly of limestone. When Frank left school at twelve there were ten or fifteen men here making the scythestones. He can talk of other quarries in this locality that have been worked for four hundred years and have sent stone to the building of cathedrals. But no young lads learn the job nowadays, John says. It takes eight or ten years to learn the craft and the future is too chancy.

OPPOSITE, TOP *Margaret and Mary Mulholland feeding the fowl. Life has remained relatively unchanged for the past fifty years on this Co. Fermanagh farm.*

BOTTOM *The small Friesian herd kept for their milk and calves go lazily back to pasture.*

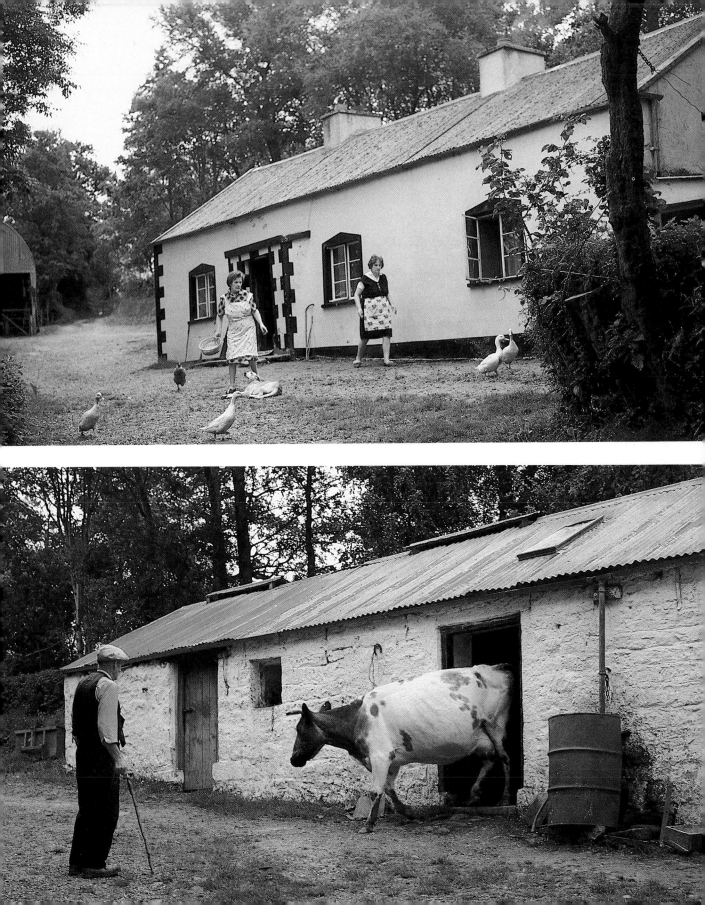

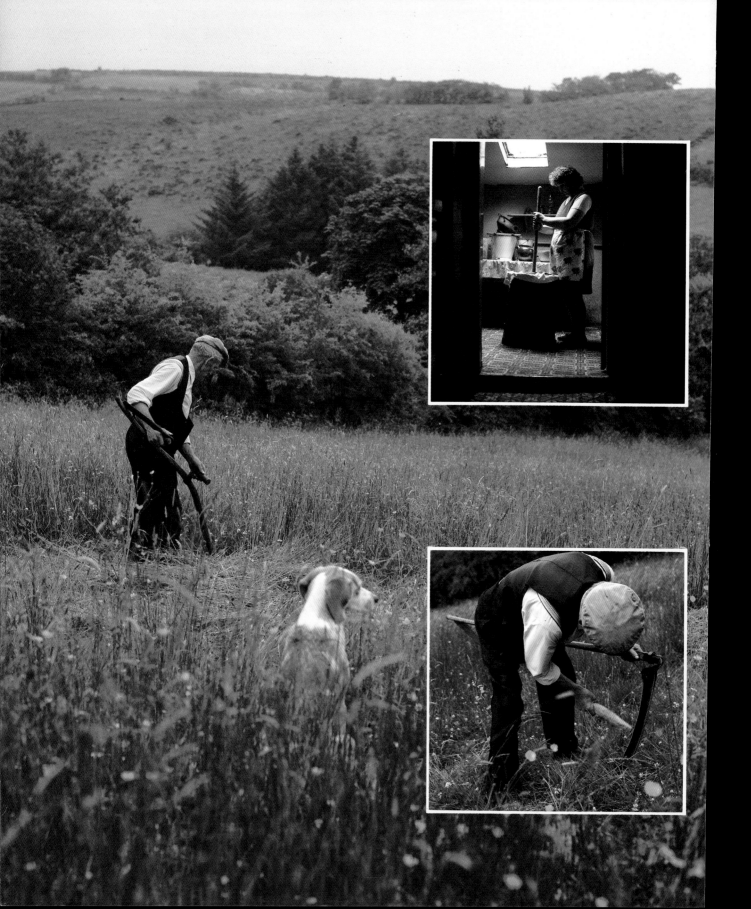

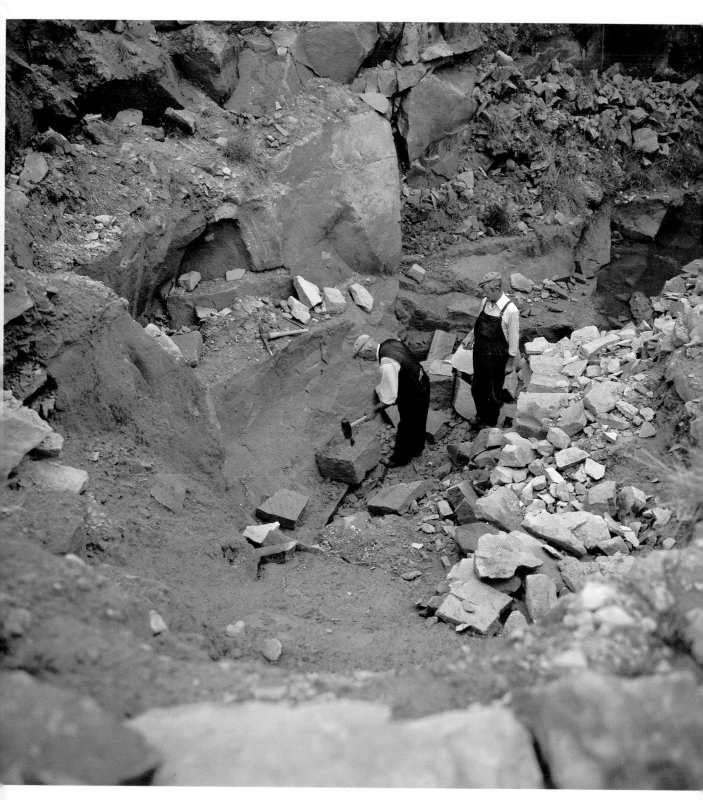

OPPOSITE *In the long days of early summer the well-sharpened scythe still cuts the hayfields with its ancient rhythm.* INSET, TOP *Mary starts the weekly churning, using a churn owned by her mother.* INSET, BOTTOM *The scythe is sharpened with a scythe stone, the fruit of the Mulhollands' labours in the quarry.* ABOVE *The Eshbrally quarry, a pocket of sandstone on the edge of the limestone Erne basin. Frank splits a block with a sledgehammer and wedge.*

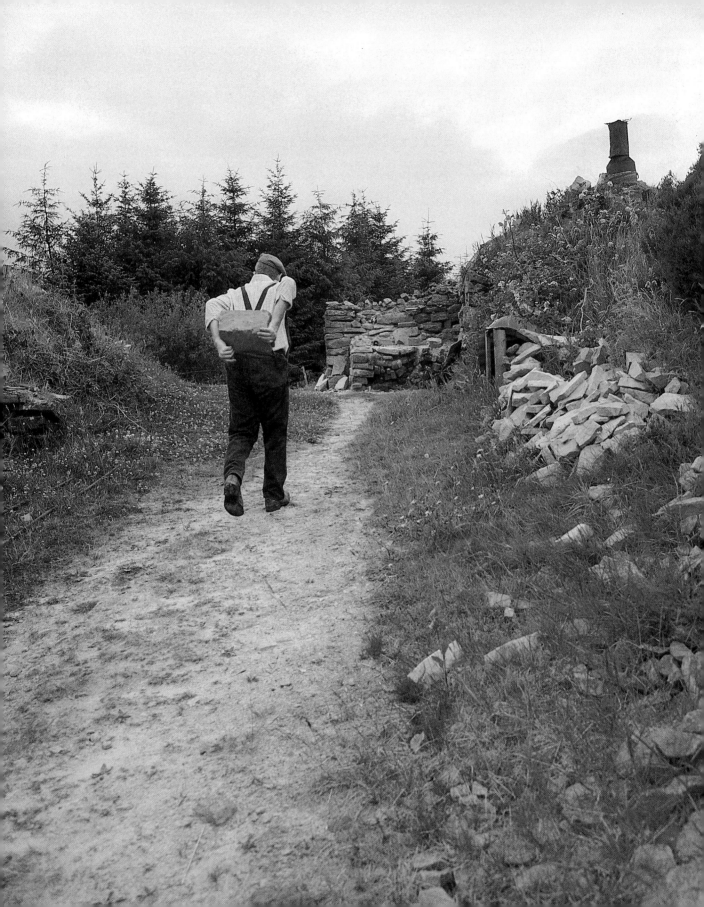

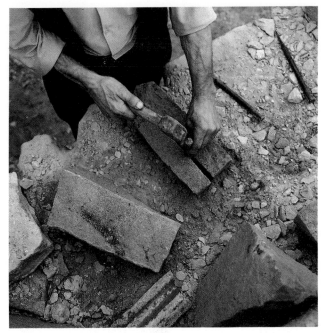

Splitting or 'cindering' a block of sandstone to get the basic size and shape of a whetstone.

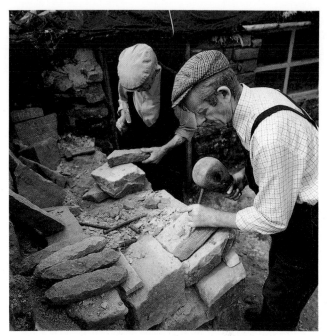

At the banker Frank (LEFT) roughs out a block. Dan dresses a whetstone with crab-apple mallet and punch; the stone rests in a 'thraugh' (trough).

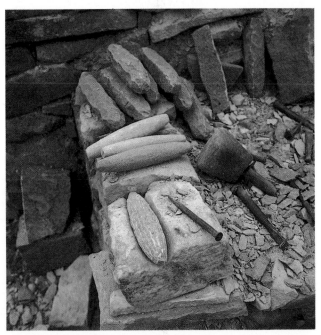

On the banker a whetstone lies in the 'thraugh'; completed whetstones behind, and blocked-out ones await punching.

OPPOSITE *All the stone is brought out by hand or barrowed to the banker. The finished articles are not so large as to warrant a crane and bogey.*

Finishing at the stake using an old scythe blade.

The stone is quarried and 'bottomed' with the aid of a punch whose holes take metal wedges. The stone opens as easily and evenly as slicing bread. Then the pieces which are the basis of the whetstones are taken to the banker, the support where the stone cutter works on it. He 'scribes' each block of stone with lines drawn by the long punch in order to 'cinder' it – the twist the Ulster accent gives to the word sunder. The blocking hammer roughly shapes the stone and out of the oblong block the fish-like shape of the whetstone emerges.

Now the unfashioned whetstone is held in position by a traw (trough) while the preliminary smoothness is accomplished with the claw chisel, the only factory-made tool used in the process. The final scraping and shaping at the wooden stake is done with a scythe blade.

When John Mulholland started work half a century ago, whetstones sold at two shillings a dozen (10p). Now it is £7 a dozen. One year long ago Frank and his father made seventeen hundred scythestones, some of which were sent as far away as the USA. They worked by lamplight on winter evenings, the lamps dotted around the quarry to shine on the tapping hammers. In the old days millstones were made here, but the millwheels are all gone. Today it is the whetstones, together with grindstones and crazy paving, that are still in demand.

The day at the quarry is a long one and there is a monotony to the process of shaping stones. It does not pay well, but the satisfaction of plying effortless skills that have taken years of patient practice to perfect is the reward the brothers enjoy.

The routine of farming in this deep-hedged slumbrous valley has to be maintained along with the quarrying. The cows must be milked and in the long days of early summer the well-sharpened scythe still cuts the hayfields with its ancient rhythm. But there is time for leisure, and the brothers, like their neighbours, keep a couple of hounds. Most houses on the moor or in the valley have their quota of hounds. In summer they are exercised on the lead to protect the young hares from their eager jaws.

In the evenings when work is done and the brothers have returned to the homestead, their sisters have a meal waiting in the spotless farmhouse kitchen. The cake of currant bread and the pale yellow brick of country butter loom large on the laden table. After they have eaten, the brothers will spend some of the evening sitting in the lamplight and listening to old seventy-eight records of traditional Irish music on the wind-up gramophone. Their slow talk will have memories of fresh mornings with the sun on distant lakes as well as exchanges about their ancient craft.

Perhaps we too readily romanticize the simple lifestyle of the Mulhollands. We easily forget that by avoiding the opportunities the outside world offers they have endured poverty and a lifetime of grinding, often boring work. But we have to envy the satisfaction they enjoy by maintaining the circumstances whereby hardworking craftsmen pass their lives experiencing the happiness that comes from contentment. It is a way of living that was once commonplace, but now is only to be found in a few places in Ireland. Even in this remote part of Ulster it is slipping away. In a decade or two when the brothers and sisters have gone to their rest, farm and quarry will be silent. The lowing of cattle in the byre and the tap of the blocking hammer and chink of sandstone under Eshbrally will be heard no more.

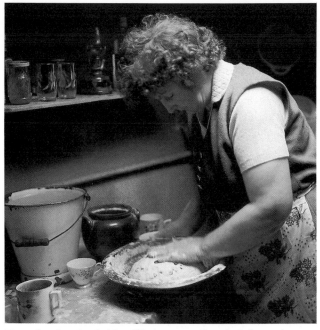

Every day there is a baking. The hungry workers look forward to their fresh currant cake and tea.

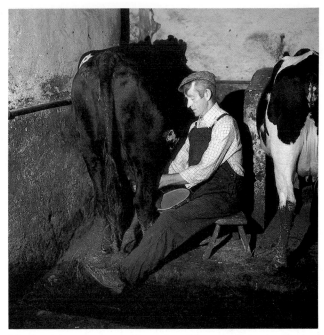

No electricity means no new-fangled machinery, and a hand-milked herd.

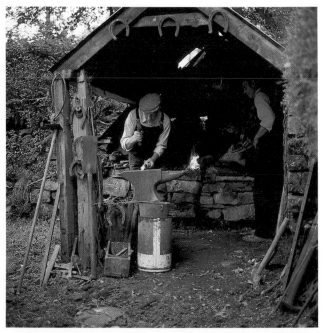

Not every Fermanagh farm has its own forge. Here Dan and Frank make wedges and punches for use in the quarry.

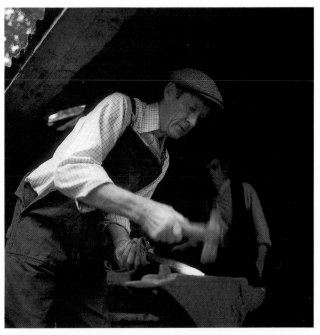

Chisels need constant re-sharpening and tempering.

ABOVE LEFT *The ducks, shut up at night to protect them from the fox, seek their morning freedom.*

ABOVE *Most families hereabouts keep a hound or two. In wintertime they will join forces with neighbours to form a pack to hunt hares and foxes. The horn was made by Dan's grandfather.*

LEFT *On a farm there is rarely an idle moment. Dan spraying the potatoes against blight.*

OPPOSITE *A break from the heavy work in the quarry.*

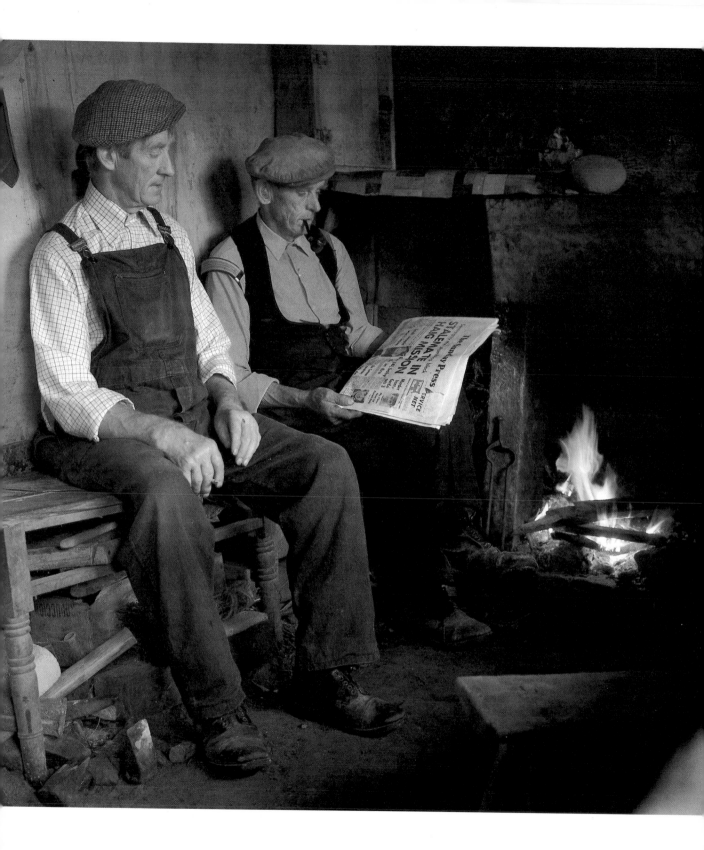

Map
About the Contributors
Suggested Further Reading
Places to Visit
Acknowledgments
Index

LOCATION OF CRAFTSMEN AND WOMEN IN THE BOOK

Textiles

1	spinning	Killadoon, Co. Mayo; Quigley's Point, Co. Donegal
2	flax (growing)	Greenmount, Co. Antrim
3	flax (scutching)	Crossgar, Co. Down
4	dyeing	Cleggan, Co. Galway
5	weaving	Lackconnell, Co. Donegal
6	handknitting	Inishmaan, Co. Galway
7	*crios* weaving	Inishmaan, Co. Galway
8	patchwork	Taghmon, Co. Wexford
9	carpets	Killybegs, Co. Donegal
10	tailoring	Cappoquin, Co. Waterford
11	lace	near Lismore, Co. Waterford; Bruckless, Co. Donegal

Stonework

12	stonemasonry	Dublin; Carrigtohill, Co. Cork
13	Liscannor slate	Liscannor, Co. Clare
14	millstone dressing	Martry, Co. Meath
15	drystone walling	Co. Clare and Co. Galway

Woodwork

16	coopering	Ballinagh, Co. Cavan
17	furniture	Monasteraden, Co. Sligo; Tuam, Co. Galway, and Lauragh, Co. Kerry
18	hurls	Kilkenny, Co. Kilkenny
19	briar pipes	Sallynoggin, Co. Dublin
20	spinning wheels	Carndonagh, Co. Donegal
21	cabinets	Milltown, Co. Cavan
22	river and lake boats	Cornamona, Co. Galway
23	hookers	Mweenish Island, Co. Galway
24	currachs	Fahamore, Dingle Peninsula, Co. Kerry; Kincashla, Co. Donegal
25	uilleann pipes	Fanore, Co. Clare
26	fiddles	New Quay, Co. Clare; Limerick
27	*bodhráns*	Roundstone, Co. Galway
28	lambegs	Belfast
29	harps	Tooreen, Co. Cork

Willow, Rush and Straw

30	baskets	Carrick-on-Suir, Co. Tipperary
31	thatching	Kilmore, Co. Wexford; Bunratty, Co. Clare
32	bee-skeps	Clonakilty, Co. Cork
33	*súgán* chairs	Droum, Lauragh, Co. Kerry
34	rushwork	Cashel, Co. Tipperary; Strokestown, Co. Roscommon

Leather

35	harnesses	Shrule, Co. Mayo; Ennistymon, Co. Clare
36	saddles	Kilcullen, Co. Kildare
37	pampooties	Inishmaan, Co. Galway
38	shoes	Naas, Co. Kildare
39	hurling balls	Dublin
40	bookbinding	Marley Grange, Co. Dublin

Metalwork

41	blacksmithing	Slatta, Co. Roscommon; Ennistymon, Co Clare; Enniskerry and Bray, Co. Wicklow
42	carriages	Enniscorthy, Co. Wexford
43	gold- and silversmithing	Dublin and Swords, Co. Dublin

Pottery

44	coarseware	Carley's Bridge, Enniscorthy, Co. Wexford; Dún Laoghaire, Co. Dublin
45	fineware	Belleek, Co. Fermanagh

Glass

46	Waterford crystal	Waterford, Co. Waterford

Flytying

47	flytying	Bray, Co. Wicklow

Rural life

48	quarrying	Lisnaskea, Co. Fermanagh

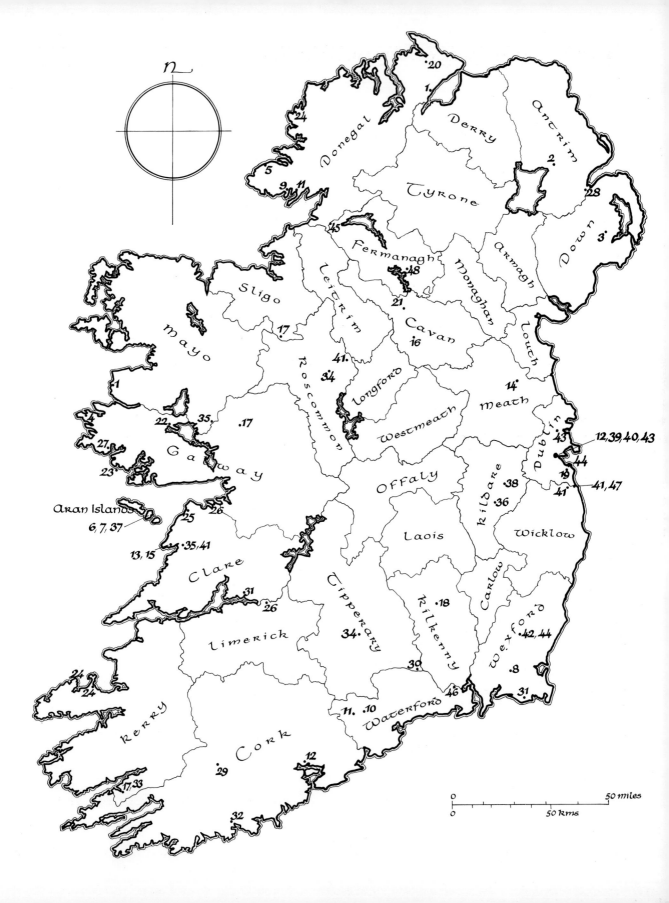

N

Donegal

Derry

Antrim

Tyrone

Down

.20
1.

.24

5

9 .11

45

Fermanagh

.48

21.

Monaghan

Armagh

Louch

28

2.

3.

Sligo

Leicrim

Cavan

.16

Longford

Westmeath

Meath

14.

Dublin

.43

12, 39, 40, 43

Mayo

.1

22. 35.

.17

Roscommon

41.

.34

44

19.

.41

41, 47

Galway

27.

23.

Aran Islands
6, 7, 37

25

26

13, 15

.35, 41

Clare

31

26

Offaly

Laois

Kildare

.38

.36

Wicklow

Carlow

Tipperary

34.

Kilkenny

.18

Wexford

.42, 44

.8

Limerick

30.

46.

31

Kerry

24.

24.

Cork

.29

11. .10

Waterford

12

17, 33

32

50 miles

50 kms

ABOUT THE CONTRIBUTORS

DOUGLAS BENNETT is an experienced silver engraver and a warden of the Company of Goldsmiths of Dublin. He is a well-known lecturer and his books include the definitive *Irish Georgian Silver*.

DESMOND BREEN is a teacher of bookbinding and finishing. He started and managed the fine binding department and conservation laboratory of John F. Newman & Son (1965–81) and then formed his own company in partnership, called Antiquarian Bookcraft.

KEVIN DANAHER is a lecturer in ethnology in the Department of Irish Folklore, University College, Dublin, and has written and lectured widely on folklife subjects and military history.

IDA GREHAN is a journalist, broadcaster and author who has written extensively about Irish people, places and crafts.

LAURA JONES is the Head of Textiles at the Ulster Folk and Transport Museum, where she has been responsible for building up one of the finest textile collections in the British Isles.

BENEDICT KIELY has won a considerable reputation as a writer and broadcaster. He is the author of sixteen books, including novels, short stories and non-fiction.

PETER KILROY did his apprenticeship in violin making but his research into the medieval Irish harp led to his successful attempts to reconstruct that forgotten instrument.

MARY MCGRATH's dual interests are the conservation of paintings and the role of horses in Irish society. Between 1976 and 1979 she set up and became director of the Irish Horse Museum at the National Stud, Tully, Co. Kildare.

MEGAN MACMANUS is Assistant Keeper of Crafts at the Ulster Folk and Transport Museum. She has contributed on anthropological subjects to educational and specialist publications.

BRÍD MAHON is a well-known writer of plays, stories and documentaries for radio and television, and has contributed popular articles on Irish affairs to various newspapers and journals. She is Senior Folklorist/Lecturer at the Department of Irish Folklore, University College, Dublin.

ANNE O'DOWD is on the staff of the Folk Life Department at the National Museum of Ireland. She is the author of a study of co-operative labour in rural Ireland.

TIMOTHY P. O'NEILL is head of the History Department at Carysford College of Education, Dublin. He writes and lectures on Irish history and folk life.

MAIREAD REYNOLDS is in charge of glass, ceramics and textiles in the Art and Industrial Division of the National Museum of Ireland.

PATRICK F. WALLACE is the son of a blacksmith from Askeaton in Co. Limerick. He is Assistant Keeper of the Irish Antiquities Division at the National Museum of Ireland.

General

Louis Cullen *Life in Ireland*. Batsford, London, 1968
Kevin Danaher *A Bibliography of Irish Ethnology and Folk Tradition*. Mercier, Dublin, 1978
—, *Irish Country People*. Mercier, Cork, 1976 (new edn)
E. Estyn Evans *Irish Heritage*. Tempest, Dundalk, 1942
—, *Irish Folk Ways*. Routledge and Kegan Paul, London and Boston Mass., 1957
Henry Glassie *Passing the Time in Ballymenone: Culture and History of an Ulster Community*. Univ. of Pennsylvania Press, 1982
W.A. McCutcheon *The Industrial Archaeology of Northern Ireland*. HMSO, Belfast, 1981
John Manners *Irish Crafts & Craftsmen*. Appletree, Belfast, 1982
Timothy P. O'Neill *Life and Tradition in Rural Ireland*. Dent, London, 1977
Sean O'Súilleabháin *A Handbook of Irish Folklore*. Folklore of Ireland Society, Dublin, 1942, repr. 1963
Sean Popplewell *The Irish Museums Guide*. Ward River Press in association with the Irish Museums Trust, Dublin, 1983

Specific crafts

R.B. Armstrong *Musical Instruments* (Part 1: *The Irish and the Highland Harps*). David Douglas; T & A Constable; Edinburgh, 1904
Douglas Bennett *Irish Georgian Silver*. Cassell, London, 1972
Elizabeth Boyle *The Irish Flowerers*. Ulster Folk Museum, Holywood, Co. Down; Queen's University (Inst. of Irish Studies), Belfast, 1971
Maurice Craig *Irish Bookbindings, 1600–1800*. Cassell, London, 1954
Richard K. Degenhardt *Beleek: The Complete Collector's Guide and Illustrated Reference*. Portfolio Press, Huntington, New York, 1978
Wilbert Garvin *The Irish Bagpipes: their Construction and Maintenance*. Blackstaff, Belfast, 1978
Conrad Gill *The Rise of the Irish Linen Industry*. Clarendon Press, Oxford, 1925
Ida Grehan *Waterford: an Irish Art*. Portfolio Press, Huntington, New York, 1982
J. Hornell *British Coracles and Irish Curraghs*. Society for Nautical Research, London, 1938

John de Courcy Ireland *Ireland's Sea Fisheries. A History*. Glenvale Press, Dublin, 1981
Laura Jones 'Patchwork Bedcovers', *Ulster Folk Life*, xxiv (1978), 31
—, 'Quilting', *Ulster Folk Life*, xxi (1975), 1
H.F. MacClintock *Old Irish and Highland Dress*. Dundalgan, Dundalk, 1950 (2nd, enlarged, edn)
Seamus MacConIomaire *Cladaigh Conamara*. Dublin, 1938
Lillias Mitchell *Irish Spinning, Dyeing and Weaving*. Dundalgan, Dundalk, 1978
W.A. McCutcheon *Wheel and Spindle*. Blackstaff, Belfast, 1977
Seamus Murphy *Stone Mad*. Routledge and Kegan Paul, London, 1966 (rev. edn)
Liam P. O'Caithnia *Sceal na hIomana* (The history of hurling, in Irish). An Clochomhar, 1981
Art O'Maolfabhal *Caman: 2,000 Years of Hurling in Ireland (1973)*
Donal O'Sullivan *Carolan. The Life, Times and Music of an Irish Harper*. Routledge and Kegan Paul, London, 1958
Joan Rimmer *The Irish Harp*. Mercier, Cork, 1977 (2nd edn)
Lee-Lee Schlegel *Aran: a Saga in Wool*. Harlo, Detroit, 1980
E.F. Sutton *Weaving: the Irish Inheritance*. Dalton, Dublin, 1980
Kurt Ticher *Irish Silver in the Rococo Period*. Irish University Press Ltd, Dublin, 1972
Kurt Ticher, Ida Delamer and William O'Sullivan *Hall-marks on Dublin Silver: 1730–1772*. National Museum of Ireland, Dublin, 1968

Eason's Irish Heritage Series are well-produced, compact guides on a range of subjects. The titles include *Irish Furniture, Irish Silver, Irish Glass, Irish Bookbinding, Irish Pottery, Irish Porcelain* and *Irish Lace*.

Exhibition Catalogues

Alex Meldrum *Irish Patchwork*. Kilkenny Design Workshops, Co. Kilkenny, 1979
Mairead Reynolds *Early Belleek Wares*. National Museum of Ireland, Dublin, 1978
Irish Silver. An Exhibition of Irish Silver from 1630 to 1820 at Trinity College, Dublin. Trinity College, Dublin, 1971

National Collections
National Museum of Ireland, Dublin: occasional exhibitions from its permanent collection of folk life material; lace, glass, silver, ceramics and furniture on permanent display.

Ulster Museum, Belfast: industrial archaeology, glass, silver, ceramics and furniture.

Folk parks
(re-creations of rural life and crafts)
Bunratty Castle and Folk Park, Co. Clare: reconstruction of farmhouses and village street providing a view of rural life of various eras.

Ulster Folk and Transport Museum, Cultra, Co. Down: embraces the folk life of the nine counties of Ulster, extensive textile collection and rural artefacts, reconstruction of farmhouses.

Muckross House, Killarney, Co. Kerry: re-creation of craftsmen's workshops with practising craftsmen.

The Ulster–American Folk Park, Omagh, Co. Tyrone: creation of eighteenth- and nineteenth-century dwellings and demonstrations of various skills and crafts.

The Irish Agricultural Museum, Johnstown Castle, Co. Wexford: emphasis is on agriculture and particularly the importance of the horse.

Museums of specialist interest
Guinness Museum, St James Gate, Dublin: brewing and coopering
The National Maritime Museum, Dún Laoghaire, Co. Dublin
Mill Museum, Tuam, Co. Galway: milling, working water wheel
Irish Horse Museum, Irish National Stud, Tully, Co. Kildare
Damer House Museum, Roscrea, Co. Tipperary: Irish furniture
The Threshing Museum, Mullinahone, Co. Tipperary
Wellbrook Beetling Mill, Cookstown, Co. Tyrone: beetling (the final process in the manufacture of linen)

Local museums relevant to folk life
Larne and District Historical Centre, Co. Antrim
Lisburn Farm Museum, Co. Antrim

Mullaghbawn Folk Museum, Forkhill, Co. Armagh
Carlow County Museum, Town Hall, Carlow
Pighouse Collection, Corr House, Cornafean, Co. Cavan
Craggaunowen, Quin, Co. Clare
Cape Clear Island, Co. Cork
Clonakilty, Co. Cork (housed in former Methodist National School)
Cork Public Museum, Fitzgerald Park, Cork (including butter making)
Kanturk Museum, Co. Cork
Kinsale Museum, Co. Cork
Donegal Historical Society Museum, Rossnowlagh, Co. Donegal
Glencolmcille Folk Museum, Co. Donegal
Fermanagh County Museum, Enniskillen, Co. Fermanagh
Rothe House, Kilkenny
Limerick City Museum, St John's Square, Limerick
St Mels Diocesan Museum, Longford
Millmount Museum, Drogheda, Co. Louth (includes last coracle to fish on the Boyne)
Monaghan County Museum, Courthouse, Monaghan (1980 Council of Europe Museum Prize)
Toomevara Folk Museum, Nenagh, Co. Tipperary
Reginalds Tower, Waterford
Athlone Castle Museum, Co. Westmeath
Mullingar Town Museum, Old Market House, Co. Westmeath
County Museum, Enniscorthy, Co. Wexford

Where craft workers may be seen
Bórd Fáilte (The Irish Tourist Board) keeps up to date lists of craft workers throughout the twenty-six counties.
The Craft Council of Ireland, Dublin, can also put people in touch with craftsmen and women.

Specific craft centres include:
Kilkenny Design Workshops, Co. Kilkenny
Ballycasey, Co. Clare
Marley Park, Marley Grange, Co. Dublin
Kilworth, Co. Cork
Strokestown Craft Centre, Co. Roscommon
Powerscourt House, Dublin

ACKNOWLEDGMENTS

When in the spring of 1977 I approached Radio Telefís Eireann with a proposal for a series of filmed television documentaries on Irish traditional crafts, it was fortunate and significant that the two people I met were the then Controller of Programmes, the late Jack White, and his successor, Muiris MacConghail. They shared my deep concern that important urban and rural crafts were about to disappear without record and I was initially commissioned to make six programmes. I have made more than thirty documentaries for RTE in the past six years and this book is an extension of the research for my filmed television series 'Hands', commissioned by them. Muiris MacConghail has a wide knowledge and love of traditional crafts, which has given him a personal interest in the series, and it was he that suggested I should have a book published; to him I owe a particular debt of gratitude for his support and encouragement. I would like to thank RTE for enabling me to undertake much original research for this book while making 'Hands'; they have been very understanding in accepting the inroads made into my programme-making time.

In the course of my travels to just about every corner of Ireland in the last few years, researching and photographing crafts for this book, many people and organizations have helped me. I would particularly like to thank Muriel Gahan, whose own contribution to the survival of traditional crafts has been enormous. I am also especially grateful to the writers for their very considerable contributions and the knowledge and insight they have brought to their subjects.

To name everyone who has helped me would take many pages, but the following people have been particularly generous with their assistance: John Baragwanath, John Clancy, Alison Erridge, Patrick Farrell, Peter Gahan, Teresa Gillespie, J.R. Harris, John de Courcy Ireland, Justin Keating, Frank J. Kinsella, Alex Meldrum, John O'Loughlin Kennedy, Brendán Ó Ríordáin, Blanaid Reddin, Nicholas Ryan, Elizabeth Searson, Tom Sheedy, Beatrice Somerville-Large, Peter and Gillian Somerville-Large, Frank Sutton, Tarlach de Blacam, Comharchumann Inis Meáin Teo, Adrian Saunders of Greenmount Agricultural College, Mary Coleman of the Irish Lace Guild, Edmond Myers of Muckross House, Patricia Duigan and Patty O'Flaherty of the Slievebawn Cooperative, the Bunratty Folk Park, the Craft Council of Ireland, the Irish Country Furniture Society, the Irish Countrywomen's Association, the Irish Tourist Board, the Kilkenny Design Workshops, the National Museum of Ireland, the Office of Public Works, Trinity College, Dublin, the Ulster Folk and Transport Museum and the Department of Irish Folklore at University College, Dublin.

No acknowledgment would be complete without reference to E. Estyn Evans, who has made such a valuable contribution to the recording of Ireland's traditional crafts and folk ways.

INDEX

Figures in italic refer to captions

adze *92*
Alwright and Marshall Ltd,
 Dublin *181, 182*
appliqué lace 43, *46*
appliqué patchwork 30, *32, 33*
Aran Islands (Galway) 14, *20, 27,
 62, 94, 100, 102, 125, 136, 156*
Aran jersey (gansey) *27, 94*
Aran knitting 22, 24, 27
Ardagh Chalice 177, *197*
Ardaghy (Donegal) *28*
Arklow Pottery Ltd 196
Armstrong, R.W. 192, 196
Aspel, Kevin and Patricia *20*
assaying 177, 180

bagpipes *103–6*
Ballinagh (Cavan) 64
Ballyedmonduff (Dublin) *53*
barrels *see* casks
Barry, Mrs Hannah *146*
baskets 118–27, *146*
basting (tailoring) *38*
bedcovers, patchwork 30, 31
beds 71
Belleek Pottery 192, *195*, 196
Belfast *111*
Berney, Tom 153, *153*
Biggs, Michael *55*, 60
birdeog 125
blacksmithing 168–9, *170, 171,
 172–3, 176*
blackthorns *87*
boats
 currachs 95–102
 wooden *88–94, 102*
bobbin lace 42–3
bodhráns 110, *111*
bookbinding 161, *162, 163, 164*
Boyle, Mrs Agnes *44*
Bray (Wicklow) *176*
Breen, Aidan *179*
Breen, Colm and Kevin *175*
Brehon Laws 16, 26
Brennan, Edward and Michael *78*
Brennan, James 43
Brennan, Peter *195*, 196
Brett, Liam *79*
Brickley, Samuel 188

Brooks, Billy *175*
Bruckless (Donegal) *44*
Bruges (Belgium) 26
Bunratty (Clare) *58*
Bushmills (Antrim) 64

cabinets *85–6*
Cahill, Peter *38*
candlemaking *201*
canoe, Kerry *see naevóg*
Cappaquin (Waterford) *38*
carding *15*, 18
Carey, Jack *139*
Carley's Bridge pottery,
 Enniscorthy (Wexford) 186,
 188–9
Carndonagh (Donegal) *82*
carpets *35–7*
carriageworks *175*
Carrick (Donegal) 16
Carrick (Galway) *88*
Carrick-on-Suir (Waterford) *120,
 127*
Carrickmacross lace 43, *46*
Carrigaline pottery 196
Carrigtohill (Cork) *55*
Casey, Paddy *133*
Cashel (Tipperary) *145, 146*
casks 64–5, *65*, 72
casting (silver) 184
castles 52
Ceramics Ltd, Kilrush (Clare) 196
chairs 71, *72–3, 74, 76, 141–2*
chasing *179*, 184
chests 71, *73*
chimney cowl 196
churns 64–5, *66, 67–8, 70, 76, 204,
 207*
Ciaran, St 24
ciseán 125
ciseog 120, 121, 125, 126–7
Cleggan (Galway) *20*
Cleriestown (Wexford) *131*
cliabh (creel) *121, 123, 126*
cliath thulcha 95
Clifford, Declan *154*
Clonakilty (Cork) *139*
Clonmacnoise (Offaly) *52*
Cogley, Willie *190*
Connemara *53*
Cooke, Tony *198*
coopering 64–70
Cork *153*

Corrib punt *88*
cots (boats) *88*
Cox, Kathleen 196
Coyne, Mrs Mary *20*
cradles 72, 77
crannóg 118
creamware 192
creel *121, 123*, 126
crib (churn) 68, *69*
crios 27, 28–9
crochet *20*, 42
crochet lace 43, *45*
cropping machine *36*
Cross of Cong 177, *181*
crosses, high 50, *50, 52*, 113, *113,
 149*
crottle 19, *20*
Crowe, Paddy *151*
Currach ámaid (wood) *91, 94, 97,
 102*
currachs (hide) 95–7, *96, 102*
Curryglass (Cork) *197*

Dante Alighieri *113*
Dargan, Liam *160*
dash, butter-making 68, *69*
Delamain, Henry 192
delftware pottery 191, 192
Derryinver (Galway) *97*
Dingle peninsula (Kerry) 50, *50,
 98, 100*
distaff 18
Donegal 35
Doonconor fort (Galway) *50*
Dowling, Ramie *79*
Doyle, Pat *174*
dressers 71, *73, 76*
Droum (Kerry) *141*
drums *110–11*
Dún Laoghaire (Dublin) *195*
Dunne, Noel *165*
dyeing 19, *20*, 22, 24
dye-plants *20*

eel trap *121, 128*
Ellison, Mary *35*
embroidery 28, *29*
engraving
 glass *199, 200–01*
 silver 184
Enniscorthy (Wexford) *174, 176,
 188*, 189
Ennistymon (Clare) *151, 171*

Faherty, Colm Mór *157*
fairs, sheep 16
Fanore (Clare) *103*
farming life, 204, 207, 210, *211–13*
Fitzpatrick, Paschal 201
flail *87*
flax 16, 18, 19, *39–40*, 130
flytying *202*
footwear *156–8*
forges 168–9, *176*, 204, 211
Freyer, Grattan 196
fulling 26
Furlong, Jack *176*
furniture 71–3, *74–7*, *86*, *142*

Gallagher, Mrs Catherine *28–9*
Galway Hooker *92–4*
Garrihy, James *151*
Gavin, Edward 64–5, *66*, 69–70
Geraghty, Peter *151*
gilding 161, *162*, 164, *165*
Gillespie, Mrs Teresa *28*
Giraldus Cambrensis 14, 149
glass 197–201
Gleeson, Patrick *58*
Gleoiteog (yawl) *94*
goldsmithing 177, 180
gorget, gold *177*
Grace, Stephen *145*
granite 54, 56, 60, *62*
gravestones (headstones) 54, *55*, 56, 60
Greencastle Yawl *90*
Greer, Sam 153
guipure lace 43

hackling 18
hallmarks 177, 180, *181*
harnen (breadstand) *169*
harness 149, *151*, 153, *154*, *155*
harps *113*, 113–16
Havel, Miroslav 200
Hegarty, Anne *36*
Hewitt, William *111*
Hogan, Joseph *119*, *128*
hoops, churn 69
horses 149
hurling, hurling balls *160*
hurls *78*, *79*

Inishmaan (Galway) 20, 24, *28*, *50*, *62*, *100*
ironwork *169*

Jerpoint Abbey (Kilkenny) *50*, *52*
jointer 65, *66*
Joyce, Thomas *120*

Kapp and Peterson *80*
Kearns, Malachi *110*
Keenan, Jim 64
Kenmare (Kerry) 42, 43, *46*
Kerrigan, Jimmy and Dan *171*
Kerry Glass, Killarney 201
Kilcullen (Kildare) *153*
Kilkenny town *79*
Killen, Vincent *76*
Killybegs (Donegal) *35*
Killyfana (Cavan) *87*
kilns 189, *190*, 191
Kilroy, Peter *115*
Kirby, Tommy *199*
knitting 22, 24, 27
knotting, carpet *36*

lace 42–3, *44*
Laffan, Fidelma *35*
Lambe, Eugene *103*, *105*
lambegs *111*
Lana, Alice *37*
Lappla, Robert 201
Latham, Susan *44*
Leadbetter, Keith 201
leather 149, *154*, *156–8*, *160*
lettering, carved *55*
Lewis-Crosby, John, *40*
lichen 19, *20*
Limerick lace 42, 43, *44*, *45*, *46*
limestone 54, 56, *62*
linen 16, 18, 19
lipe work *125*
lobster pots *126–7*
log cabin patchwork 30, 31, *32*, *33*, *34*
Lonergan, Thomas and Noel *38*
looms 18, 26
 carpet *36*
lunula, gold *177*
lusset (*losaid*) *125*

McCaffrey, John James *87*
McCawley, Liam *194*
Macdonald, Brian, Eamonn and Philip *90*
McGee's, Donegal 26
McGrath, John *133*
McHugh, Packey *18*

McMahon, Teresa *162*
McNutt's, Downings 26
Maguire, Ned *202*
Maher, Nora *24*
Mahon, Bobby 200
Mahon, Bridgid *24*
marble *53*, 56
mare, cooper's 65, *66*, 69, *74*, *120*
marl 188
marquetry *85–6*
Marshall, Tony *178*, *181*
Martry Mill *59*
meerschaum *80*
Mellifont (Louth) 52, 54
Midleton (Cork) 64
millstones *59*
Moloney, John and Paddy *171*
Moloney, Paul *190*
Moore, Mrs Mollie *45*
mordants 22
Morrison, Mrs Bessie 14, *15*
mosaic patchwork 30–31, *32*, *33*, *34*
Moville (Donegal) *90*
Mulholland family 54, 204, 207, *209*, 210, 211, 212
Mulkerrins, Colm 92, 94
Mulrankin (Wexford) *133*
Murphy, Paddy *187*, 188, 189
Mweenish Island (Galway) *91*

naevóg 98, *98–100*, *102*
napping 26–7
Nash, John *107*, *109*
needlepoint lace 43, *46*
New Quay (Clare) *108*
Noritake, Arklow 196

O'Brian, Garry *108*
O'Connell, John 153
O'Donnell, Mrs Maureen *28*
O'Gorman, Mrs Mairead *33*, *34*
O'Leary, Monty and Michael *98–9*
O'Neill, Jem and Philip, *53*, *55*
O'Reilly, Felix *53*
O'Rourke, Tommy *187*

pampooties *156–7*
pardóg 126
patchwork 30–34
Patterson, Arnold *173*
Pearce, Simon 201

Pearl Ware pottery 192
Philbin, Thomas *88*
pipes, briar *80*
planishing *182*, 184
porcelain 191, 192, 194, 196
potato strainer (*ciseog*) 120, *121*, 125
potteries 186, 188–9
pottery 186–96, *193–4*
 delftware 191, 192
 imported 191
 prehistoric *186*
 studio 196
Púcán 94

quarries *53*, 54, 56, 60, 204, *207*
Queen's Ware pottery 192
quilting 31, *32, 33*

'raising' (churns) 65
'raising' (silver) 180, 184
reed raft (*cliath thulcha*) 95
reeds 130
repoussé work *183*, 184
retting 18, *39*, 40
Robinson, Charles, Michael and
 Tom Joe *85*, 86
Roche, Captain Philip 197
Rochford, John *131*
roofing *58*, 130
roped thatch 131–2, *134, 136*
Roundstone (Galway) *110*
Royal Linen Manufacturers *16*, 19
Royal Tara, Galway 196
run lace 43, *44, 45*
rushes 131, *145–6*
Ryan, Michael 200
Ryder, Ben *176*

saddles 153, *153, 154*
sally (*saileach*) *119–20*, 121
sally garden *119*, 121, 128
sandstone 54, 56, *57*, 62, 204
saw piercing (silver) 184
'scollop' ('pinned') thatch 132–4,
 133, 135, 136, 137
scutching 18, *40*
scythestones *see* whetstones
Severin, Tim *153*
sgraffito decoration *195*
Shanafaraghaun (Galway) *119*, 120,
 128

Shanahan, Joseph *120*, 127
Shanahan, Michael 127, *128*
shearing *14*
sheep 14
Shiels, James and John *82–3*
Shilelagh (Wicklow) *87*
shoeing 169, 172, 176
shoes *158*
Shrule (Galway) *151*
shuttles *19*, 26
Silcock's Mills, nr Crossgar *40*
silversmithing 177, *178–9*, 180,
 181–3, 184
skep (*sciobóg, scib* or *cis*) *120*, 121
skeps, bee- 139–40
skib 125
slate
 Liscannor *57–8*
 Moher *57*, 62
Slatta (Roscommon) *171*
sliotar 160
Sludds, Pat *174*
Smith, Desmond *162*
spades *173*
Spillane, Michael *99*
spinning 14, *15*, 16, *16*, 18–19
spinning (silver) 184
sprigging *28–9*
sticks (blackthorn) *87*
stitches, knitting 22, 27
stone *53*, 54, 56, *57*, 60
stonecarving 49, 50, *50, 52*, 54, *55*,
 56, 60
stonecutting 49–60, *53, 57*, 204,
 207, 209, 210
stonemasonry 49–60, *62*
Stoneyford (Kilkenny) 201
straddle 51
straw 130, *131, 139, 140, 141*
Strokestown (Roscommon) 201
súgán ropes 72, *141, 142*, 153
Sullivan, Christopher and Noirin
 141–2
Sullivan, Patrick *58*
Surlis, John *74, 79*
Sweetman, David 191

tables 71–2
tailoring *38*
Tallon, Michael *59*
tambour lace 43, *46*
Tara brooch 177, 180, 197

teasing (wool) 18
Thallbawn (Mayo) *15*
thatching 130–36, *137–8*
Thompson, Kenneth *55*, 60
thrust thatch 134, *136*
tiachóg 125–6
tombs, megalithic 49
tooling 164, *165*
tools
 agricultural *171*
 basketmakers' 122, *122*
 blacksmiths' 168, 172
 bookbinders' *165*
 harness makers' *155*
 potters' *187, 189*
 silversmiths' 184
 stonecutters' 210
 thatchers' 132, 134
 woodworkers' *85, 92*
towers, round 50
Toye, Hugh *24*
tress hoops 64, *67*
Trulight (yawl) *94*
Tutty, Edward, George and
 Joseph *158*
tweed *16*, 18, 26

uilleann pipes *103–6*

Vikings 52
violins *107–9*
Vodrey, Frederick 196

Waddington, Victor 196
Wall, Tommy 200
walling, drystone 60, *62*
Walsh, Anne *195*
warping *16*
Waterford glass 197, *199*, 200–01
weaving 16, *16*, 18, 26
Welsh, John *88*
Wentworth, Sir Thomas 19
wheel-shoeing 172, *174–5*
wheels, spinning *15–16*, 18–19,
 82, 83
whetstones 204, *207, 209*, 210
willow *118*, 121
woods 65, *85, 87, 88, 105, 107*, 113,
 114, 115, 116, 118
wool 14, *15*, 18–19